"Few origami artists have been as accomplished in as wide a range of styles, constantly pushing the boundaries on uncharted approaches. Fuse's style is so rich, her geometric forms have an organic feel. This book also showcases the incredible execution of her works, clearly demonstrating her worthiness of the title of 'Origami Master.'"

MARC KIRSCHENBAUM, AMERICAN ORIGAMI ARTIST
AND AUTHOR OF *ORIGAMI IN AN INSTANT*

"The 'queen of origami' opens her treasure chest and shows us her incredible paper jewels, one by one. But this is not simply paper; it is art! Tomoko Fuse transforms a simple sheet into a tapestry, a painting, an expanding universe, into a triumph of intriguing and splendid forms that inevitably attract and overwhelm us with their beauty, like a roaring train. In a certain sense, origami offers a third way to art, it is transformative ... and what a spectacle! The origami in this book is of a higher level, a purely artistic origami."

FRANCESCO DECIO AND VANDA BATTAGLIA,
ITALIAN ORIGAMI ARTISTS AND AUTHORS OF
LEZIONI DI ORIGAMI [ORIGAMI LESSONS]

RED PARK
MIXING TECHNIQUE

41.5 x 24.8 inches (1055 x 630 mm)
PAPER Washi/Hamada, Kochi

布施 知子

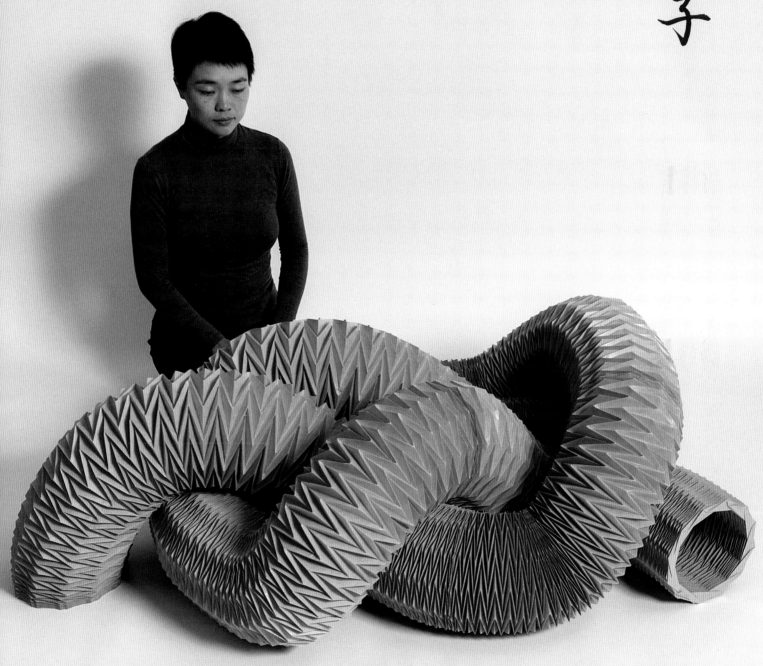

OROCHI

Big
Diameter 8.9 inches (227 mm)
Small
Diameter 5.9 inches (150 mm)

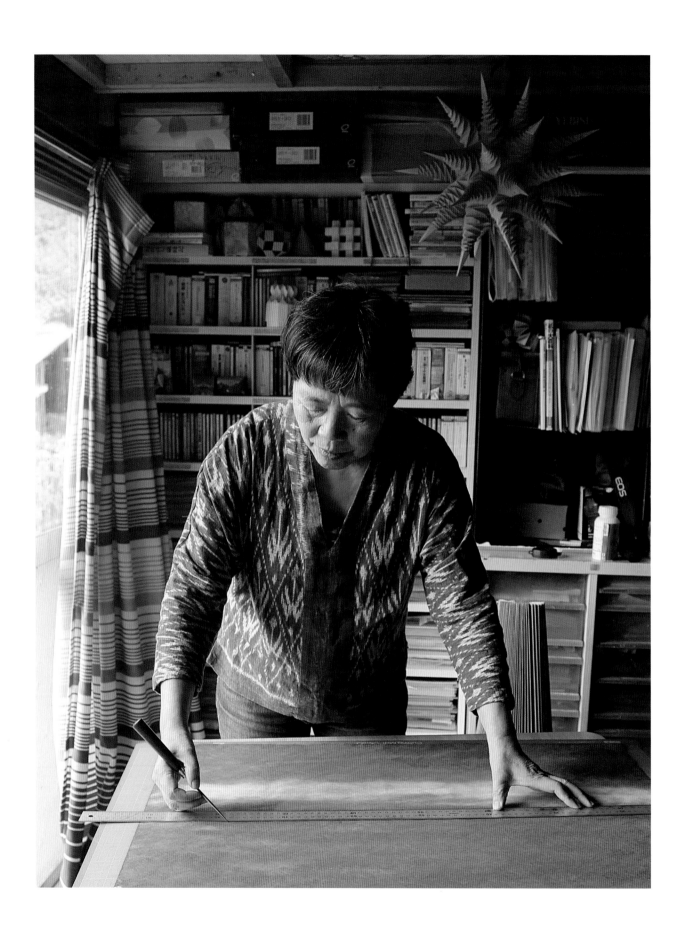

Tomoko Fuse's Origami Art

WORKS BY A MODERN MASTER

PREFACE BY
HIDETO FUSE

INTRODUCTION BY
DR. ROBERT J. LANG

TEXT BY
DAVID BRILL AND **TOMOKO FUSE**

TRANSLATED BY
ORNELLA CIVARDI AND **IRINA ORYSHKEVICH**

PHOTOGRAPHY BY
TSUYOSHI HONGO
KENGO ENDO

TUTTLE Publishing

Tokyo | Rutland, Vermont | Singapore

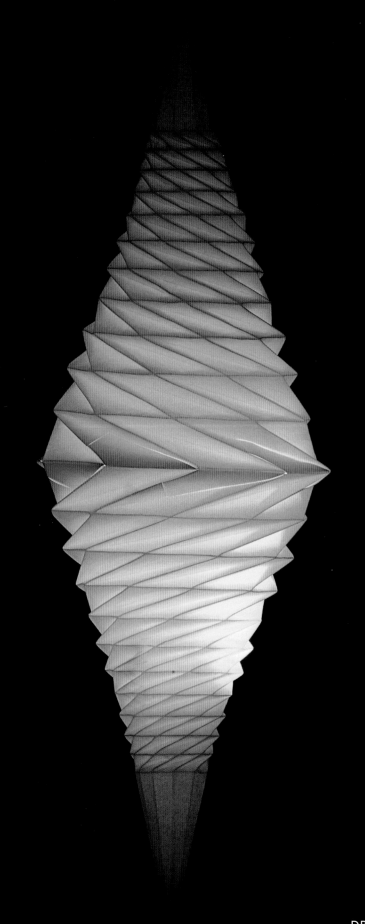

DROP

Height x Diameter
30 x 8.7 inches (760 x 220 mm)

CONTENTS

●

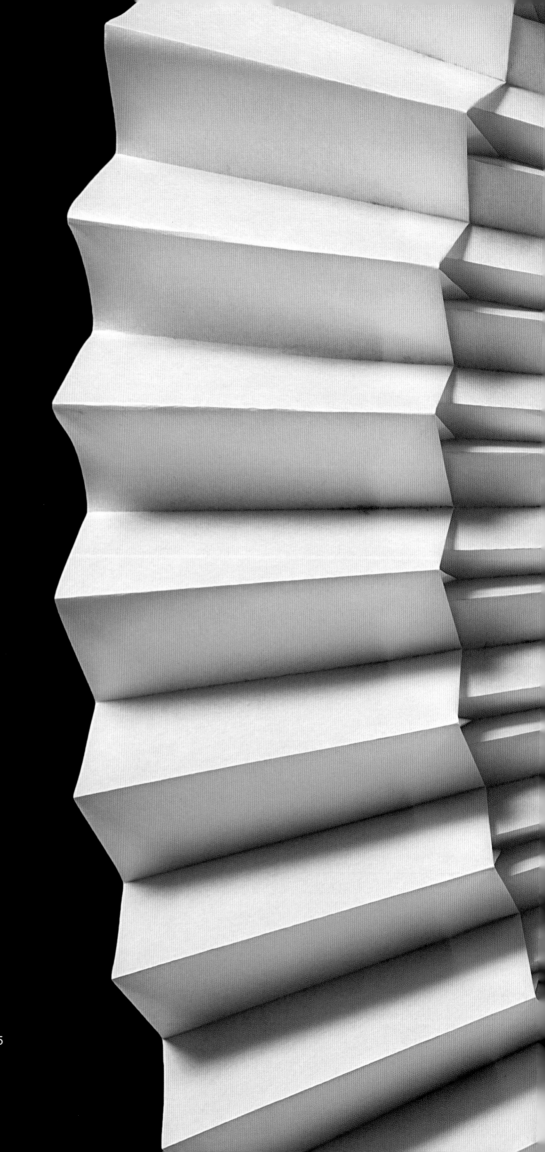

MODELING WITH SWALLOW 45
WHIRL 3

Height x Diameter
7.9 x 51.1 inches (200 x 1300 mm)

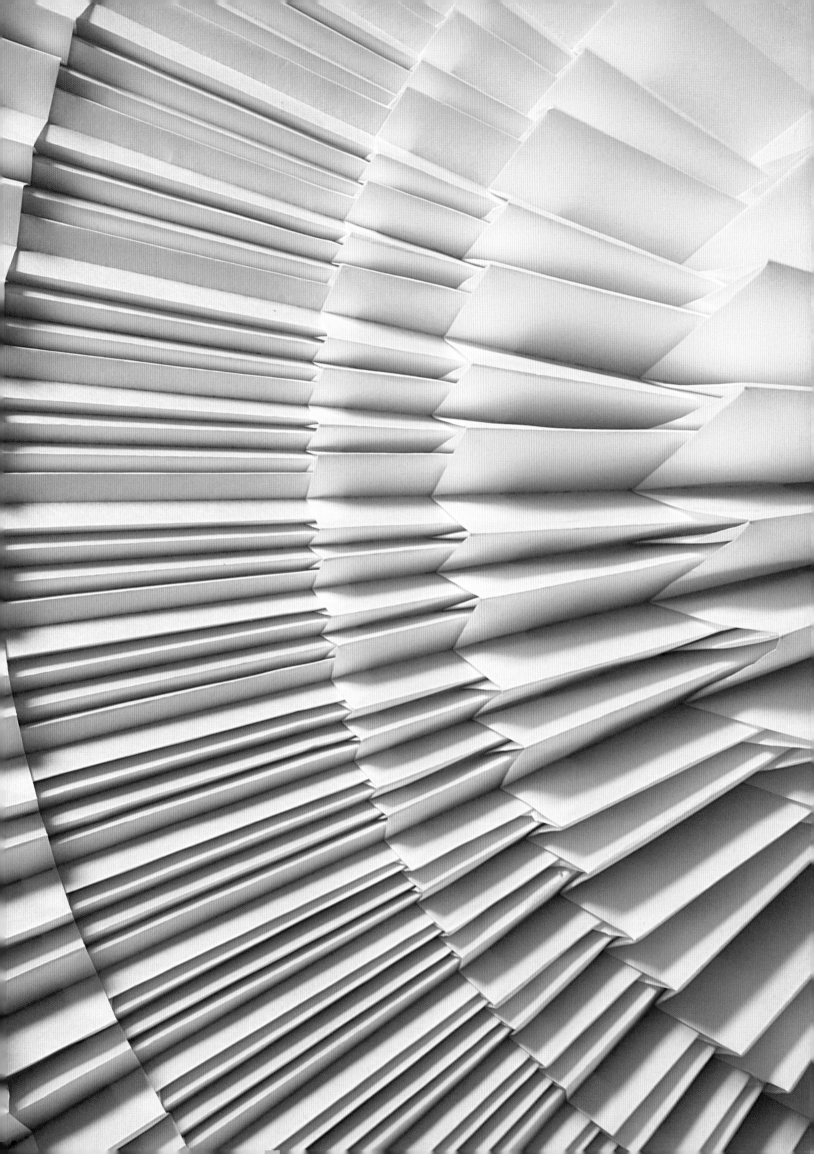

AN ART WITH RULES

● Origami is not an art without rules. Constraints and restrictions begin at the very moment that we make the first crease in the sheet. As we proceed to fold, the field of possibilities begins to narrow until only *that* particular form becomes possible. But if we get it right, the result leaves us breathless. What a great joy it is whenever an entire world is uncovered through a brief series of gestures.

Not necessarily everything begins with a preliminary design and plan for a specific object to be attained. An idea can easily pop up even at a seemingly insignificant moment, when, for example, we suddenly decide to flatten a certain fold or twist a certain element, or get an urge to roll up an edge or perhaps bend a component in half, and then in half again. We think as we fold. Head and hand work together.

The sensation that overcomes us as we perform one gesture after another is the desire not so much to create as to search and discover. Each time we make a fold in the right place and, by combining the various elements bit by bit, succeed in completing a model, we think to ourselves with great satisfaction, "See! That's how it's done!"

Handling paper is not like handling clay. Some use both in the same manner, but that is not my philosophy. In fact, it is precisely because paper cannot be molded according to our wishes that heretofore unseen forms may emerge from it. My goal is never to impose a shape of something onto the paper, but rather the reverse, to discover the amazing forms that slowly take shape as I proceed to fold it. This is what truly fascinates me.

Tomoko Fuse

布施和子

SNAKE

▶ Width x Height 5.3 x 3.7 inches (135 x 95 mm)

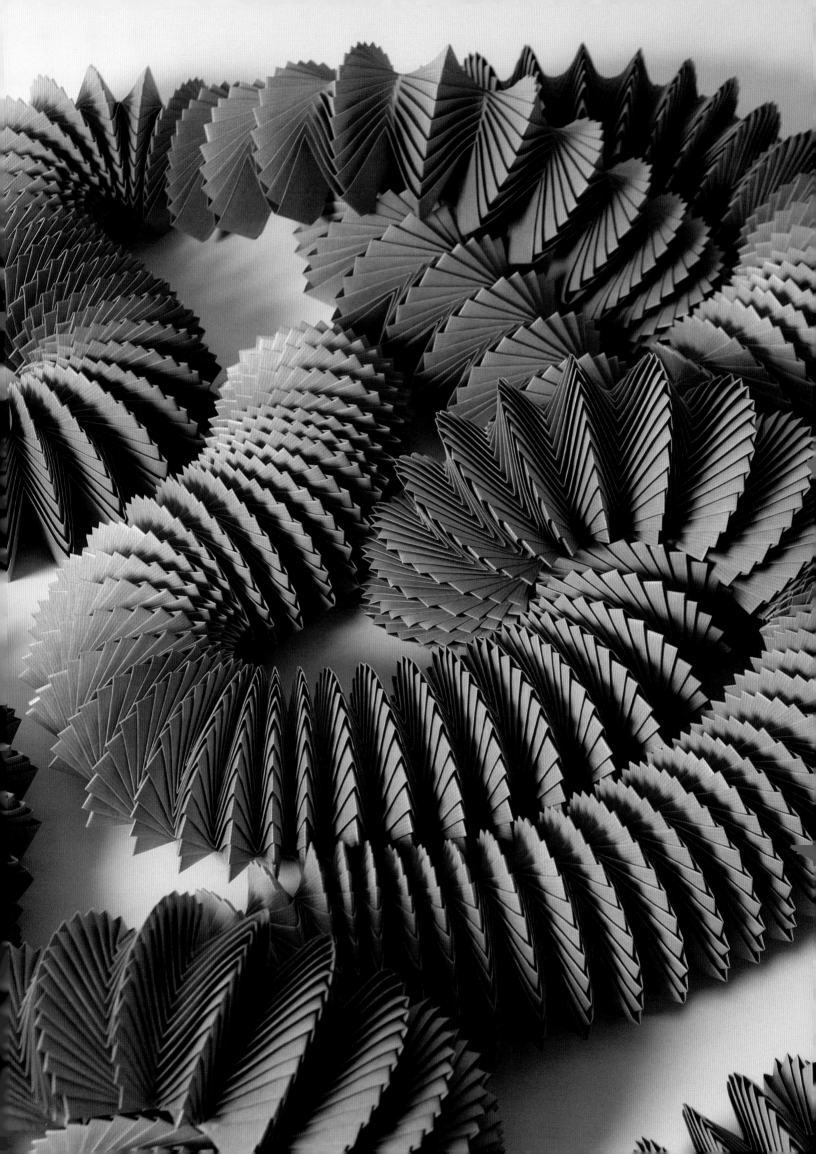

ORIGAMI AS ART

Among traditional handmade items used on a daily basis in Japan is the *furoshiki*, a bundle for holding and transporting goods, and the kimono, the country's quintessential clothing item. In both, the most conspicuous formal quality is two-dimensionality.

When fulfilling the task of wrapping contents (that is, when used to transport a load), the *furoshiki* transforms itself from a flat piece of cloth into a three-dimensional object. So too does the kimono, which, when performing its function as a piece of clothing for covering the body, acquires volume and depth. Nonetheless, both the *furoshiki* and the kimono start out as flat, two-dimensional objects. The first is nothing but a square piece of cloth; the second, once folded, turns into thin layers of fabric (unlike Western garments which remain three-dimensional even when folded). In both cases, we confront something two-dimensional that becomes volumetric. Here, therefore, is the Japanese sense of form, one that is based on the concept of flat surfaces.

In the realm of contemporary art, Takashi Murakami has gained attention on the international art scene by working on the concept of Superflat, a term that captures the exaggeration of two-dimensionality which characterizes Japanese expression as a whole, not only *manga* and *anime*, but even the country's ancient art, particularly *ukiyoe*.

The work of the origami artist Tomoko Fuse, in which form arises from the folding of a two-dimensional sheet of paper, is likewise based on a flat surface. In origami, a two-dimensional square is manipulated to obtain another kind of form that develops differently in space, but the starting point remains very similar to that of *furoshiki*. It is precisely from this two-dimensional square that—as if by magic—the sculpted form is born and reveals the art of Tomoko Fuse. Perhaps it is by chance that *kami*, the Japanese word for "paper," also means "god." What is certain, however, is that in the hands of Tomoko Fuse, paper acquires a sublime beauty that brings it closer to the divine.

But let us see how this paper universe of Tomoko Fuse's work is configured. The photographs and explanatory illustrations that unfold in the pages of this book, offer a comprehensive essay broken down into five chapters that bring together "nodes," "tessellations," "endless folds," "multiple folds," and, finally, works illuminated from within.

Like art as a whole, so too origami can be figurative or abstract. Much origami does tend towards figurative subjects such as flowers, birds, and insects. But even a quick flip through the pages of this collection will reveal that the works here are nearly all abstract. One could say, in effect, that works such as these make us ask whether origami is an abstract art. Therefore, let us try to frame the work of Tomoko Fuse in the context of contemporary art, particularly that of the twentieth century.

**MODELING WITH SWALLOW 45
CIRCULAR STUMP**

▶ Height x Diameter
9 x 19.3 inches (230 x 490 mm)

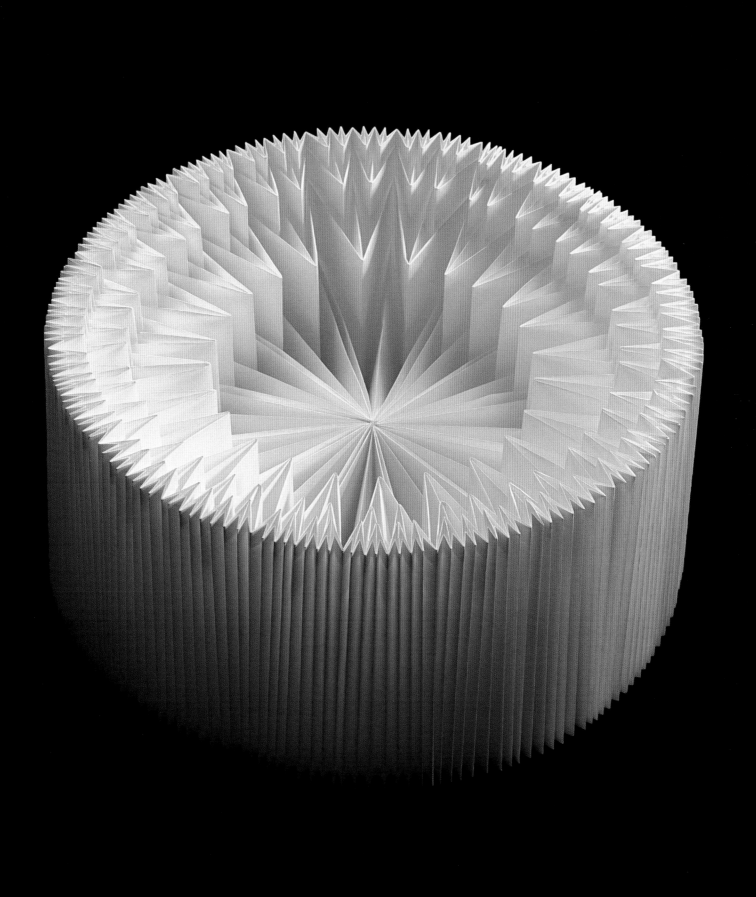

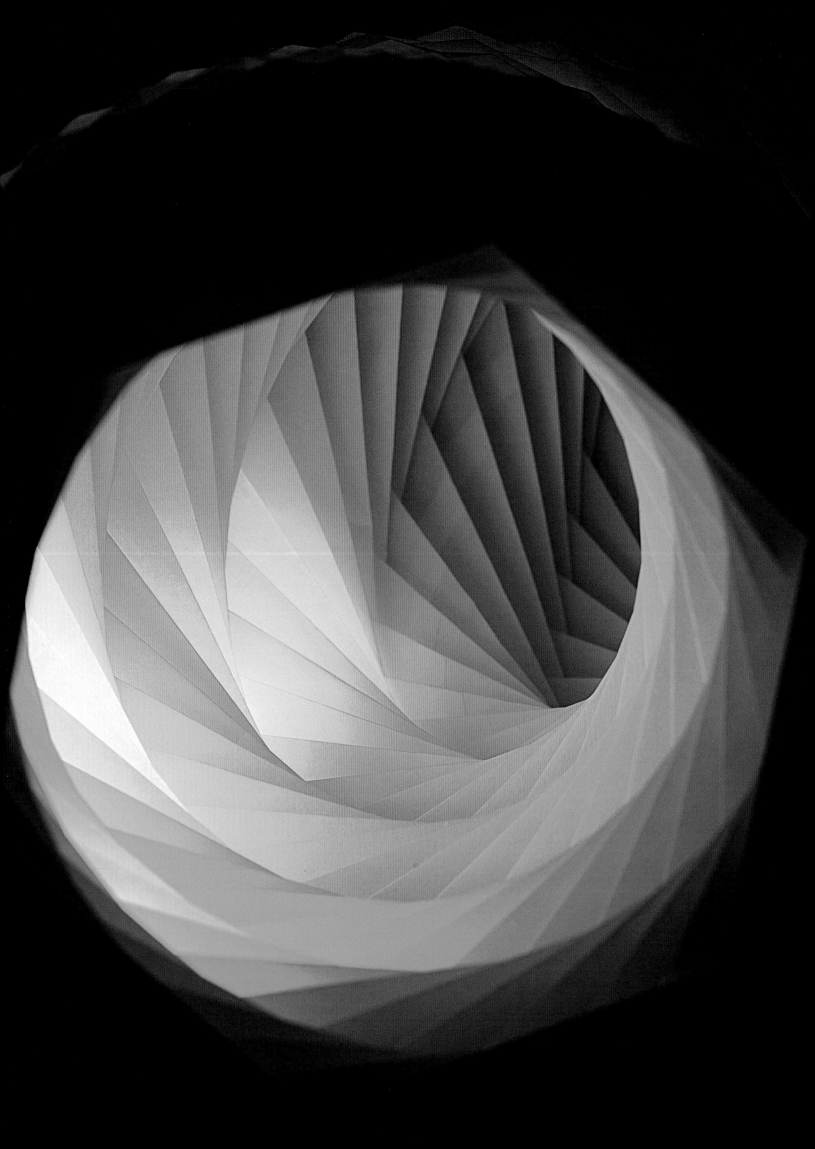

Take, for example, the "nodes" in Chapter 1. The sight of them makes my mind jump to the paintings of Piet Mondrian, to the intersections of their horizontal and vertical lines. Taking figurative art as his starting point, the painter developed his style through successive simplification, submitting images of trees and houses to a process of abstraction in order to extract from them grids constructed of perpendicular lines. Next, he extended the process of simplification and abstraction to color, which led him to retain—in addition to black and gray—only red, blue, and yellow. Tomoko Fuse's "nodes" are structures fabricated out of thin strips of paper that are inserted into an intersection of lines. What makes them different from the works of Mondrian is the angle of intersection, which does not necessarily have to be 90 degrees, and the point of departure, which does not consist of simplifying and abstracting figurative images but working directly with geometrical and mathematical concepts.

The next series, which falls under the title "flat folds" recalls Picasso and Braque's Cubism. While painting generally strives to create the impression of depth on a flat surface, that is, three-dimensions in two-dimensions, Picasso and the Cubists compose figures by combining multiple images (flat surfaces) from different viewpoints so as to create solid figures, or "cubes." Of course, flat folds do not generate similar "images arising from multiple viewpoints," but they do reveal an urge for three-dimensionality— much like that of Cubism—in which the flat surface of the paper springs into a sort of high relief.

The "endless folds" of Chapter 3 and the "multiple folds" of Chapter 4 remind me (perhaps somewhat audaciously) of the work of Andy Warhol, of his multiple soup cans or movie stars that, reflecting on mass production and consumption in capitalist society, showcase the repetition of a subject and turn this "act of repetition" into an artistic gesture. This kind of Warholian aesthetic is not alien to certain of Tomoko Fuse's figures, in which an element may repeat itself and multiply indefinitely. Yet, what is also present in them is the mathematical and philosophical concept of "infinity." Infinity signifies infinite growth, or something increasing to infinity, hence the infinitely large, as well as infinite diminution, hence the infinitely small. Both are present in Tomoko Fuse's universe: the infinitely large of endlessly repeating folds, and the infinitely small of an element divided in half, and then in half again. In some works, the infinitely small assumes amazing shapes, inexplicable even in mathematical terms, as when a long, thin triangle, through a series of folds, finally approaches the form of an equilateral triangle.

TORNADO
◀ Height x Diameter 9.4 x 18.9 inches (240 x 480 mm)

Now, as a three-dimensional object, origami is constituted of a combination of flat surfaces, as is a Cubist painting, as already noted. And, as is the case in Cubist painting, each of these various surfaces are presented from a different angle. In the presence of a light source, some surfaces will cast shadows, while others (if the origami is made from white paper) will brightly glow. Such play of light and shadow is magical.

The "luminous" series of Chapter 5 does not simply respond to an external light source, but rather introduces light into its solid forms, illuminating them from within. In this way, origami becomes a light instrument, a lamp. If in certain respects the work of Tomoko Fuse recalls contemporary and abstract art, in other respects it lends itself to novel applications in the field of design.

Tomoko has been creating these works in her home in the mountains of Nagano for thirty years. In order to gather material for this essay, I visited her home-studio. (By coincidence we bear the same surname but we are not, in fact, related.) Tomoko lives with her husband, the woodblock printmaker Taro Toriumi, and a cat. On the shelves in her studio were sheets of all kinds of paper (were she a painter, these would have been paint tubes) and hundreds of tiny works, little models and experiments tightly arranged in beautiful order in a series of boxes. Faced with this display of creativity, I asked myself whether I was in an artist's studio or in the laboratory of a scientist (particularly one studying geometry).

Is Tomoko Fuse's work ultimately art or science? According to her, it is science (mathematics) for artists and art for scientists. Members of each category would tend to regard it as a world other than their own. This would be correct if origami were in truth a genre unto itself, different from both art and science, but the truth is that it falls within the sphere of both art and science.

In this age of ours, which is advancing towards ever greater specialization and reduction in general skills, the transcendence of borders, the ability to connect different worlds is extremely valuable. Origami, besides simply being a set of gestures for folding paper, is also a significant activity that is capable of uniting art and science within itself.

Hideto Fuse

布施英利

GARDEN IN SPRING
▶ 16.7 x 68.5 inches (425 x 1740 mm)
PAPER Washi/Kashiki, Kochi/Hand dyeing

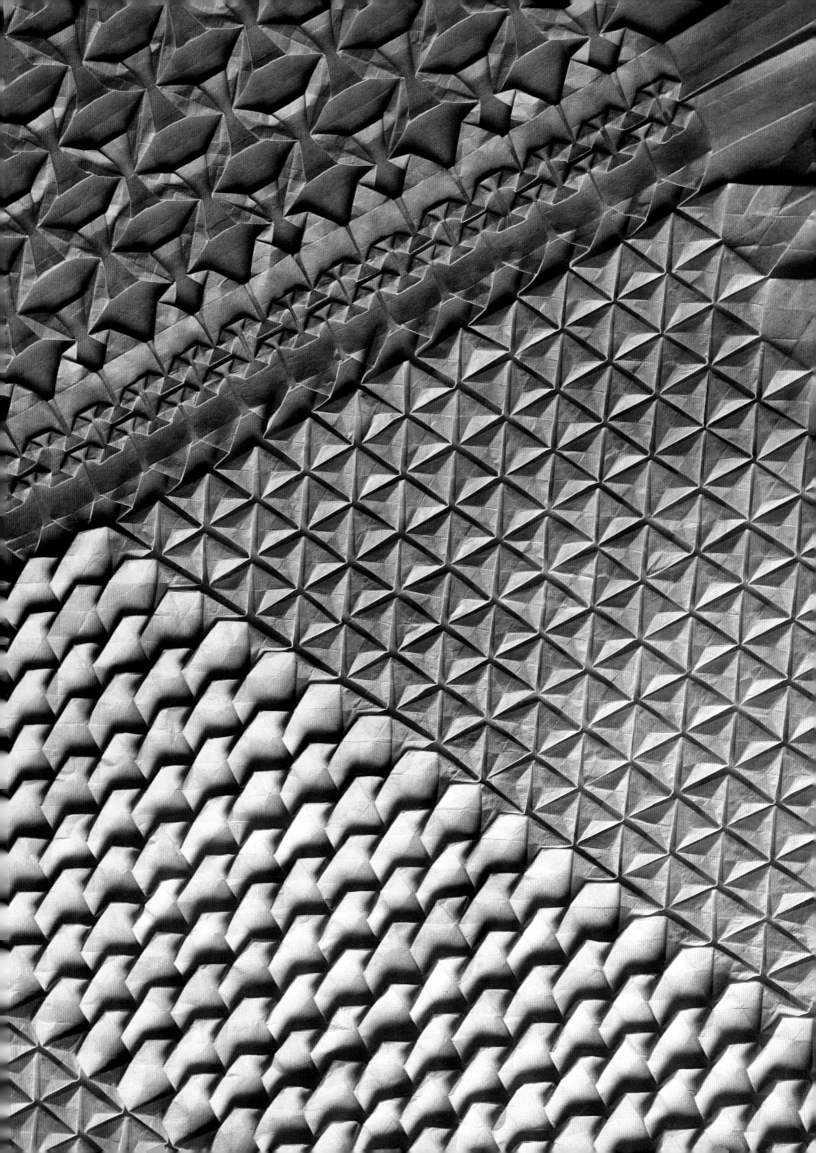

TOMOKO FUSE: A MODERN MASTER

It is a truism of almost every field that experts have their specialty. This is especially so in the art world. We associate the greats with a particular style and genre: Rodin with bronze figurate sculpture, Calder with the mobile, Picasso with cubism. The days of the generalist—think Leonardo da Vinci, moving between painting, fresco, sculpture, and invention—seem long past. The only way to be successful, it seems, is to find one's unique but narrow niche, that special vein of gold, then mine it artistically and assiduously.

Tomoko Fuse, though, is an artist in the da Vinci mold, moving among multiple origami genres and taking each, in turn, to new heights, before moving on to the next. If you asked an origami aficionado a few years ago about Fuse, they would rave about her modular work. *Unit Origami*, now almost thirty years old, is the classic reference in the field. Its combination of enjoyable folding sequences, ingenious locks, and stunningly beautiful finished forms set the standard for modular origami for years to come and established Fuse as the modern master of modulars, the standard bearer of the genre.

As she continued through the following years to dip into her apparently boundless well of modular designs (which she regularly shared in her columns in *Origami Tanteidan Magazine*), it would have been natural for her to stay in the modular lane. But a single genre was not for her. Instead, she added to her portfolio the vast field of single-sheet geometric origami: tessellations, corrugations, pleated forms, and more. Her landmark book, *Spiral: Origami / Art / Design*, brought the same combination of enjoyable sequence, clever design, and gorgeous finished form to single-sheet geometric folding, and once again established Tomoko Fuse at the top of an entirely new genre.

And the present work continues her artistic evolution, again exploring single-sheet folded forms, but now using pleated forms as the unifying feature of the genre.

The field of origami tessellations has roots in both the Japanese origami art by such masters as Fujimoto and Momotani, as well as Western folded paper forms, including works from the German Bauhaus movement of the 1920s and explorers of the 1960s like Ron Resch. From the mid-1990s onward, the field has grown explosively, with origami artists around the world producing a vast range of geometric forms. Even among these, though, Fuse's work stands out. There is a grace, an elegance, and, most of all, a richness of texture that is nearly overwhelming. Her folded forms are intensely detailed, with hundreds, if not thousands, of interlocking folds. But these are not simply massive repetition. There are patterns and motifs on multiple scales, so that as one focuses inward or zooms outward, there is a new story at each level of viewing. The work is always fresh and there is something new to discover and perceive, whether on first viewing or fiftieth.

TRIPLE WHIRLPOOL

▶ 11.8 x 8.9 inches (300 x 225 mm)
PAPER Washi/Hamada, Kochi

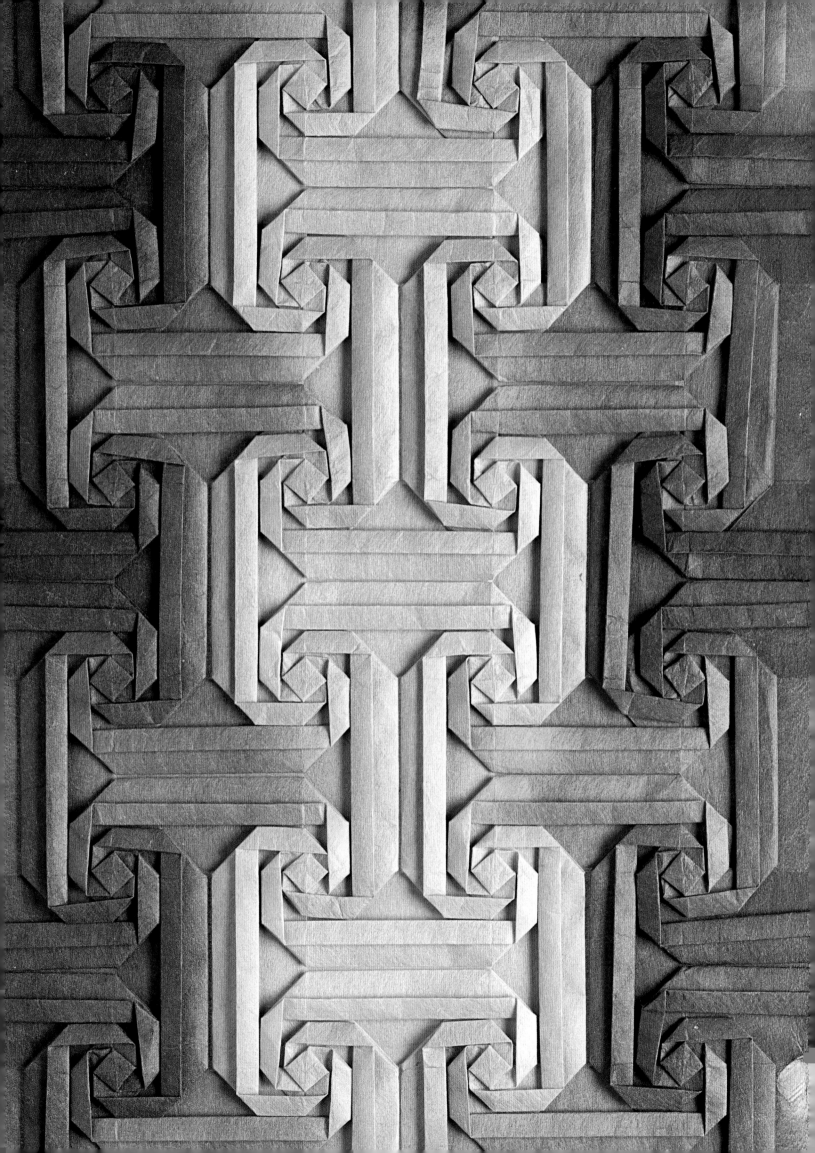

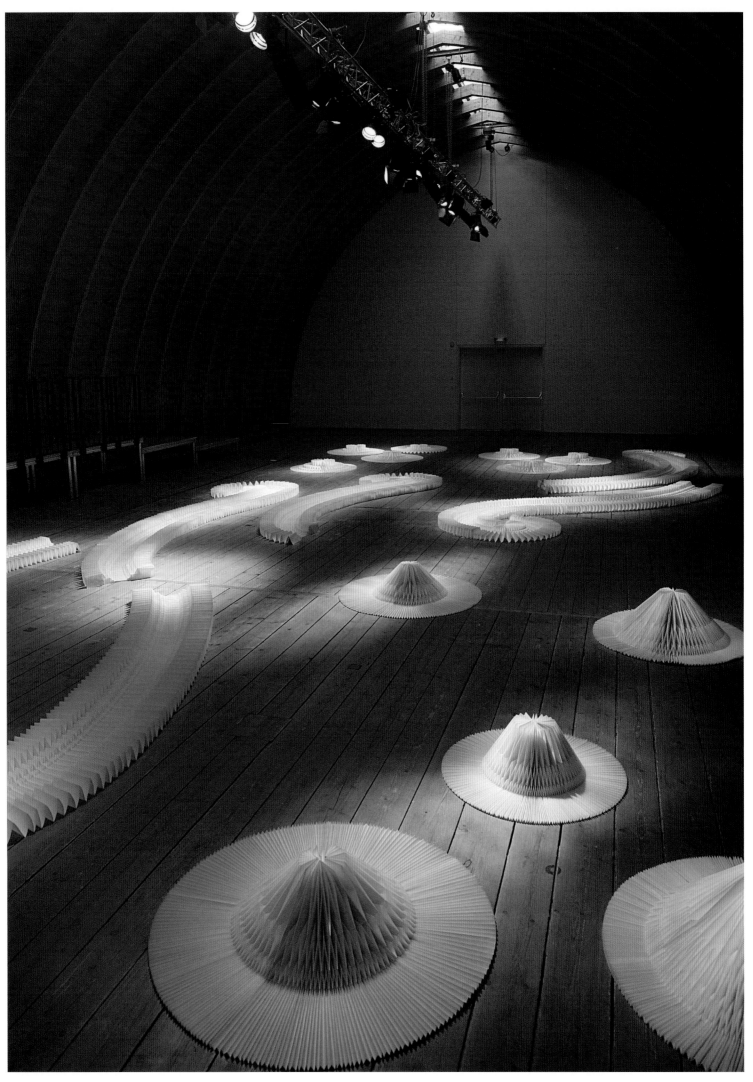

One of the characteristics of many origami tessellations—and here I use the term "tessellations" broadly, to take in any geometric folding containing repeated motifs—is exposure of the paper. A large fraction of the paper surface is visible in the finished work. This is to be contrasted with the most complex origami representational work, in which layers are tightly packed and stacked, so that only a tiny fraction of the paper surface is visible in the finished work. In many tessellations, and in many of Fuse's tessellations, in particular, we can see most of the paper. Fuse takes full advantage of this, using papers with delicate textures and often graded coloration across the sheet. The interplay between the color gradation and the patterns of folds brings a new depth to the folded work.

There is yet another form of exposure in her artwork. Many of the pieces are shown twice, with front and back lighting, the latter illuminating the now translucent works. In her backlit work, we now see even more of the paper—filtered and transformed by the foreground layers, but now revealing hidden structure and patterns so rich that it is sometimes difficult to believe that both forms arise from the same pattern of folds.

A single chapter of this book could well serve as a life's work for an artist, but Fuse has moved across genres her entire life and the five chapters here display both variety and evolution. Here we see the next iteration of her landmark explorations of unit folding. Now, though, the units are strips. They cross, knot, and re-cross, creating patterns that hearken back to the world of modulars, but also look forward to the tilings and tessellations of the next four chapters. Through the next three chapters, she explores and expands this world, and in the final chapter takes the folding to a natural crescendo by bringing light fully into the art. Light is not just a part of the staging, it, like the paper, is now a full-fledged partner in the presentation. Fuse weaves together folds, fibers, and photons. The result is magical, and will leave the reader gasping in astonishment at its beauty and, perhaps, inspired to follow their own muse into this wondrous art.

Dr. Robert J. Lang

PAPER GARDEN
BY INFINITE FOLDING

◀ European House of Art Upper Bavaria
Schafhof, Friesing, Germany, 2015

BIOGRAPHY

Tomoko Fuse's earliest encounter with origami occurred at the age of seven, when she started folding paper models during a hospital stay. In around 1980, way ahead of her time, she began devoting herself with great passion to modular origami, which she made by assembling several sheets of separately folded paper, for which she earned the sobriquet "module queen."

Experimenting with ever new ways of folding paper, she turned towards geometric form and ended up designing industrial products such as lampshades and the Origami Pots collection.

The artist has appeared on many television programs on private and public networks, such as *Oshare kōbō* (Trend Studio) on NHK. In 2015, she starred in the movie *Un monde en plis. Le code origami* [A World in Folds. The Origami Code] directed by François-Xavier Vives for La Compagnie de Taxi-Brousse, a French production company that specializes in TV documentaries. In 2016, she was the subject of discussion on Art Scene, a program featured on *Nichiyō bijutsukan* (Monday in the Gallery) on NHK, which was broadcast twice in 2017.

1951 Born in Yoitamachi, in the district of Mishima in the province of Niigata.
1973 Graduates from the University of Chiba in green design.
1986 Moves to Yamamura Yasaka, in the province of Nagano, and begins to practice origami professionally.
1987 Invited to Italy by the Centro Diffusione Origami.
1989 Visits England, Germany, Holland, Poland, and Bulgaria on behalf of the Japan Foundation.
1990 Invited to America by Origami USA, the national association for origami in America.
1991 Invited to France by the Mouvement Francais des Plieurs de Papier, to Germany by Origami Deutschland e.V., and to Spain by the Asociación Española Papiroflexia. Takes part in an ikebana exhibition with teacher Takagi Reishi at the Sogetsu school in Tokyo.

▲ *UNIT & Spiral*, Bauhaus, Dessau, Germany, 2004

1994 Assists in the organization of the second OSME (Origami Science Mathematics Education) held in Otsu, making a valuable contribution to the event's success.

1998, 2000, 2003 Invited to the Origami Festival in Charlotte, USA.

1998 Among three Japanese artists invited to exhibit at the *Paris Origami* exhibition held in that year at the Carrousel du Louvre.

1999 Invited by the Canada Origami Group and the Japanese-German Origami Association. In July, holds a solo show in Ueda Sōzōkan in Ueda, Japan.

2002 Invited to participate in the *On Paper* exhibition organized in London, England and sponsored by the Crafts Council. Presents Origami Pots, the result of research conducted with three other colleagues, at the third OSME held in America. Origami Pots are awarded a patent that same year.

2003 Invited to participate in the *Origami* exhibition held at the American Folk Art Museum in San Diego, USA.

2004 Invited by the Israel Origami Center in April to hold a solo show at the Hankin Gallery in Holon (Israel). In September, holds a solo show, *UNIT & Spiral*, at the Bauhaus in Dessau, Germany. Invited by the British Origami Society.

2005 One of her works is chosen for the poster for the *Masters of Origami* exhibition held in July at Hangar-7 in Salzburg, Austria.

2006 Invited by the Indiana Origami Association.

2008 A guest at the General Convention held on the occasion of the 25th anniversary of the Origami Sociëteit Nederland in Holland.

2009 Holds the *Felicità* exhibit at the Origami Galerie in Freising, Germany, along with her husband Tarō Toriumi, a woodblock printmaker.

2010 In March, invited by the origami associations of Colombia (Origami Bogotà) and Brazil. Along with her husband Tarō Toriumi, brings the *Felicità* exhibit to Friedrich-Fröbel-Museum in Bad Blankenburg, Germany. In August, invited to the CenterFold Origami Convention in America. In October, exhibits her origami at the Tokyo Art Shop Forum.

▲ *Masters of Origami*, Hangar-7,
Salzburg, Austria, 2005

▲ *Raumfalten*, European House of Art
Upper Bavaria, Freising, Germany, 2005

2011 In January, she and her husband reopen the *Felicità* exhibition at the Holzwerkstatt Markus Faißt in Hittisau, Austria. One of the artists whose works are included in the *Träume aus Handen* exhibition at Galerie 13 in Freising, Germany.

2012 One of the authors invited to the American traveling exhibition *Folding Paper*.

2013 In May, invited to Germany by Origami Deutschland e.V. and to France by the Mouvement Francais des Plieurs de Papier. In November, nvited by Mexico Origami.

2014 In June, invited to the CenterFold Origami Convention in America. In September, visits India and Butan on behalf of the Japan Foundation.

2015 In September, participates together with Heinz Strobl at the *Raumfalten* exhibition, held at the European House of Art of Upper Bavaria in Freising, Germany. In November, invited by the Centro Diffusione Origami (CDO).

2016 In April, holds a solo show, *Harmony between Paper and Folding*, at the Azumino Municipal Museum of Modern Art in Azumino, Japan. In May, takes part in the *Origami Universe* exhibition held at the Chimei Museum in Tainan, Taiwan. Invited by Origami USA in June, by the Korea Origami Association in August, and by the Argentine-Japanese Cultural Association in October.

2017 In June, is present at the Japan Alps Art Festival (JAAF) in Omachi, Japan. In August, invited to England to celebrate the 50th anniversary of the British Origami Society. In October, invited to France by the Organisation des origa mistes de Rhône-Alpes et d'ailleurs.

2018 In April, exhibits a new series of lamps and objects made out of *washi* paper that she conceived in collaboration with designer Denis Guidone.

◂ *Yorokobi*, with Taro Toriumi, Holzwerkstatt Markus Faißt, Hittisau, Austria, 2011

▸ *Harmony between Paper and Folding*, Azumino Municipal Museum of Modern Art, Azumino, Japan, 2016

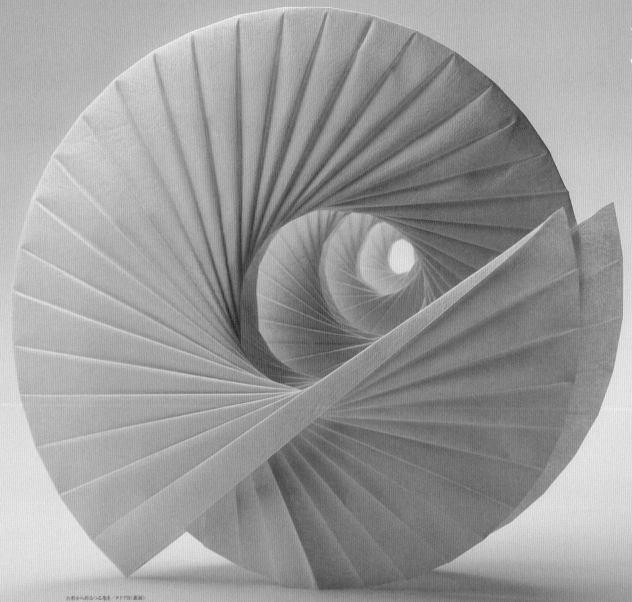

安曇野市豊科近代美術館 春の特別展

布施知子 ORIGAMI展

～紙と折りのリズム～

2016. 4. 22 金 ～ 6. 1 水

月曜休館　4/25、5/9、5/16、5/23、5/30

開館時間
午前9時～午後5時（入館は午後4時30分まで）

入館料（　）内は団体料金
一般　600（500）円
大学・高校生　400（300）円
※中学生以下、市内在住70歳以上　無料

台形から折りなじる巻き／タイプA（裏面）

主催　安曇野市豊科近代美術館・公益財団法人 安曇野文化財団
共催　信濃毎日新聞社
後援　安曇野市・安曇野市教育委員会・読売新聞松本支局・朝日新聞長野総局・毎日新聞社松本支局・産経新聞社長野支局・中日新聞社・市民タイムス・大糸タイムス社・松本平タウン情報・SBC信越放送・NBS長野放送・TSBテレビ信州・abn長野朝日放送・あづみ野テレビ・あづみ野エフエム

安曇野市豊科近代美術館
〒399-8205 長野県安曇野市豊科5609-3
TEL.0263-73-5638　FAX.0263-73-6320
URL http://www.azumino-museum.com
アクセス［車］長野自動車道安曇野I.Cから5分
　　　　　［JR］大糸線豊科駅から徒歩10分／篠ノ井線田沢駅から車で10分

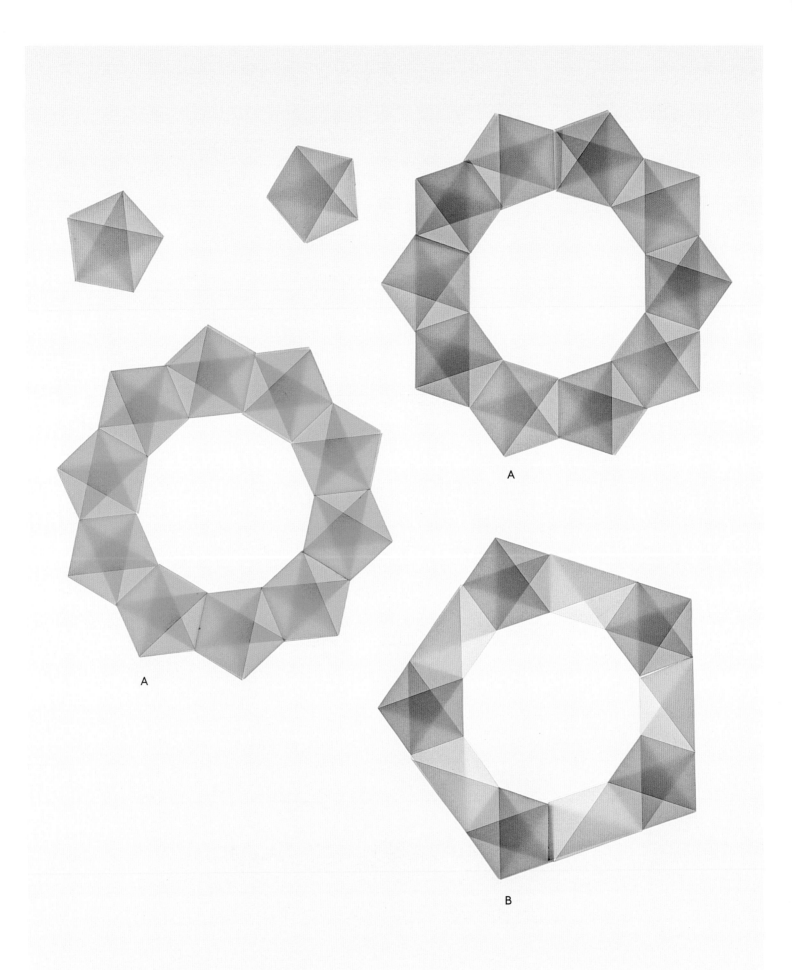

PENTAGON STAR RING

▶ A: Diameter 5.1 in (130 mm); B: Diameter 4.7 in (120 mm)
PAPER Color tracing paper

CONSTRUCTING WITH THE KNOT

● Creating a perfect pentagon out of origami without the help of a measuring device is extremely difficult. Nonetheless, if you take a thin strip of paper and make a simple knot in it—even without folding it too precisely—the pentagon will appear as if by magic. At this point, you can try using it as a base for various compositions, and afterwards extend the same principle to the square and the hexagon. This is how the pieces in this chapter came into being.

Shape the loop by repeatedly folding a thin strip of paper at a given angle until you have a polygon that can be closed by inserting the two ends into each other. Here, you will find square, pentagonal and hexagonal loops. All have slots through which other paper strips can be threaded. Using the loop as a lead and a catch to create figures at will can be stimulating. Additional pleasure arises from the combination of colors and from the possibility of generating stars and floral patterns. **(TF)**

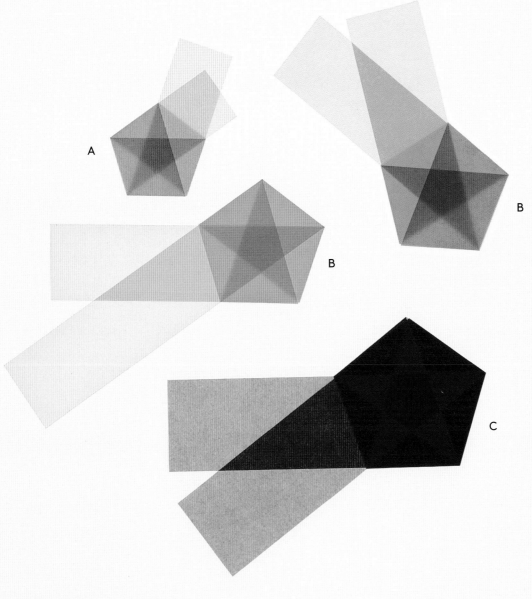

PENTAGON STAR KNOT

▶ A: Diameter 2 in (50 mm); B: Diameter 2.6 in (65 mm; C: Diameter 3.1 in (80 mm)
PAPER Color tracing paper

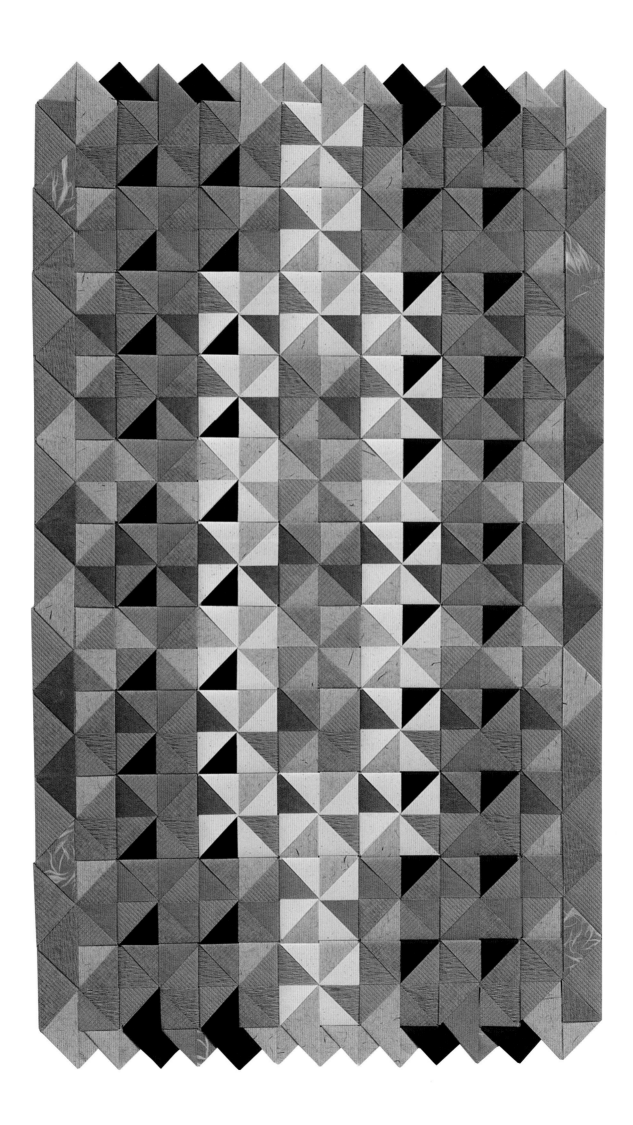

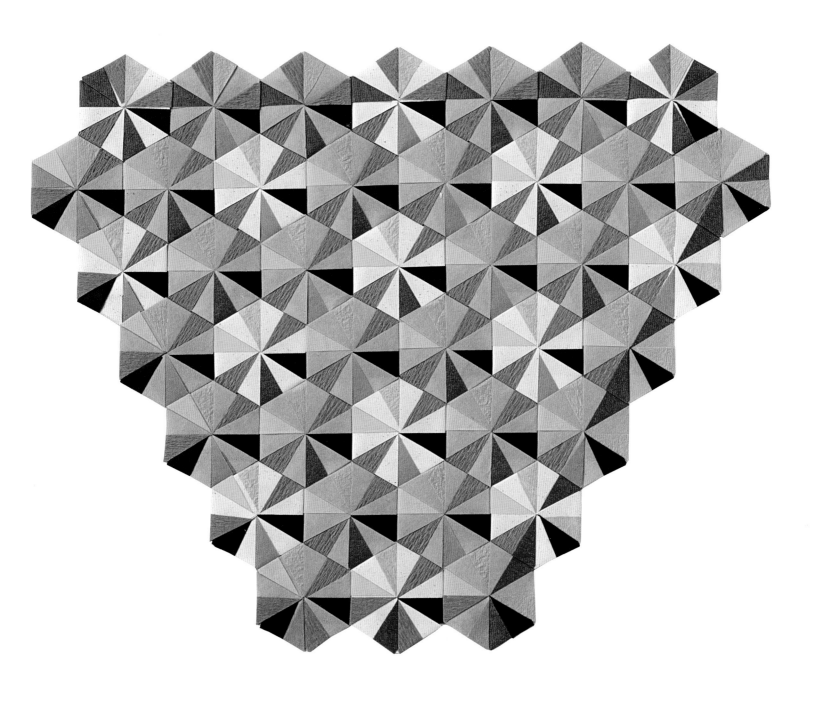

RECTANGLE KNOT 2

◀ 11 x 18.9 inches (280 x 480 mm)
PAPER Washi

HEXAGON KNOT 1

▶ 11.6 x 14.8 inches (295 x 375 mm)
PAPER Washi

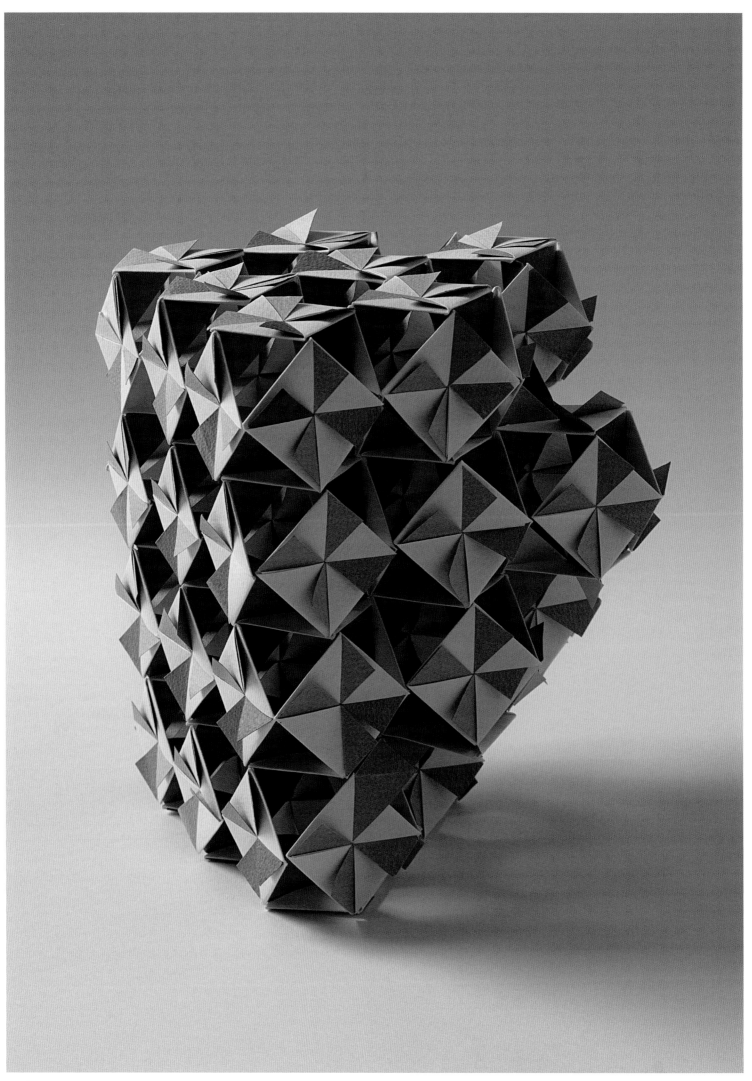

It may not be obvious that a thin strip of paper can work the same way as a string or piece of twine. We all know the simple or "package" knot. It is the one we make every day when tying our shoes. As Tomoko points out, it is amazing to discover that if we make one with a strip of paper, carefully pulling the two ends and flattening everything out, we will end up with a perfect pentagon. From here, it is only a tiny step to imagining how to create a 12-sided solid figure or pentagonal dodecahedron from a long, continuous strip.

But Tomoko Fuse goes far beyond this. This well-known master of modular origami is able to use strips to create the most elegant structures with square, rectangular, triangular, and hexagonal bases, always resorting to the principle of the knot or extending the procedure to create other flat or solid forms.

For example, the artist can make complex and elaborate two-dimensional "tapestries" out of interwoven paper strips—much like tartan or tweed textiles—from "threads" of various colored paper held together by strips that are knotted at intersections or along the edges. **(DB)**

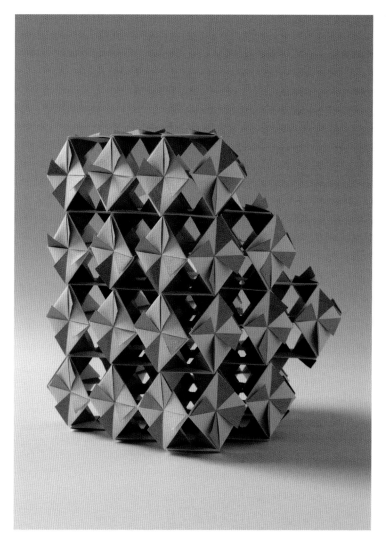

RECTANGLE KNOT SOLID 1

- Width x Length x Height
 7.1 x 7.1 x 9.4 inches
 180 x 180 x 240 mm
 PAPER Mermaid/Takeo, Tokyo

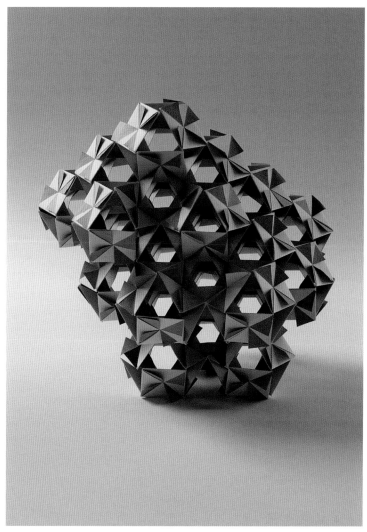

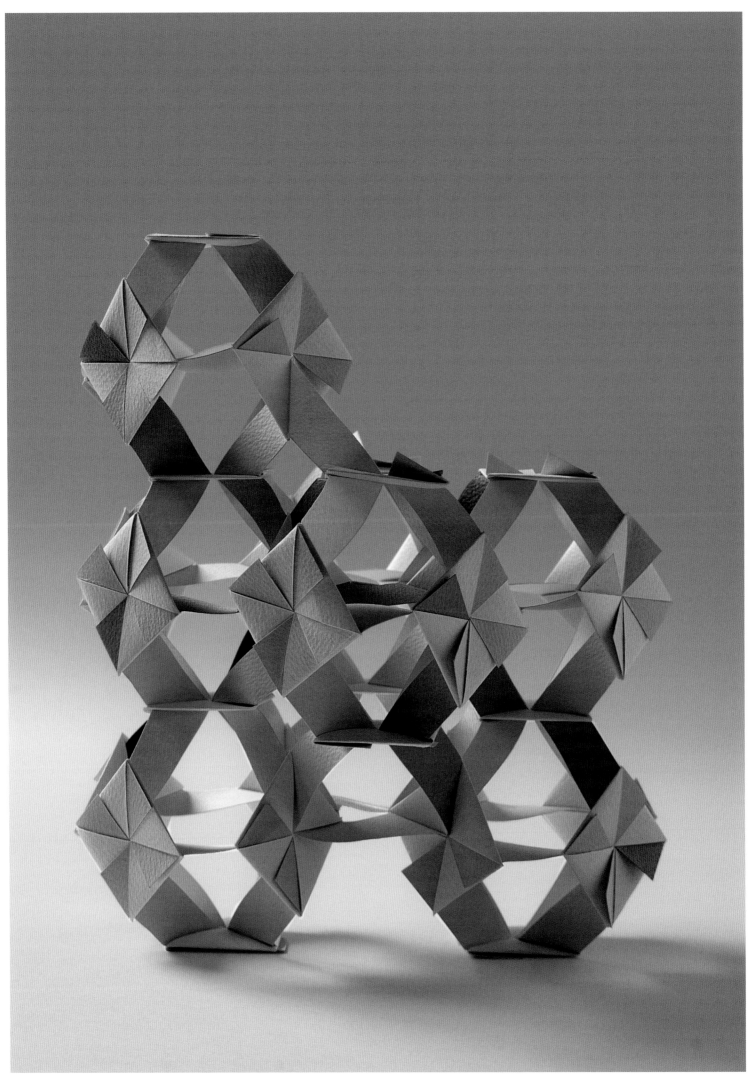

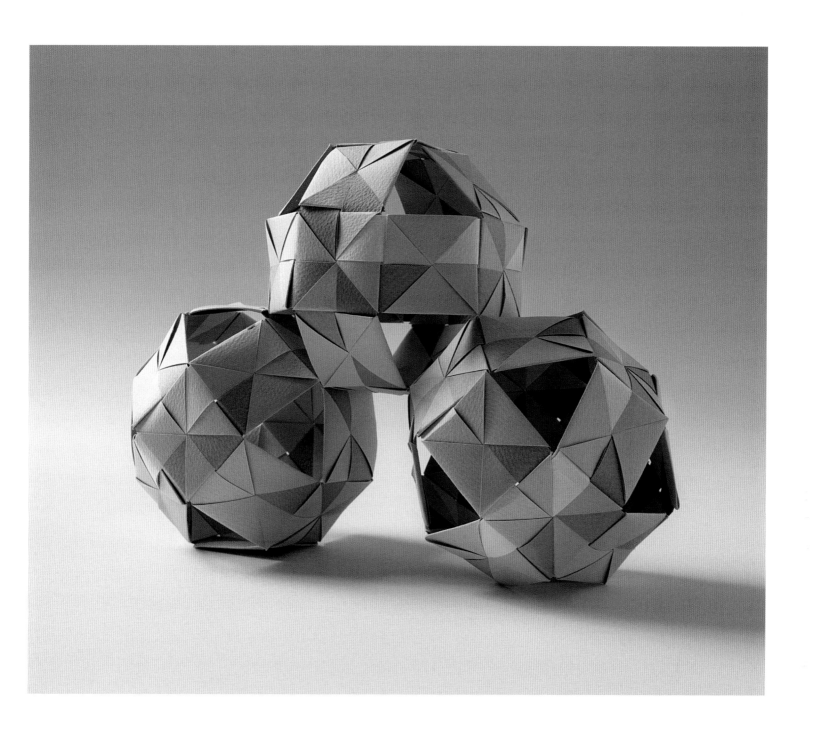

RECTANGLE KNOT SOLID 2

◖ Width x Length x Height
6.9 x 6.9 x 10.4 inches
(176 x 176 x 264 mm)
PAPER Mermaid/Takeo, Tokyo

RECTANGLE KNOT SOLID 3

◗ Width x Length x Height
10.5 x 4.3 x 7.5 inches
(267 x 110 x 190 mm)
PAPER Mermaid/Takeo, Tokyo

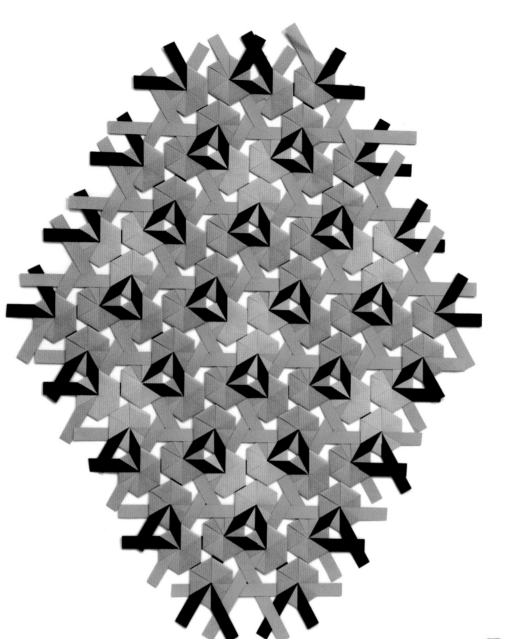

HEXAGON KNOT 5

▶ 15.7 x 14.4 inches (400 x 365 mm)
PAPER Mermaid, OK Golden River/
Takeo, Tokyo

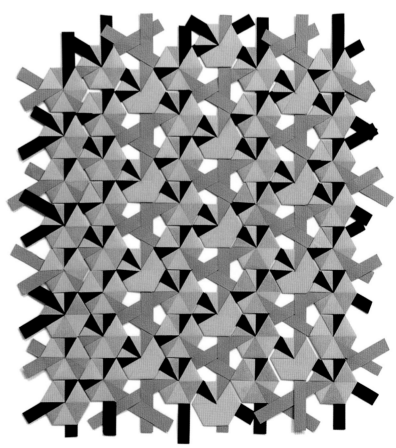

HEXAGON KNOT 3

▲ 11.8 x 16.1 inches (300 x 410 mm)
PAPER Mermaid, OK Golden River/
Takeo, Tokyo

HEXAGON KNOT 4

▶ 22.3 x 18.5 inches (567 x 470 mm)
PAPER Mermaid, OK Golden River/
Takeo, Tokyo

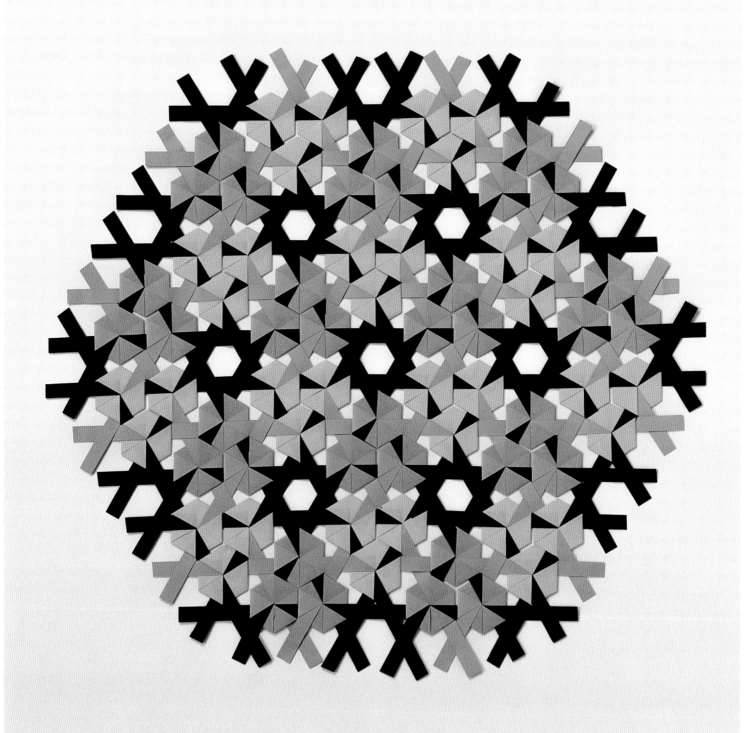

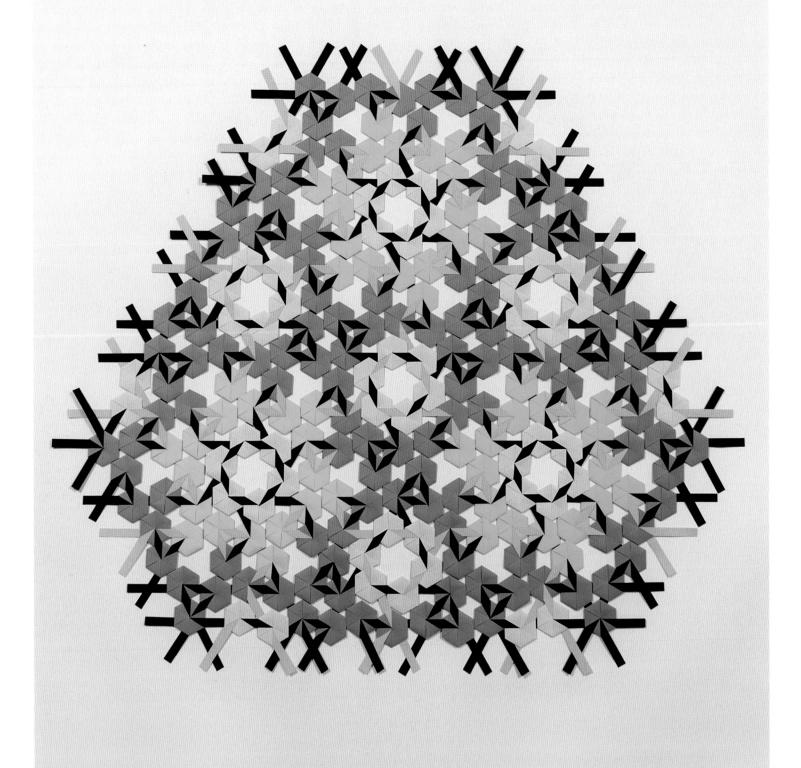

HEXAGON KNOT 5

● 29.1 x 32.3 inches (740 x 820 mm)
PAPER Mermaid, Tant/Takeo, Tokyo

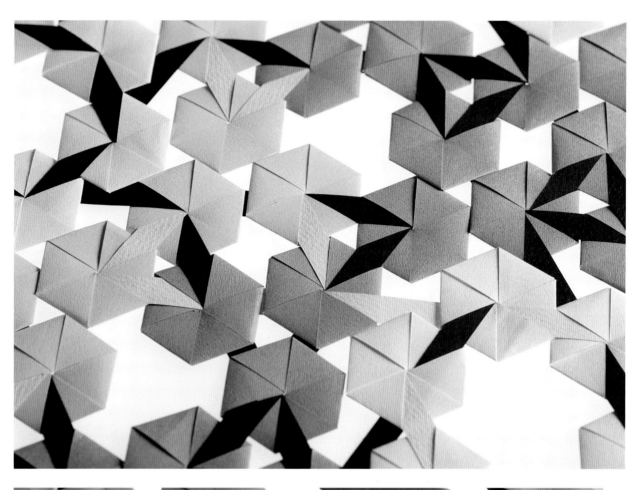

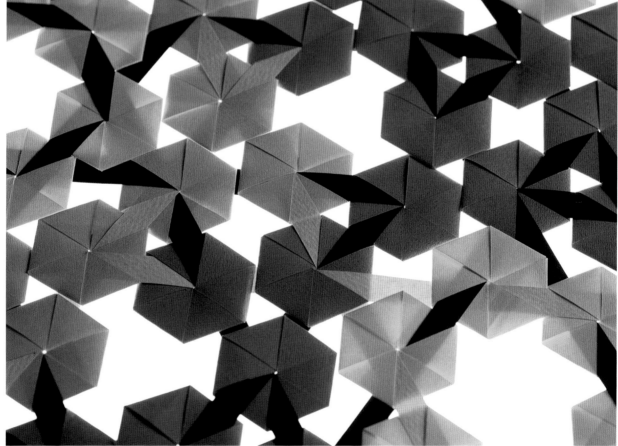

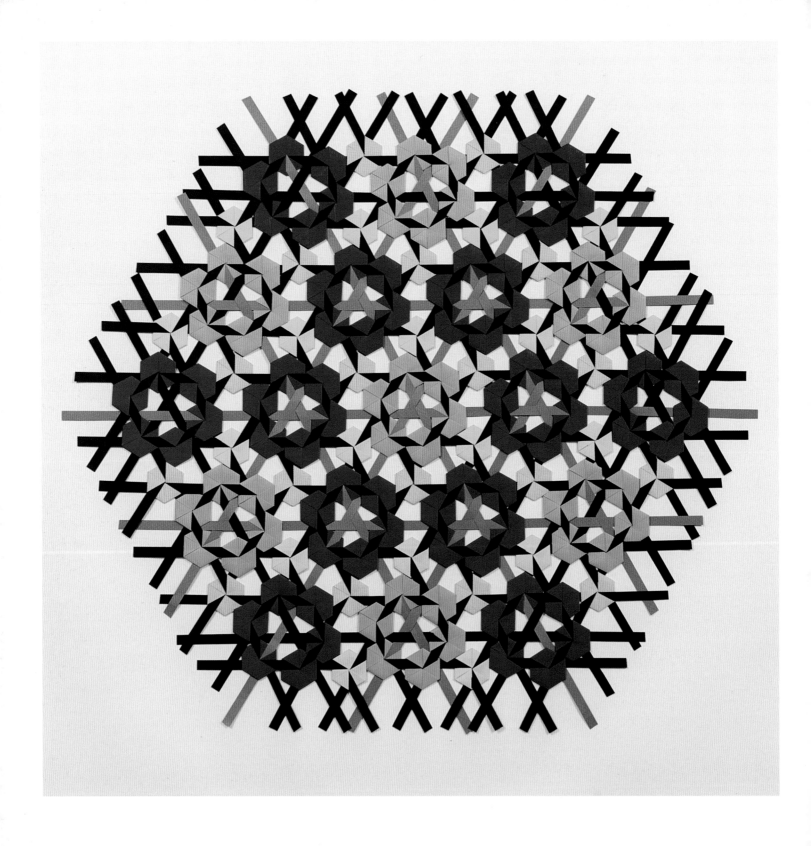

HEXAGON KNOT 6

● 26.8 x 29.7 inches (680 x 755 mm)
PAPER Mermaid, Tant / Takeo, Tokyo

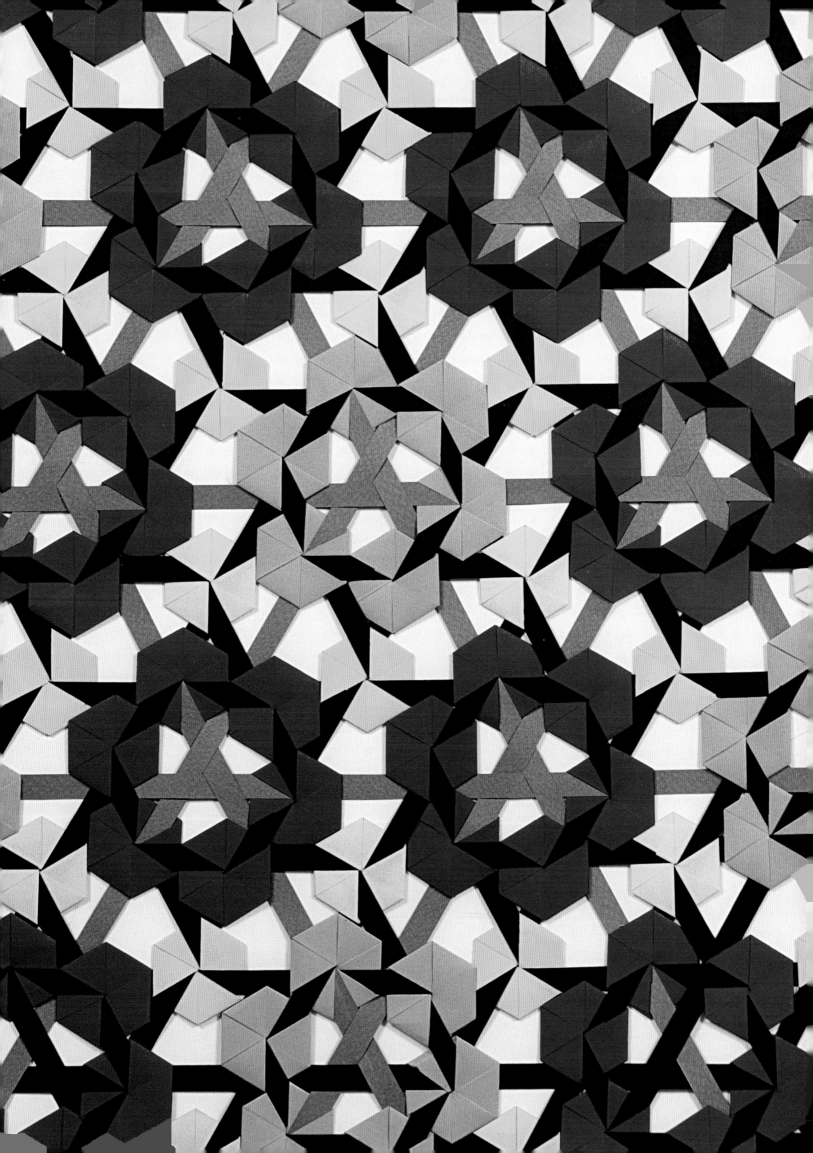

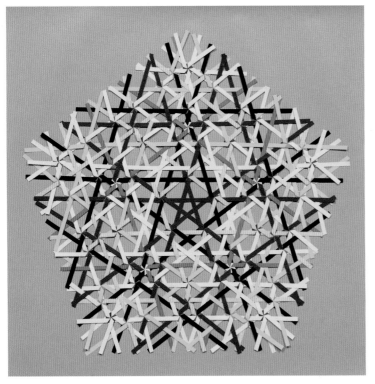

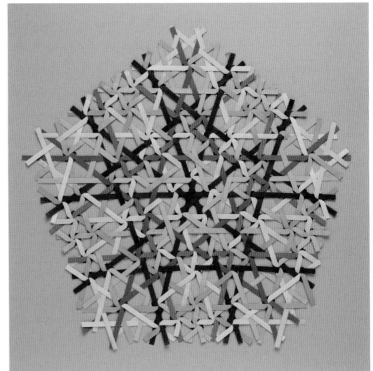

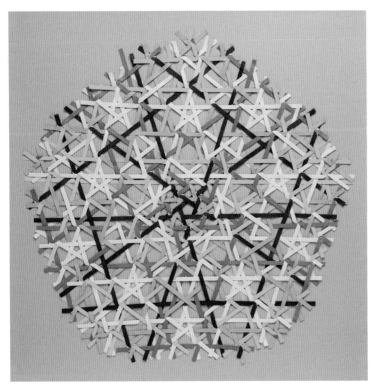

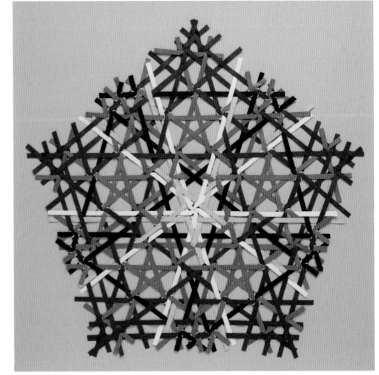

PENTAGON KNOT 1

◖◖ 30.7 x 31.1 inches (780 x 789 mm)
▶▶ **PAPER** Mermaid, Tant/Takeo, Tokyo

PENTAGON KNOT 2

◖◖ 28.3 x 29.5 inches (720 x 750 mm)
PAPER Mermaid/Takeo, Tokyo

PENTAGON KNOT 3

◖▶ 24.2 x 26 inches (620 x 660 mm)
PAPER Mermaid/Takeo, Tokyo

PENTAGON KNOT 4

◖▶ 24.2 x 26 inches (620 x 660 mm)
PAPER Mermaid/Takeo, Tokyo

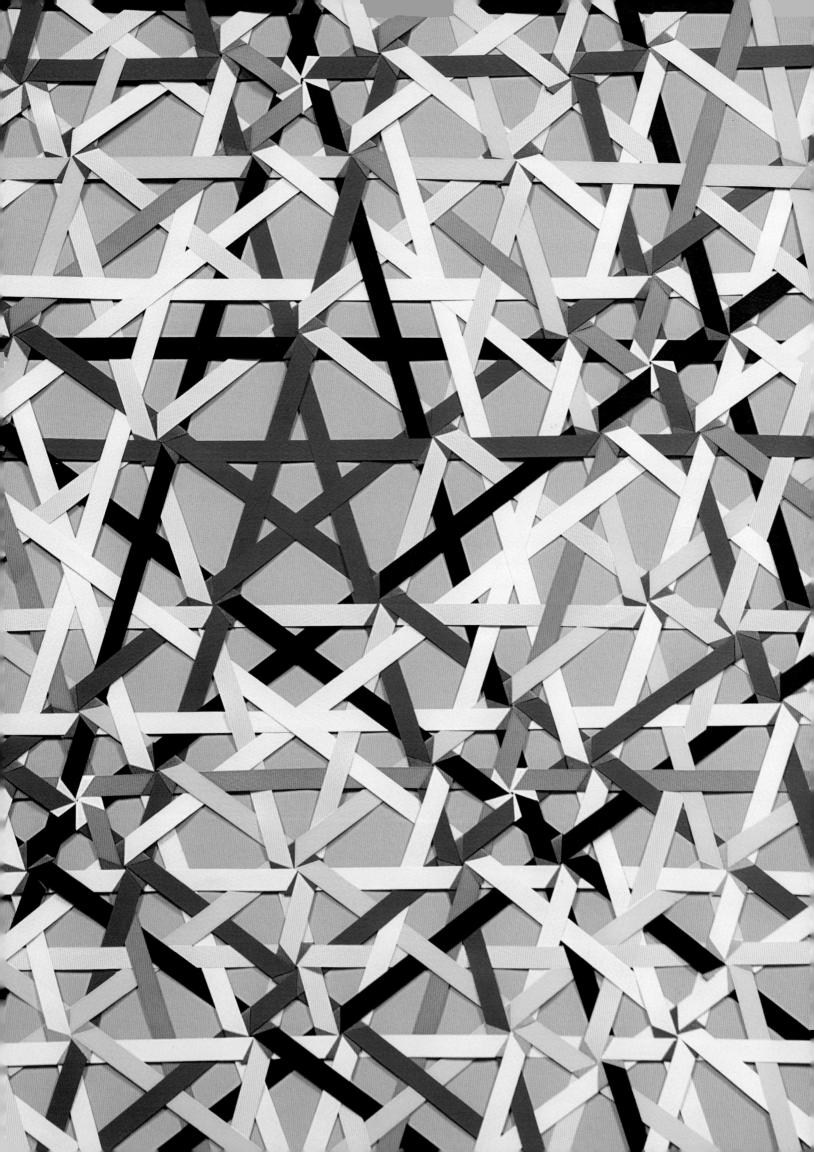

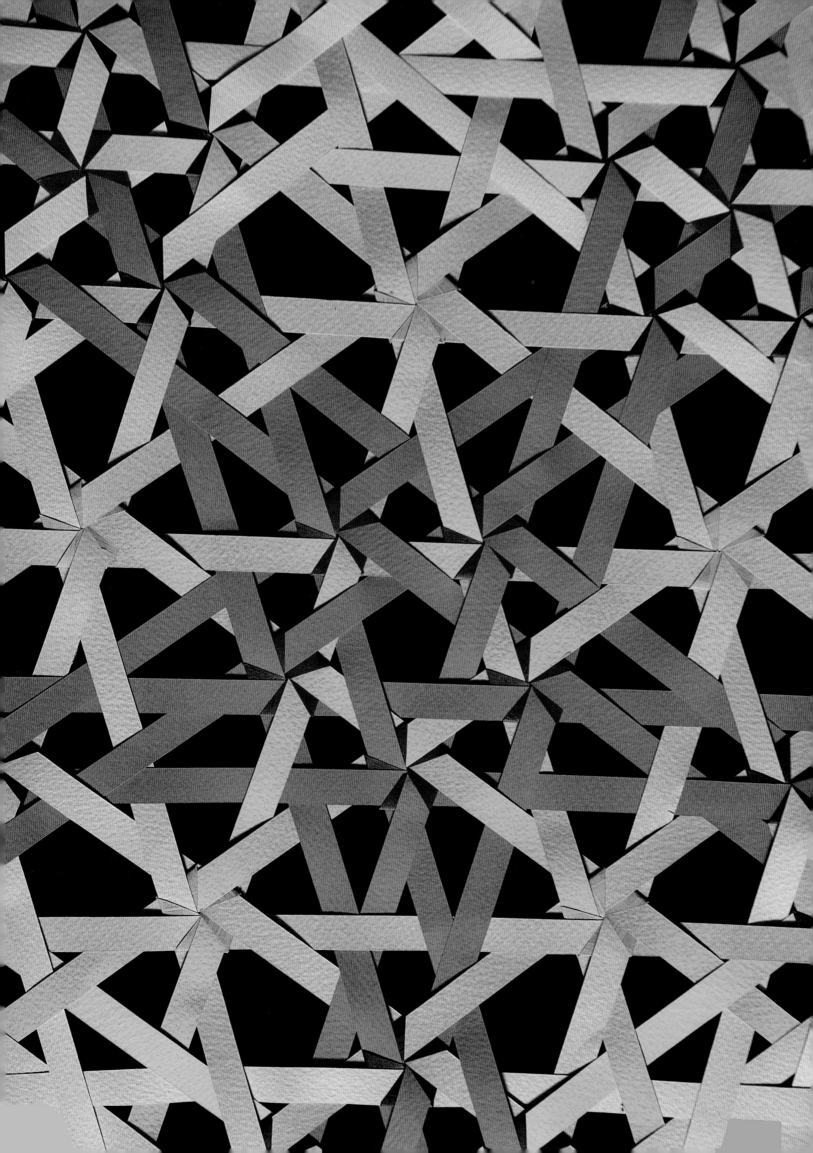

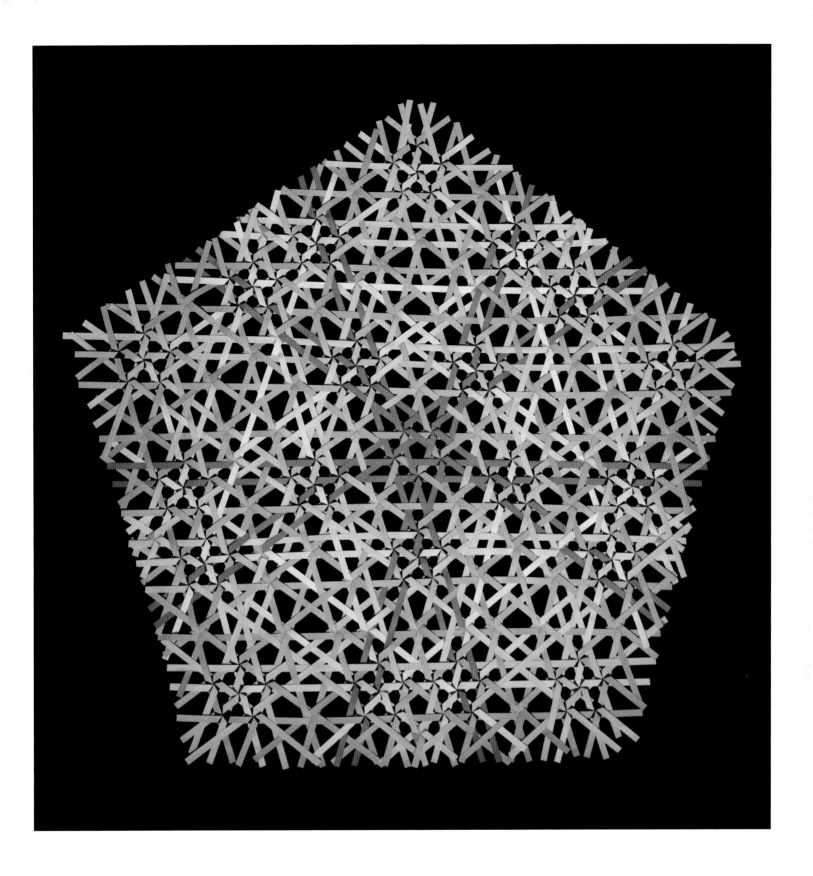

PENTAGON KNOT 5

● 39.4 x 41.3 inches (1000 x 1050 mm)
PAPER Mermaid, Tant / Takeo, Tokyo

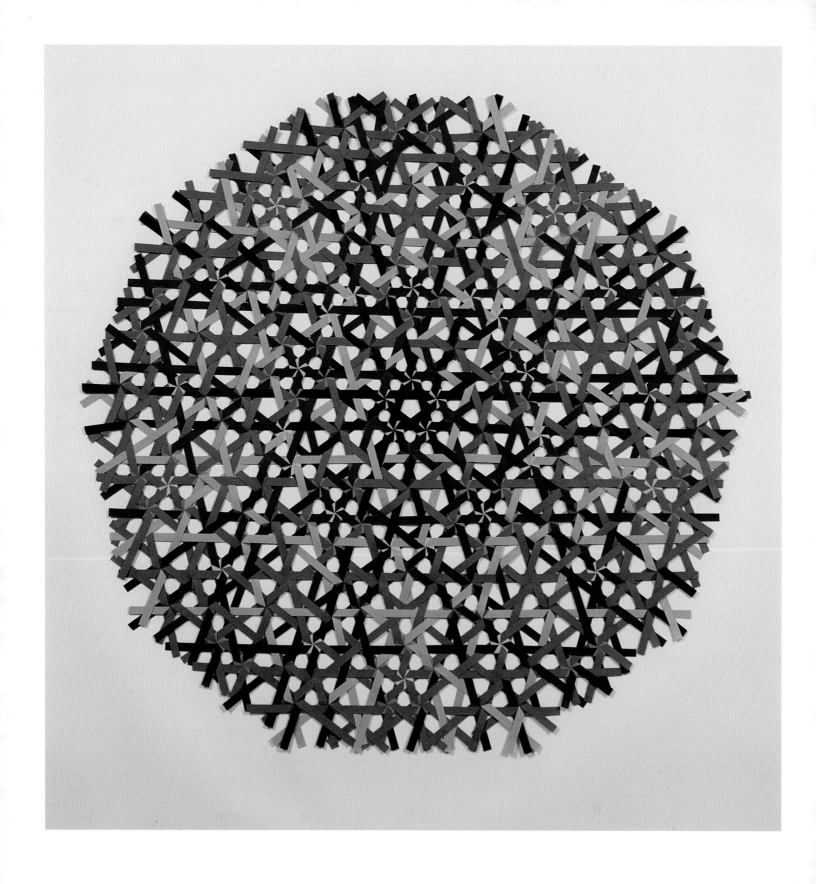

PENTAGON KNOT 6

- 32.3 x 34.3 inches (820 x 870 mm)
PAPER Mermaid, Tant / Takeo, Tokyo

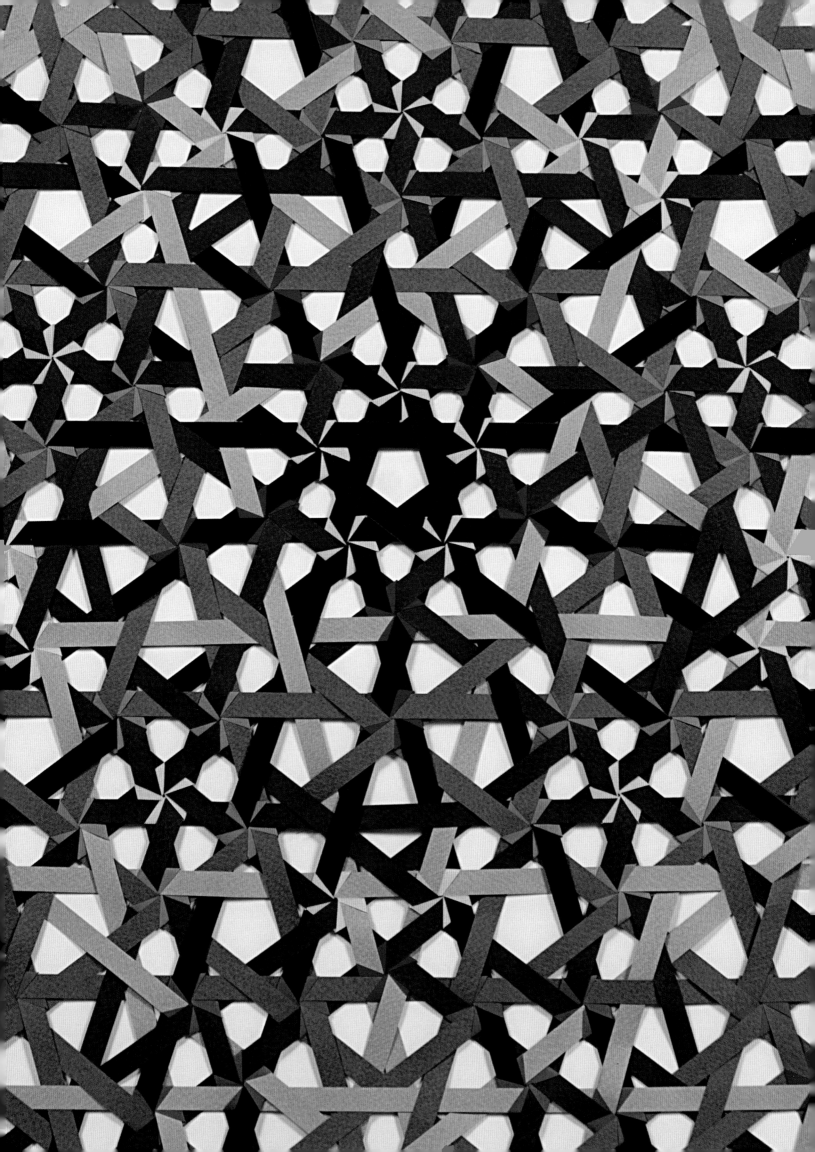

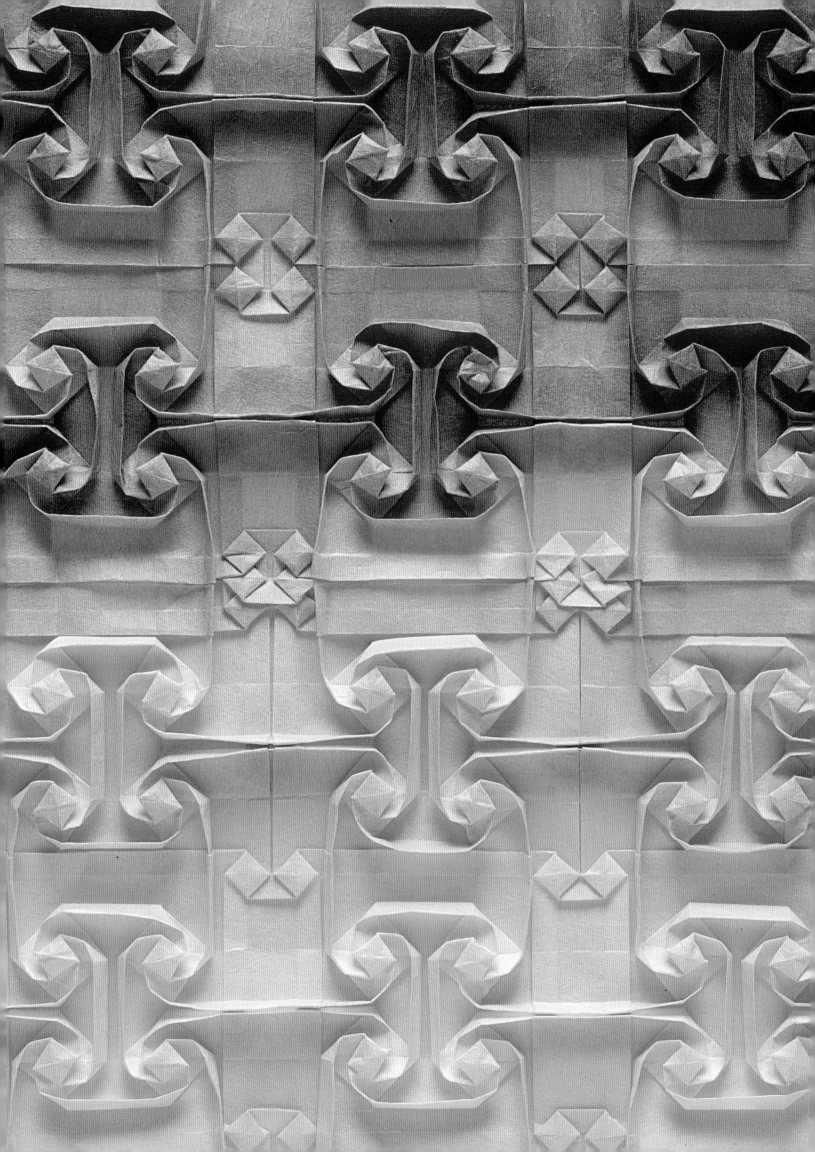

CHAPTER 2
TESSELLATIONS

In origami, tessellation is a technique used to create an endless variety of motifs from a sheet of paper without the need for cutting or pasting. Its foundations were laid in the research of Shuzo Fujimoto (1922–2000), with concurrent contributions by another Japanese scholar, Yoshihide Momotani. Since then, many other authors have appeared on the scene—Chris Palmer, Alexander Beber, Alex Bateman, Ben Parker, Eric Gjerde, Joel Cooper, and later Polly Verity and Robin Scholtz—and come up with a wide variety of designs. In 2017, Robert J. Lang published *Twists, Tilings, and Tessellations: Mathematical Methods for Geometric Origami*, a 776-page volume that organizes and systematizes information on the subject.

In this chapter, we present spirals created from double-twist folds (through original works by Tomoko Fuse) and models that combine multiple motifs. **(TF)**

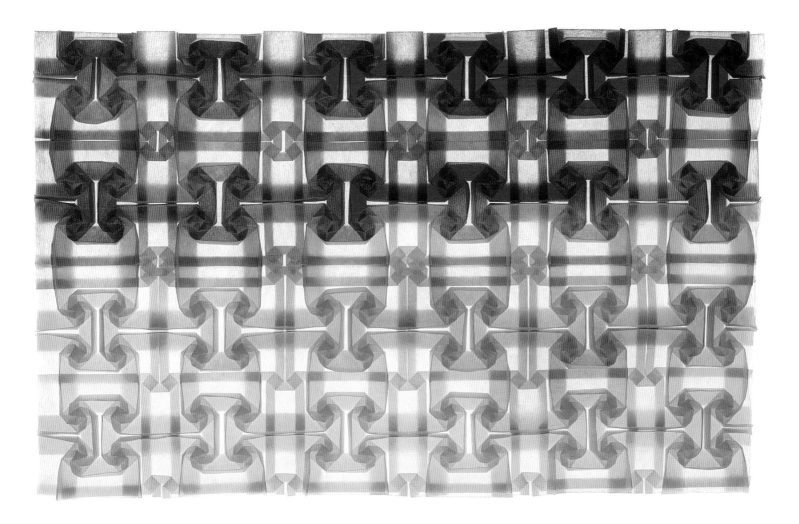

**WHIRLPOOL + SQUARE 1
STANDARD**

- 10.8 x 17.5 inches (275 x 445 mm)
 PAPER Washi/Hamada, Kochi

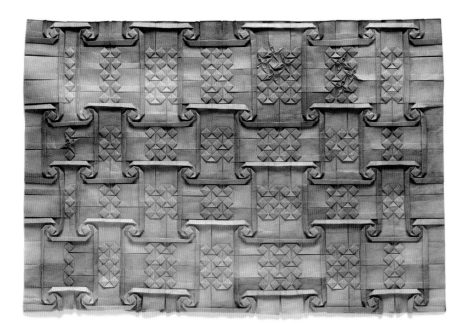

WHIRLPOOL + SQUARE 2
STANDARD

◀ 15 x 10.2 inches (380 x 260 mm)
PAPER Washi/Hamada, Kochi

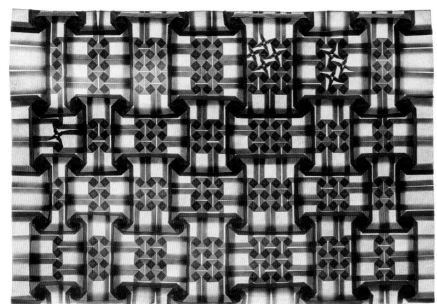

● The technique of tessellation seems to have originated over 6,000 years ago with mosaics and Sumerian majolica. The idea was further developed in Islamic and Moorish designs, as in the still visible decorations of the Alhambra in Granada, Spain. Inspired by these in the twentieth century, Maurits Escher designed tiles out of complex, closed (non-repetitive) motifs in which figures of birds, fish, or other animals gradually morph into a decorative surface. In origami, too, one can create two-dimensional patterns by individually folding modular tiles, attaching them to a base sheet, or linking them together with pockets and tabs, as is usually done in modular origami. Nowadays, however, tessellated origami, which has been immensely popular for the last twenty years, usually consists of (repetitive) two-dimensional motifs created by folding a single sheet of paper in such a manner that it finally assumes the appearance of distinct tiles. The creation of a tessellated pattern requires a great deal of preliminary work. The origami artist must first prepare a grid based on rigorous geometric criteria. Since such designs require large sheets of paper, some artists prefer using mechanical tools to speed up the process and thus resort to laser cutters that eliminate the possibility of human error and allow them to skip particularly tedious preliminary steps.

The result of executing a series of parallel folds that intersect at 90 or 60 degrees is a surplus of paper at the points of intersection that can be modeled into polygonal tiles. These layers can be opened, reworked, and flattened so that the tiles can be juxtaposed with extreme precision, or arranged into the form of a star or polygon. Origami tessellation becomes even more mesmerizing when a light source from behind makes more designs visible, as we shall see in the chapter on lamps. Various flat and reshaped layers end up generating new shapes and areas of shade, surprisingly different from those visible in the unilluminated structure. Note how Tomoko plays with material, as if she were drawing and painting with paper. Look at the colorful paper with its tessellations, and compare the regular, repeating patterns to those that gradually change across the surface. **(DB)**

WHIRLPOOL + SQUARE 2
TWIST THE INTERSECTION

▶ 10.6 x 15.6 inches (270 x 395 mm)
PAPER Washi/Hamada, Kochi

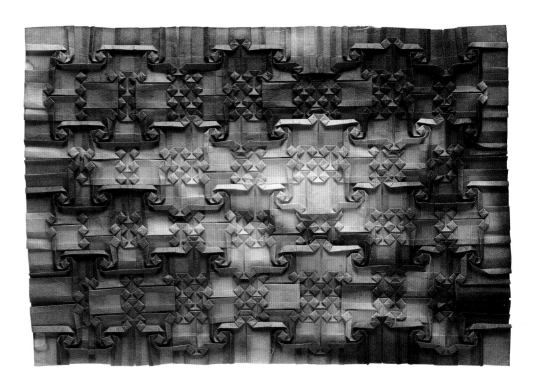

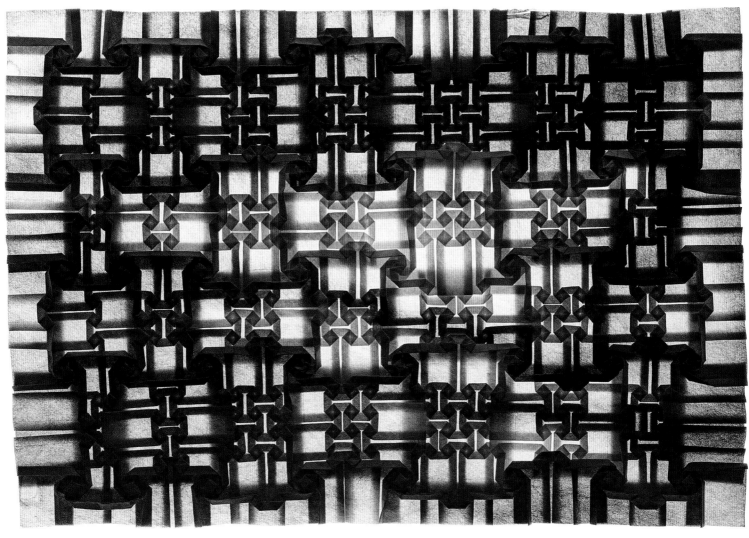

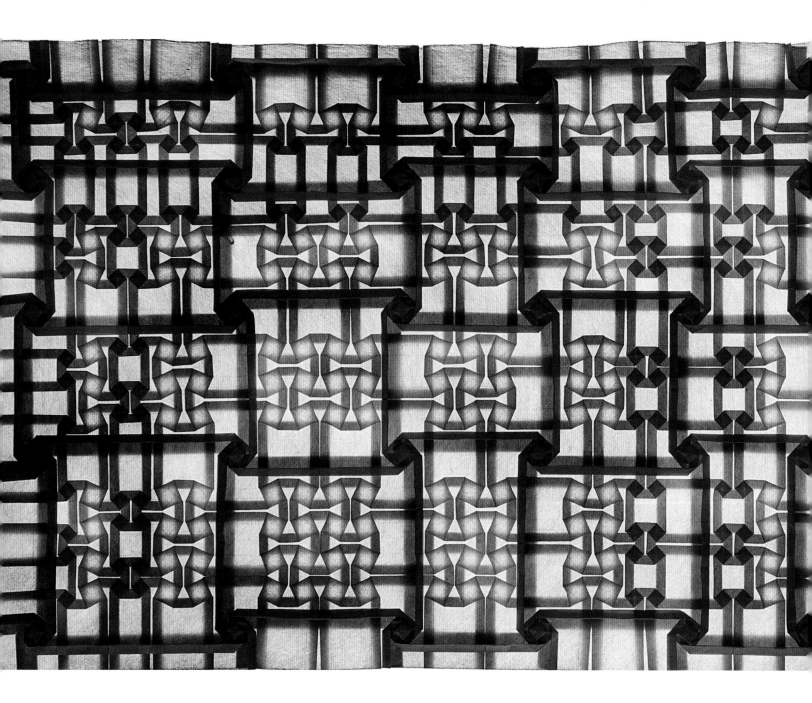

WHIRLPOOL + TILT SQUARE 1
TWIST THE INTERSECTION

◗ 11.8 x 16.1 inches (300 x 410 mm)
PAPER Washi/Hamada, Kochi

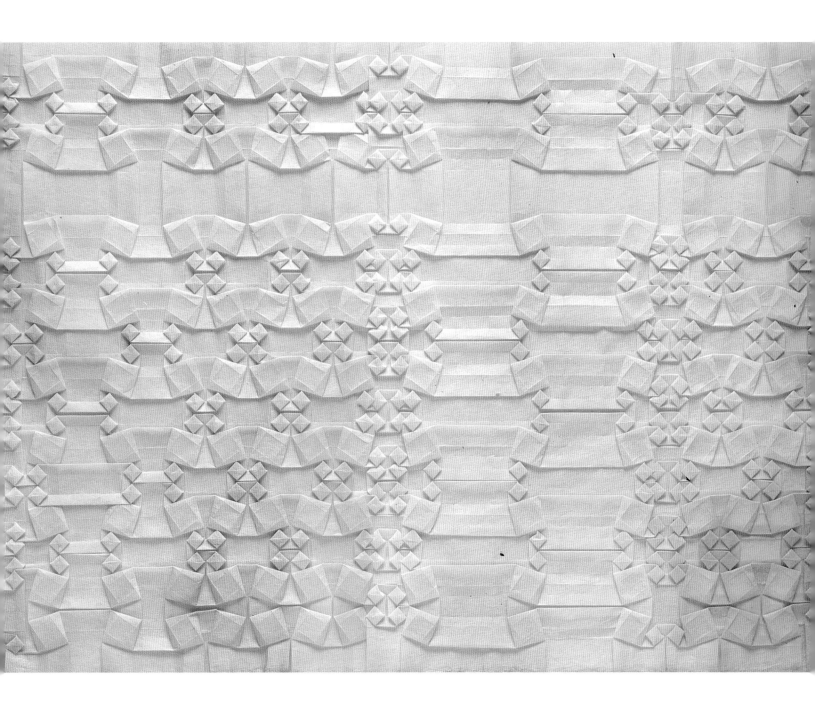

TILT SQUARE + SQUARE

11.6 x 17.1 inches (295 x 435 mm)
PAPER Washi/Hamada, Kochi

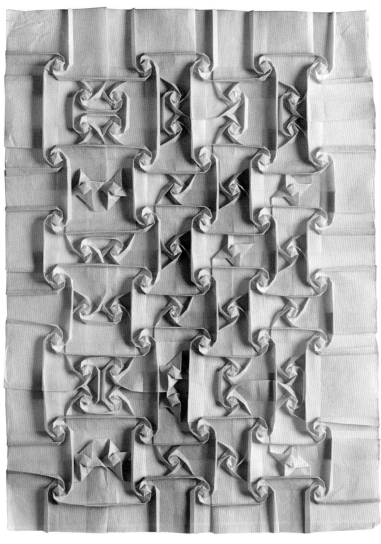

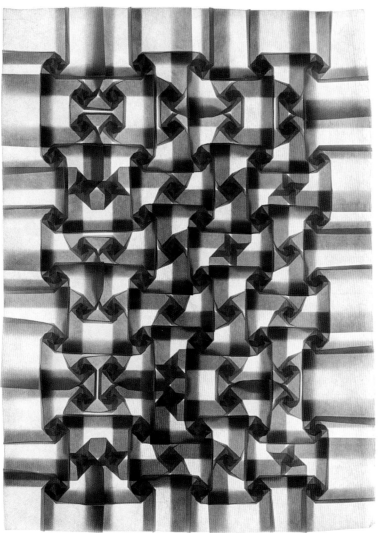

WHIRLPOOL DOUBLE

- 14.1 x 10.4 inches (360 x 265 mm)
 PAPER Washi/Hamada, Kochi

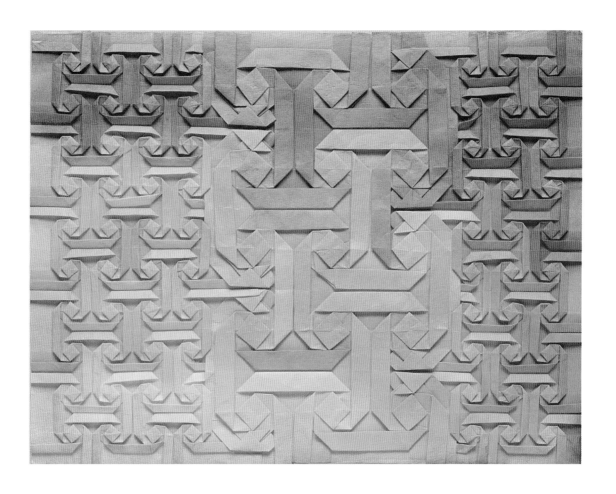

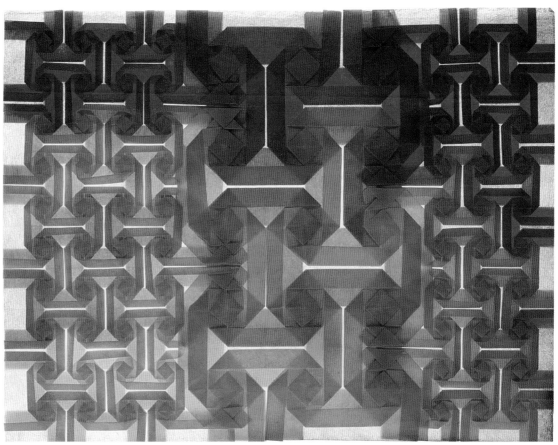

INFINITE WHIRLPOOL

- 9.4 x 12.6 inches (240 x 320 mm)
 PAPER Washi/Hamada, Kochi

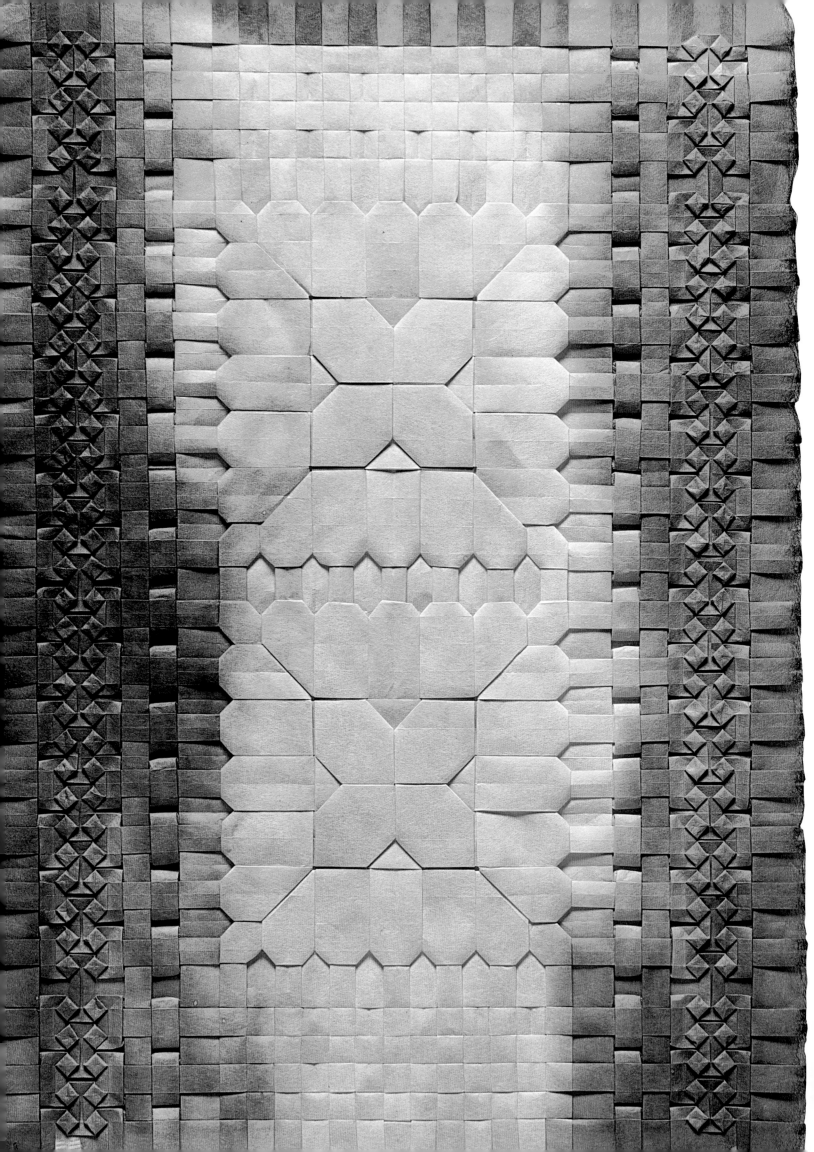

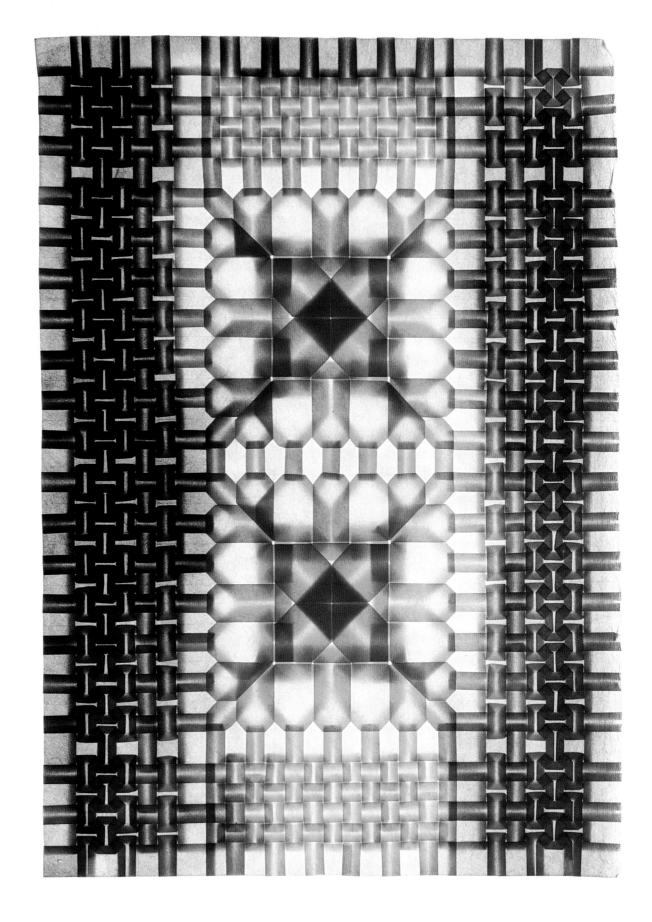

TWO FLOWERS

- 16.9 x 12 inches (430 x 305 mm)
 PAPER Washi/Hamada, Kochi

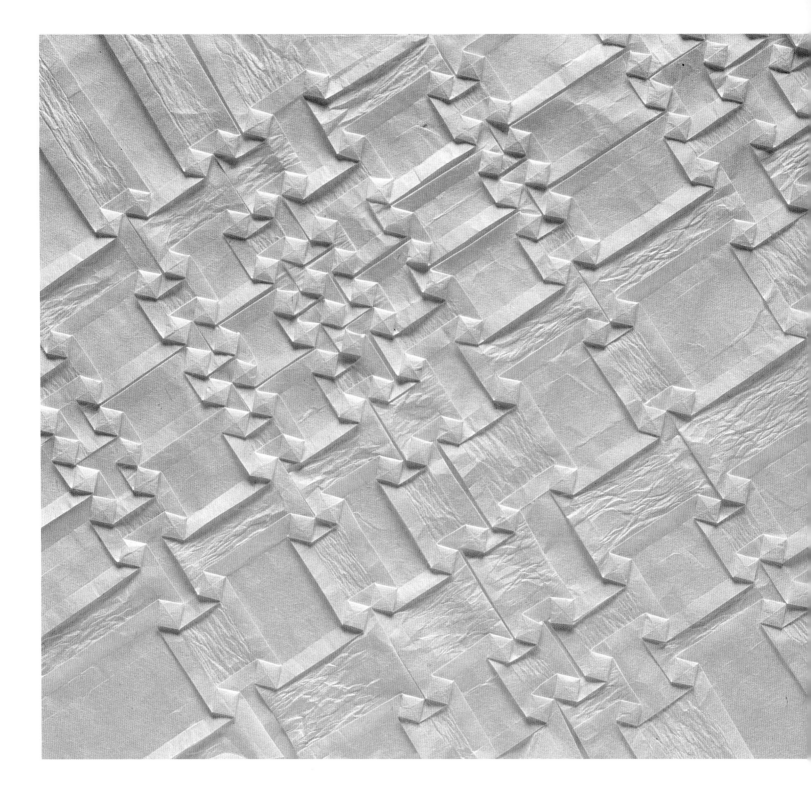

RIPPLE WAVE 1
CRIMP TECHNIQUE

● 9.8 x 14 inches (250 x 355 mm)
PAPER Washi

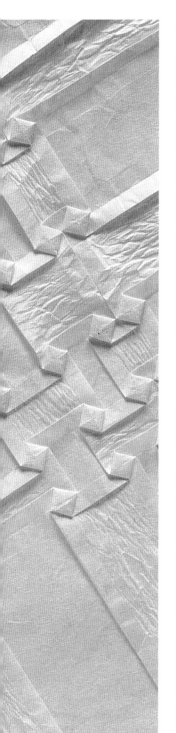

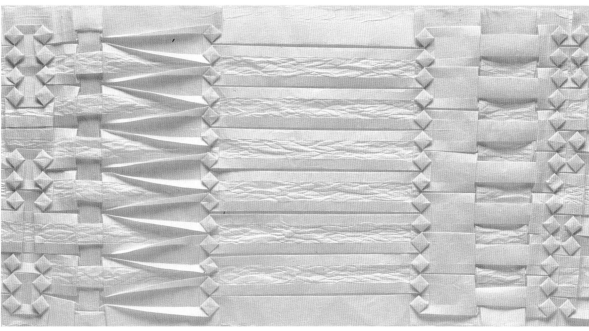

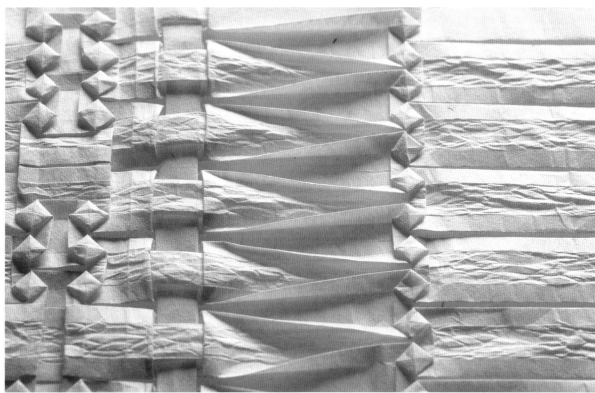

RIPPLE WAVE 2
CRIMP TECHNIQUE

▶ 5.9 x 11.8 inches (150 x 300 mm)
PAPER Washi

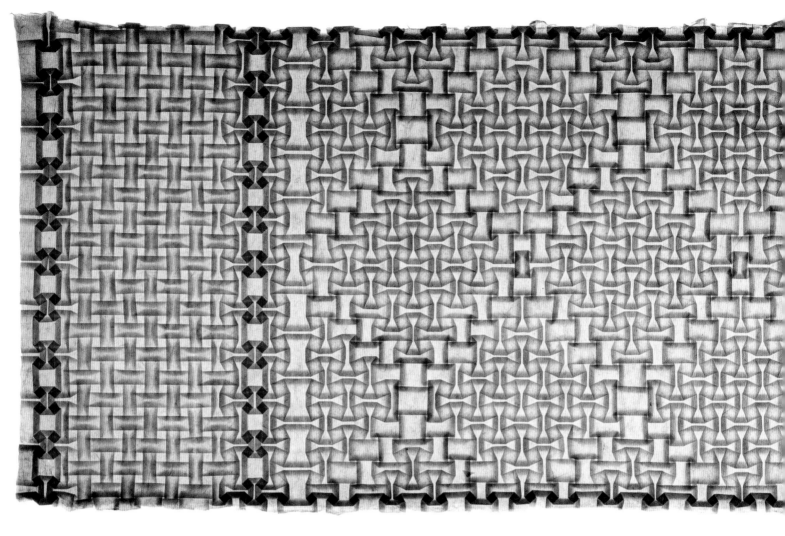

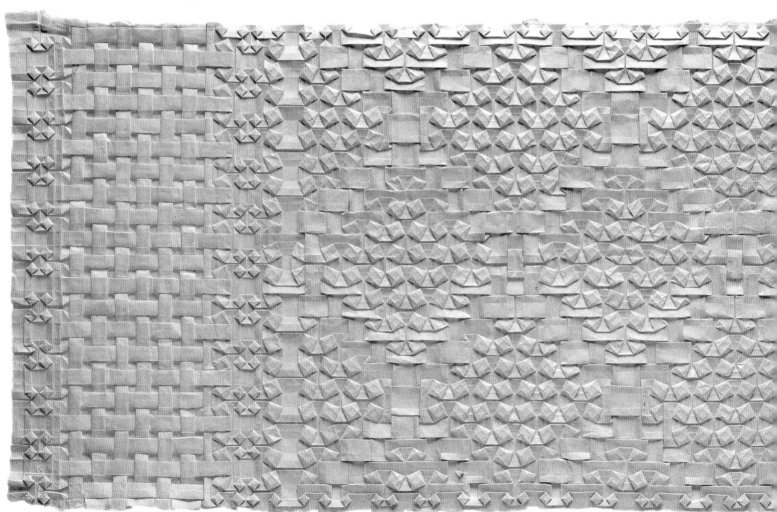

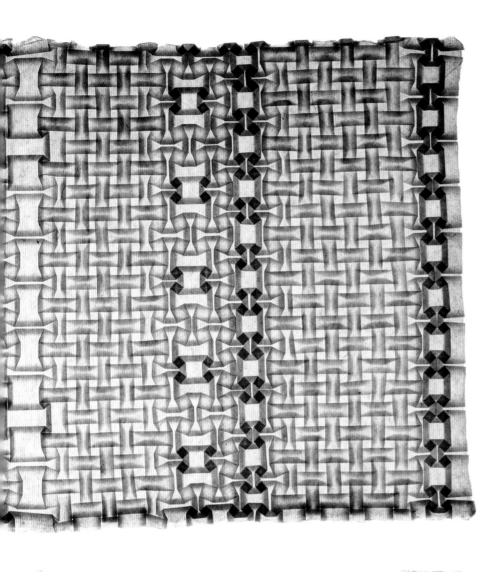

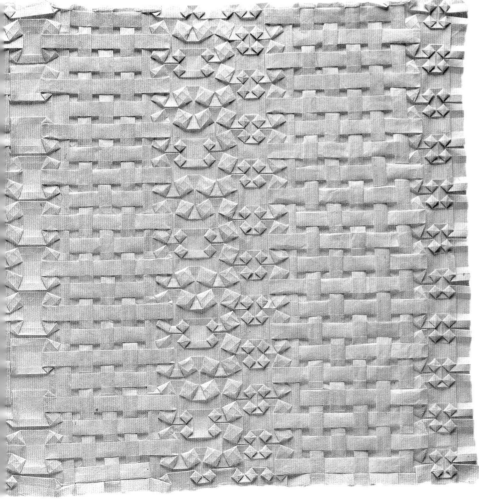

HYDRANGEA
MIXING TECHNIQUE

- 13 x 35.4 inches (330 x 900 mm)
 PAPER Washi/Koide, Niigata

AROMA IN THE FOREST
MIXING TECHNIQUE

- 17.7 x 43.1 inches (450 x 1095 mm)
 PAPER Washi/Paper Nao, Tokyo

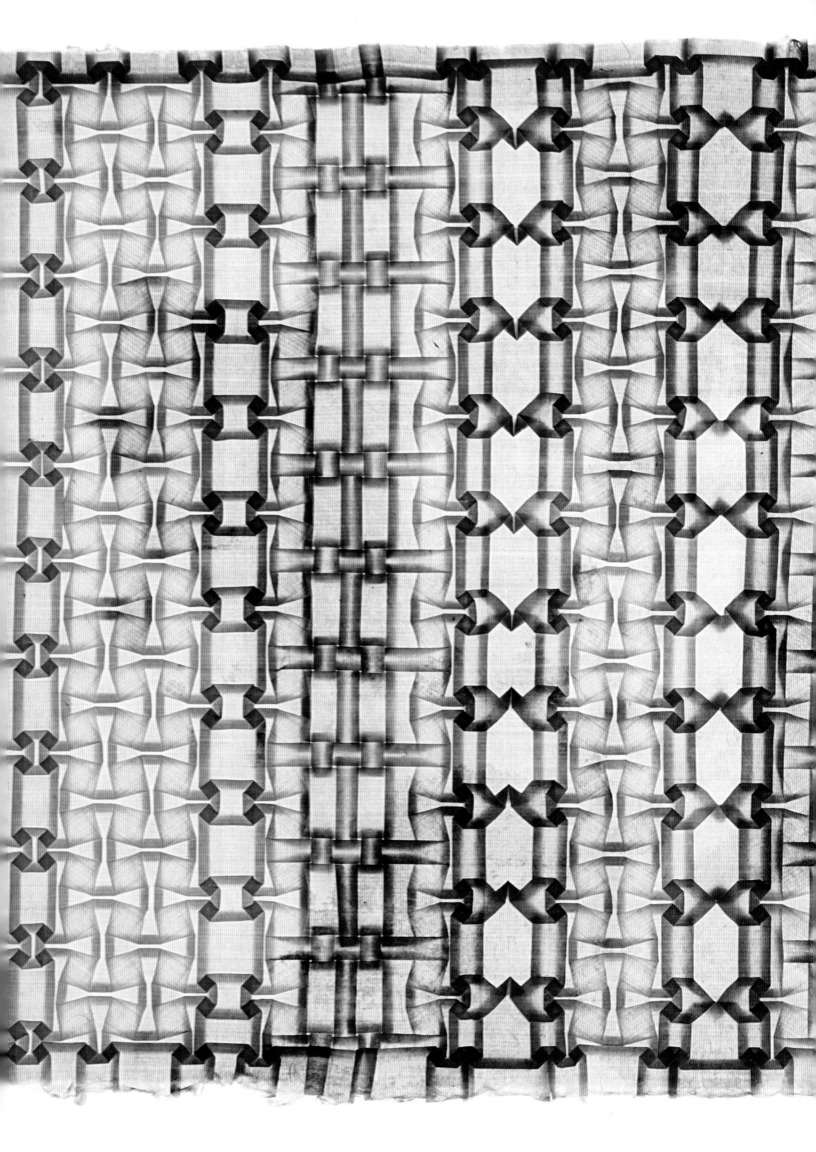

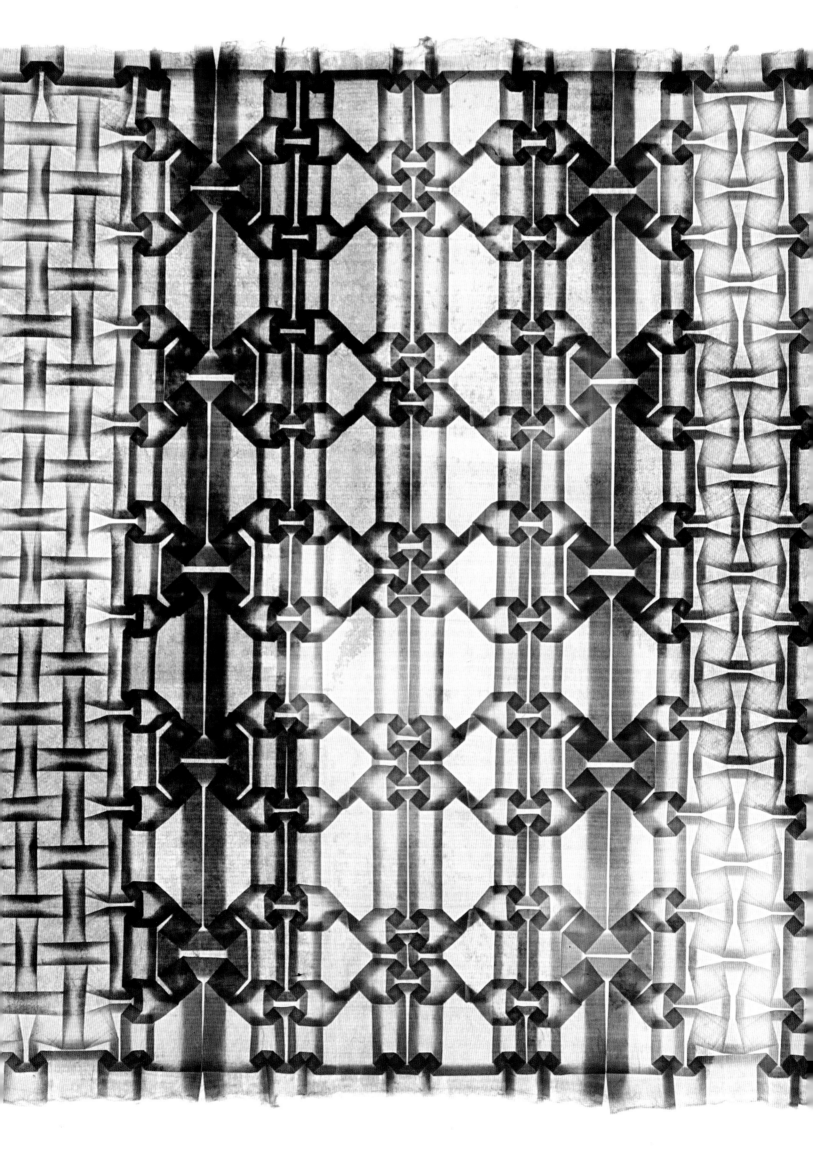

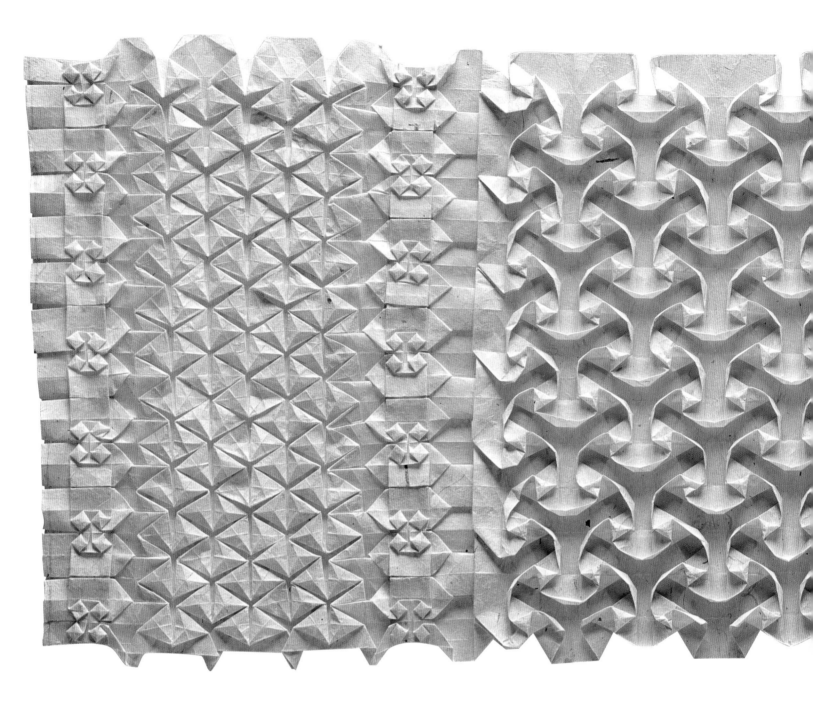

TRIANGLE DANCE
MIXING TECHNIQUE

- 11.4 x 30.1 inches (290 x 765 mm)
 PAPER Washi/Koide, Niigata

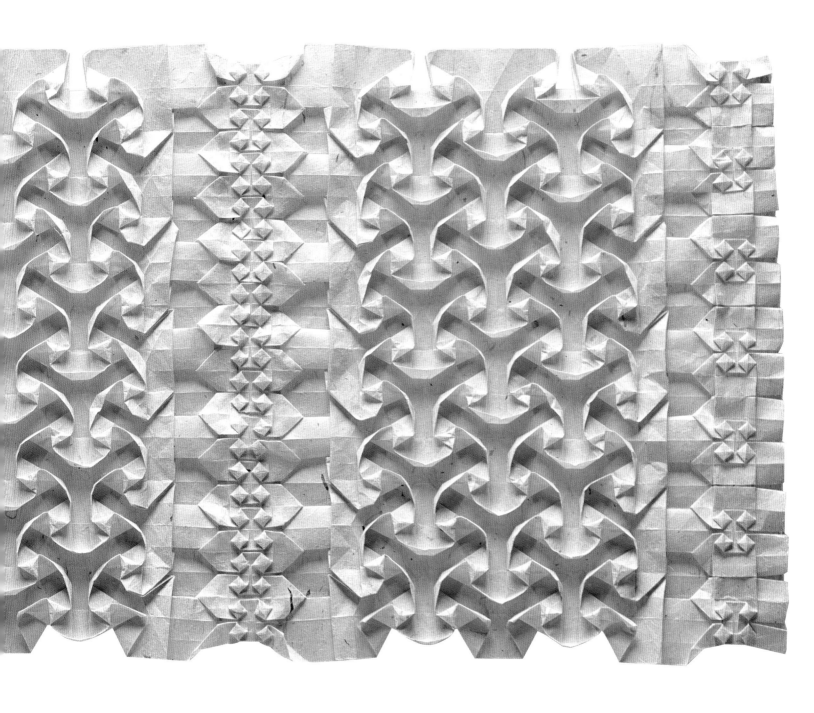

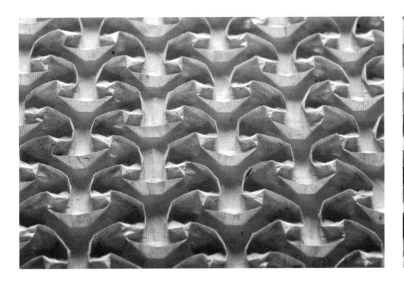

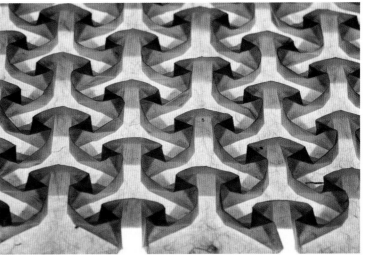

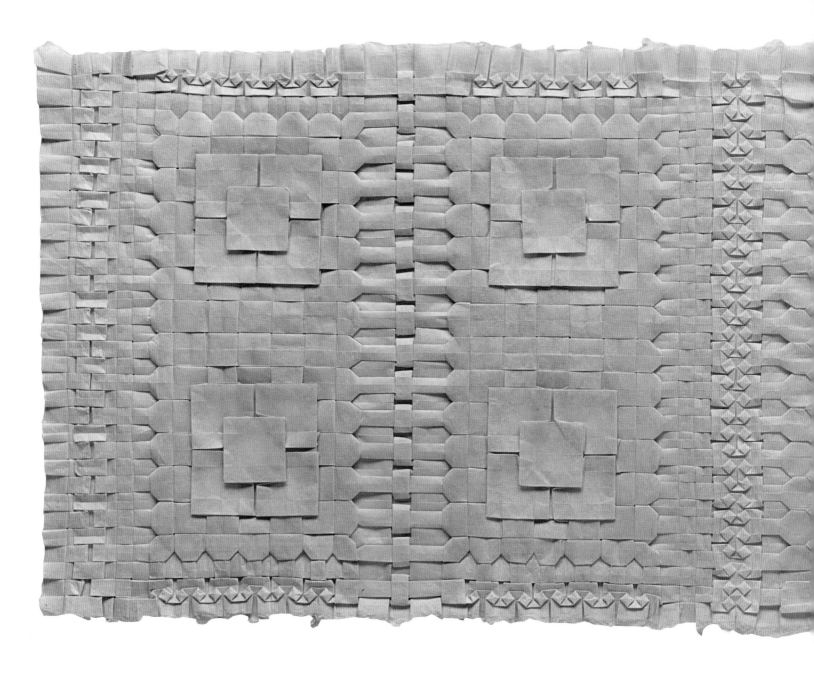

WIND OF SPRING PARK
MIXING TECHNIQUE

- 14 x 40.2 inches (355 x 1020 mm)
 PAPER Washi/Kochi (Tesuki Washi Berlin/Osaka)
 Hand dyeing

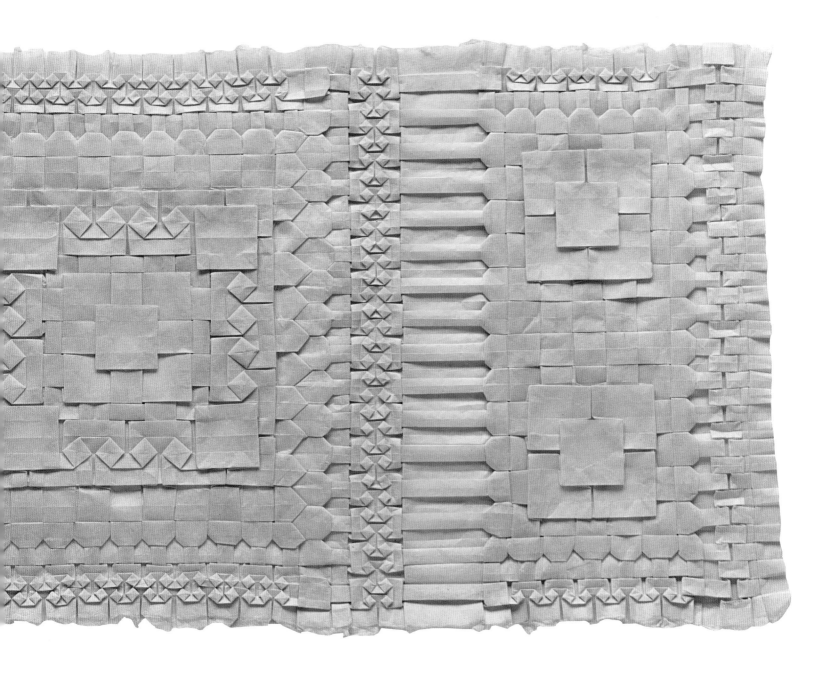

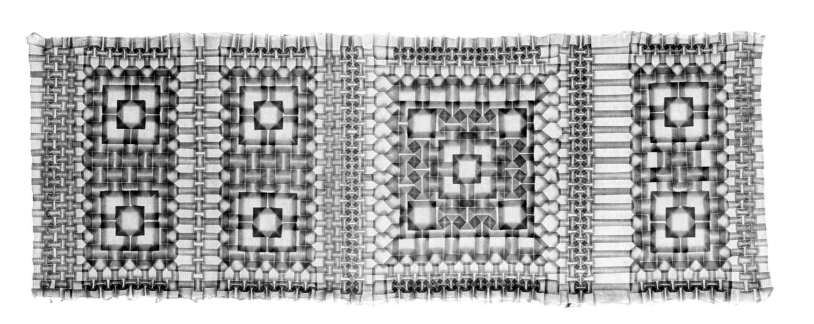

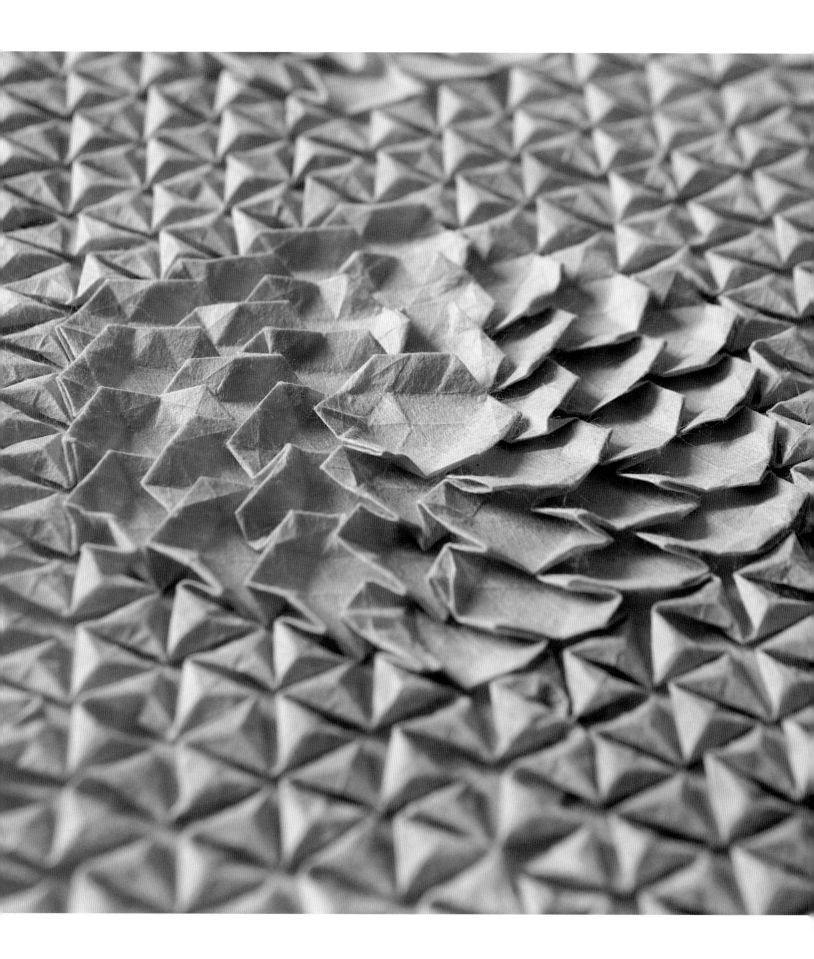

ROSE

- 42.5 x 14.2 inches (1080 x 360 mm)
 PAPER Washi/Paper Nao, Tokyo

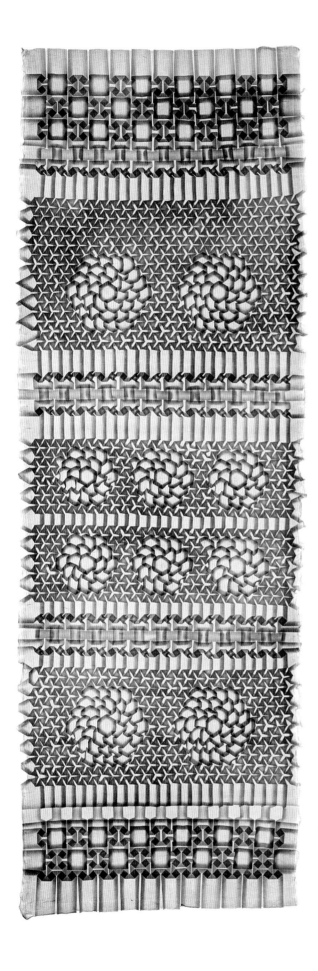
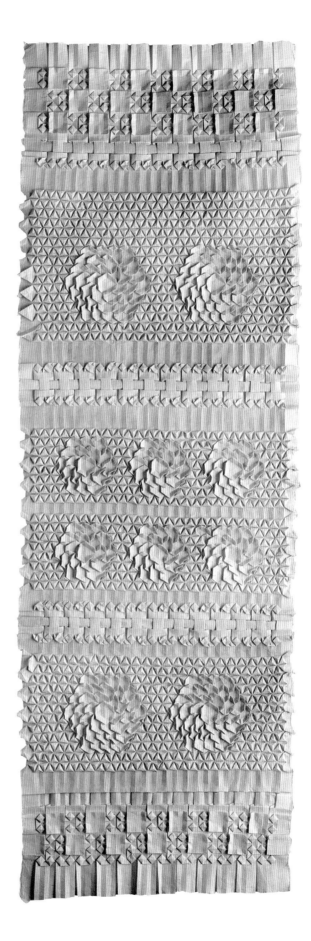

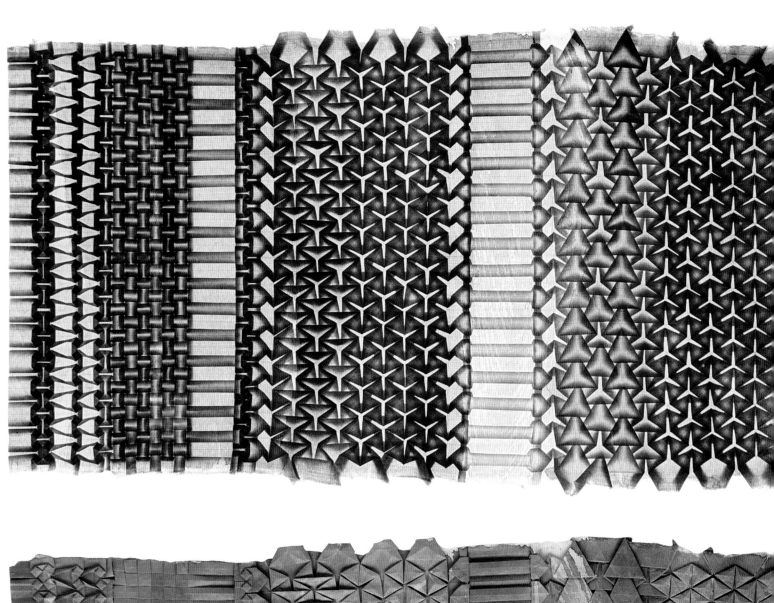

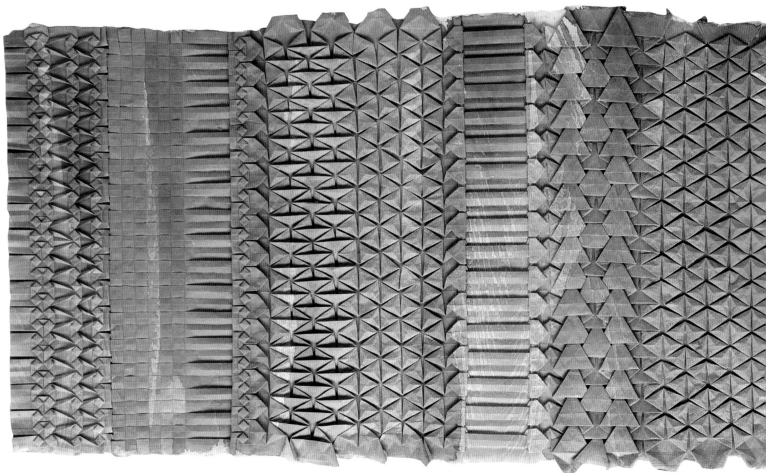

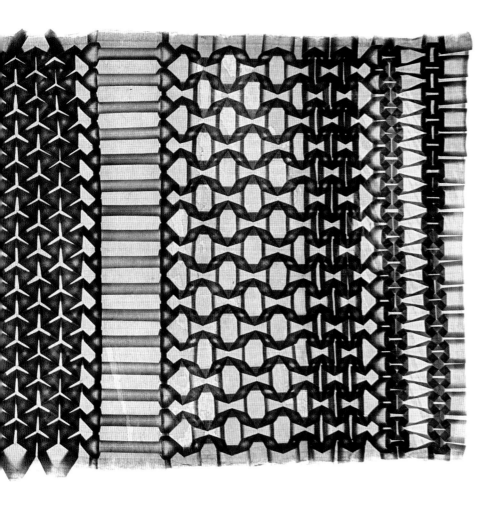

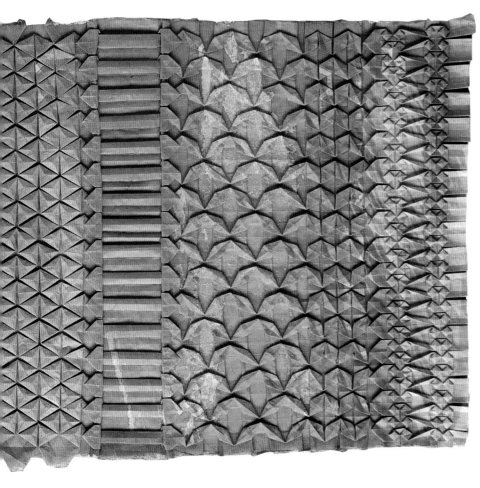

BRICK COLOR SCALES
MIXING TECHNIQUE

● 42.1 x 14.2 inches (1070 x 360 mm)
PAPER Washi/Paper Nao, Tokyo

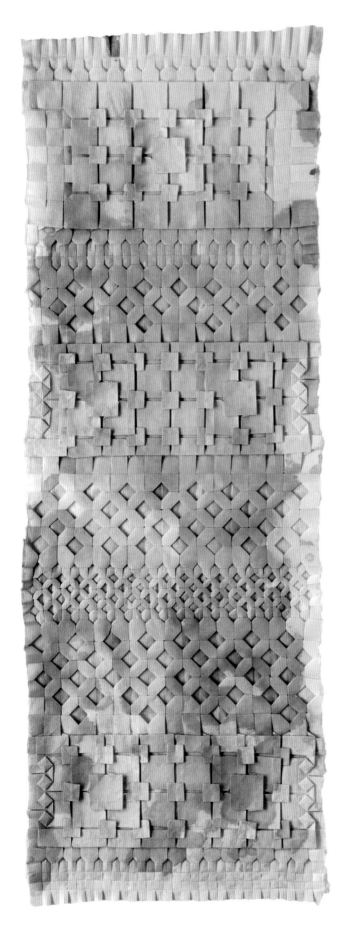
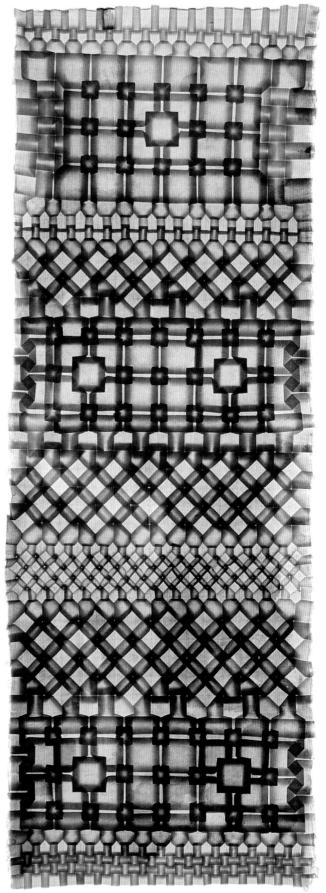

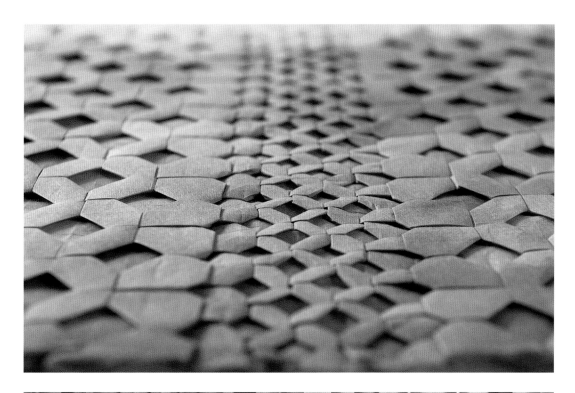

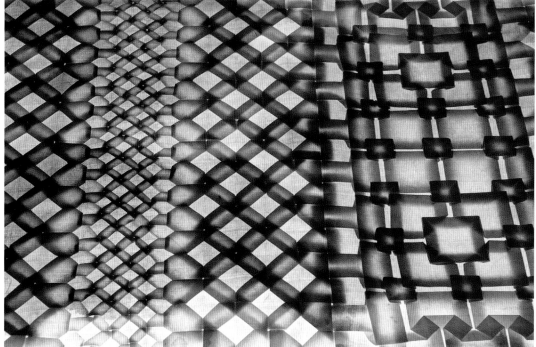

**AFTER THE RAIN
MIXING TECHNIQUE**

● 43.3 x 14.2 inches (1100 x 360 mm)
PAPER Washi/Paper Nao, Tokyo

**ORANGE
MIXING TECHNIQUE**

▽ 14.2 x 37.2 inches (360 x 945 mm)
PAPER Washi/Kochi (Tesuki Washi Berlin/Osaka)
Hand dyeing

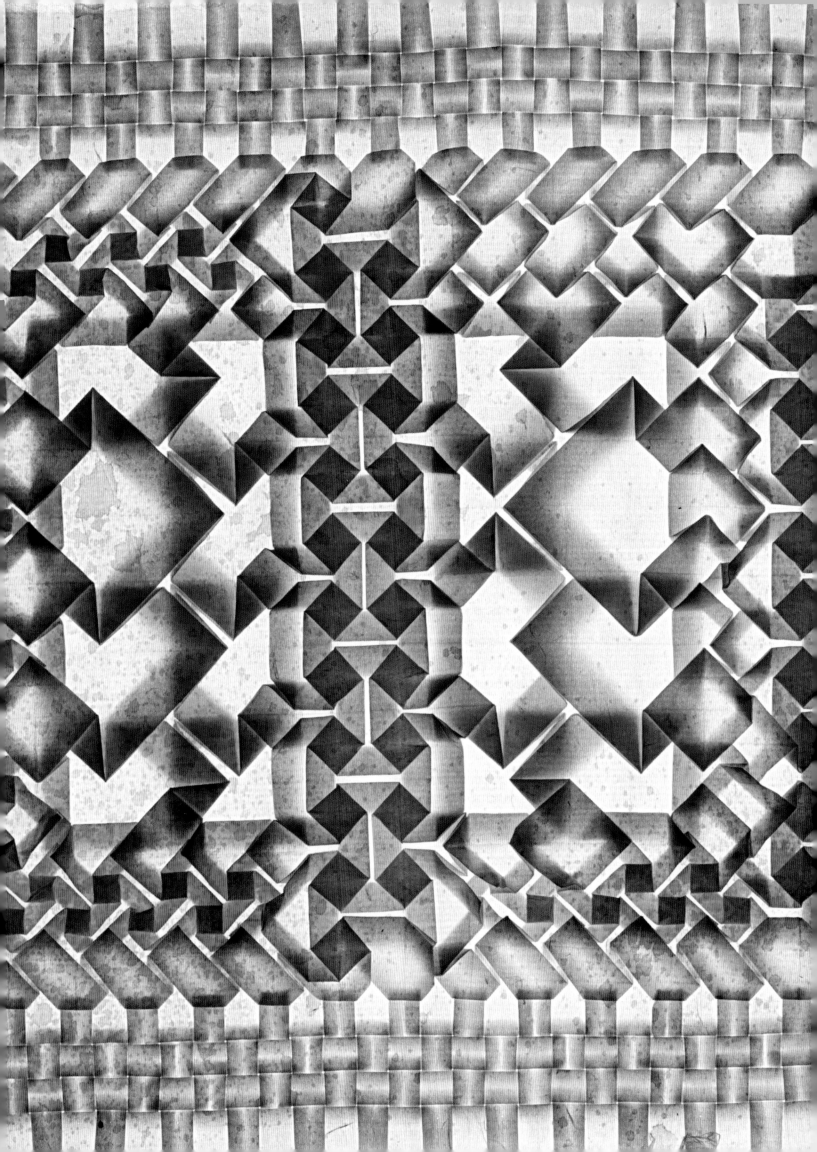

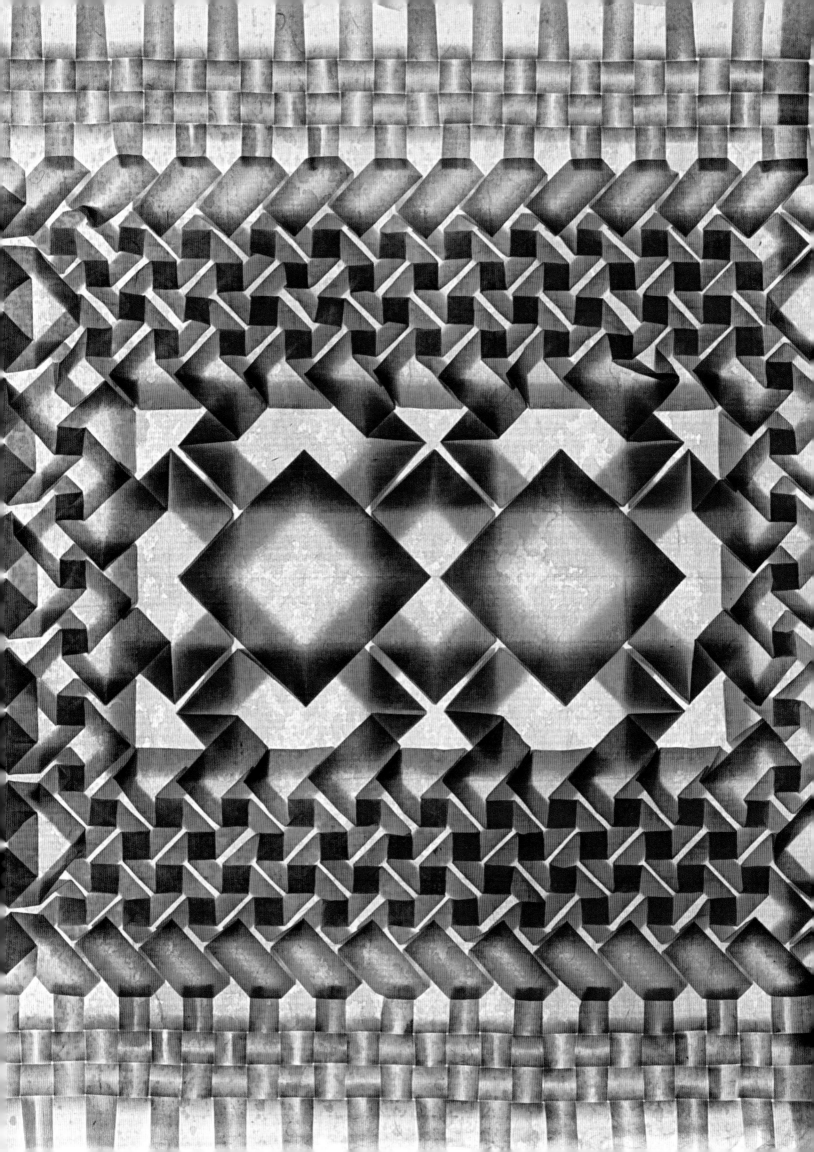

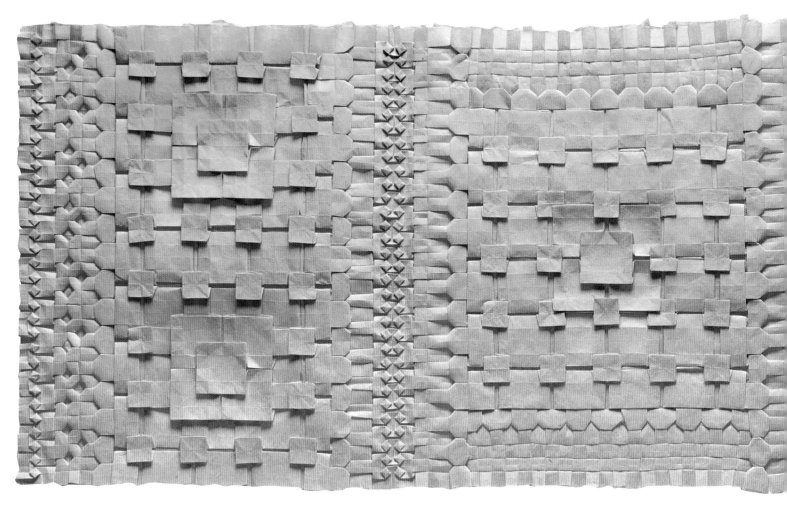

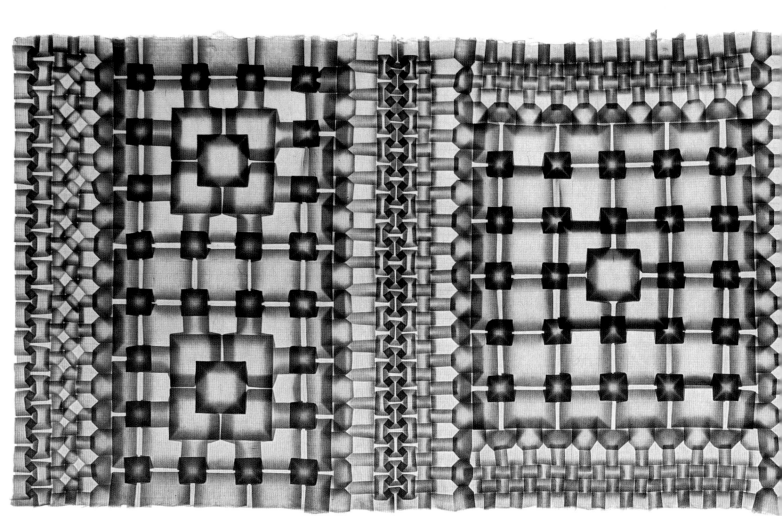

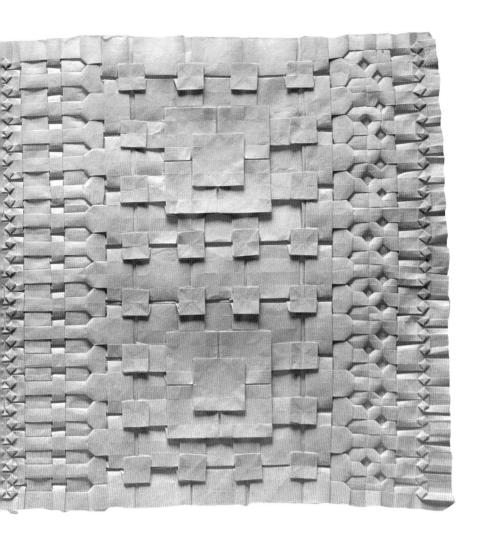

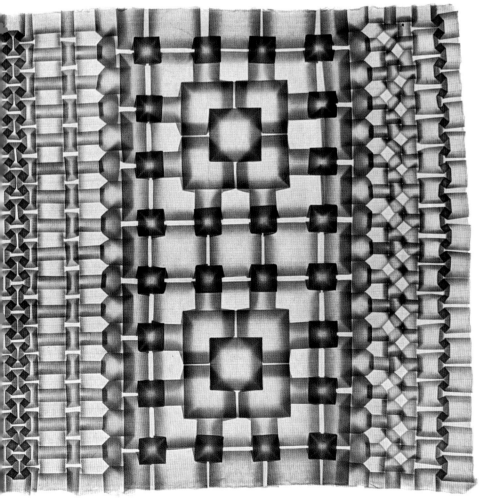

EARLY SPRING PARK
MIXING TECHNIQUE

- 13.8 x 39 inches (350 x 990 mm)
 PAPER Washi/Kochi (Tesuki Washi Berlin/Osaka)
 Hand dyeing

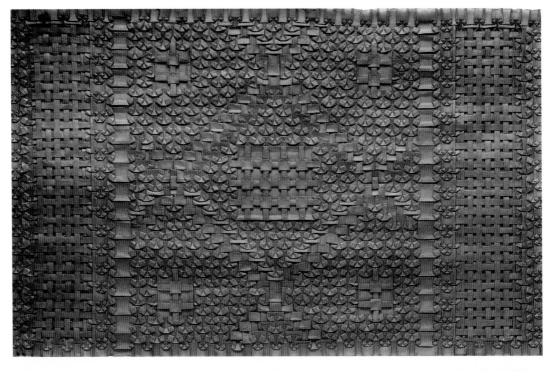

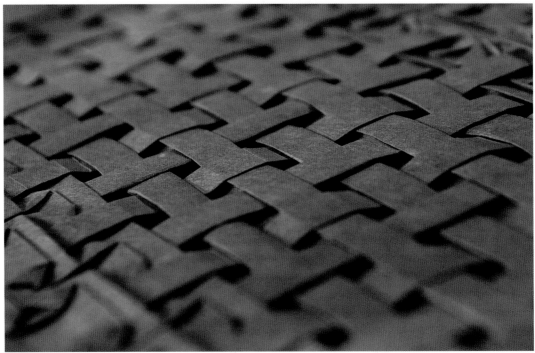

PURPLE PARK
MIXING TECHNIQUE

46.5 x 28 inches (1180 x 710 mm)

PAPER Washi/Hamada, Kochi

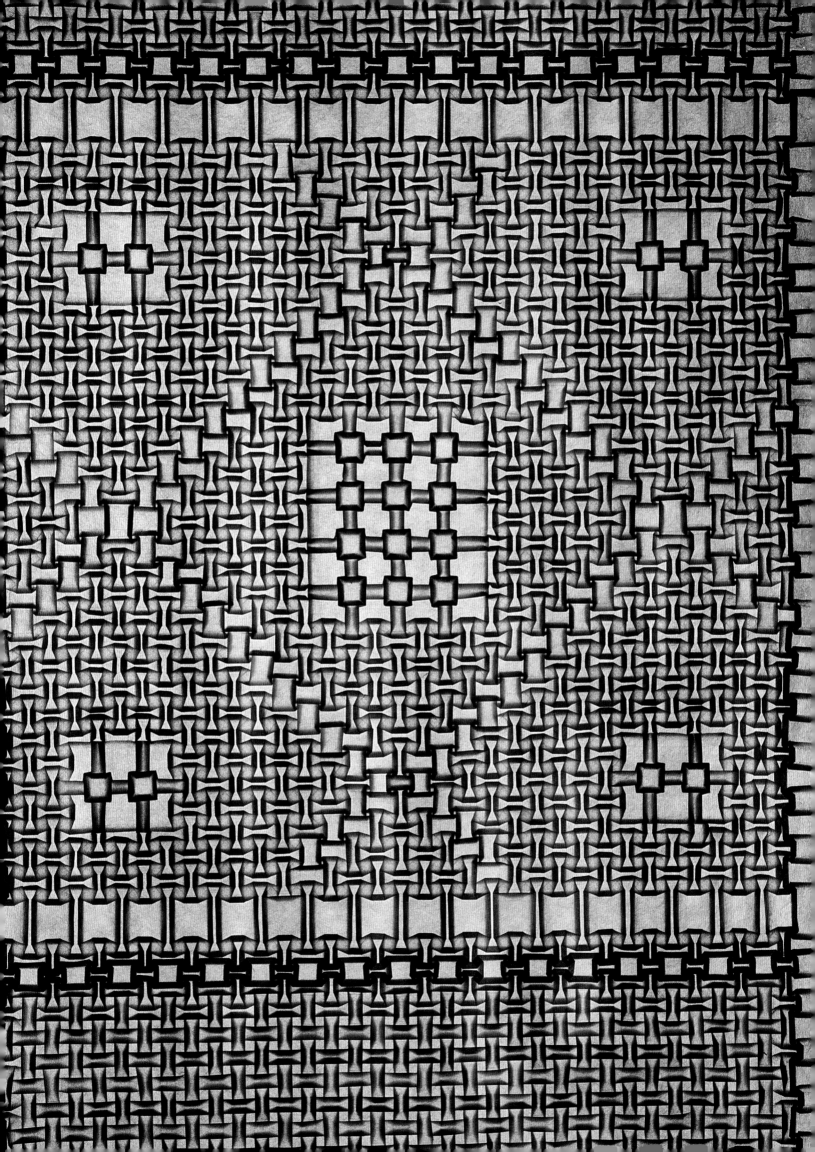

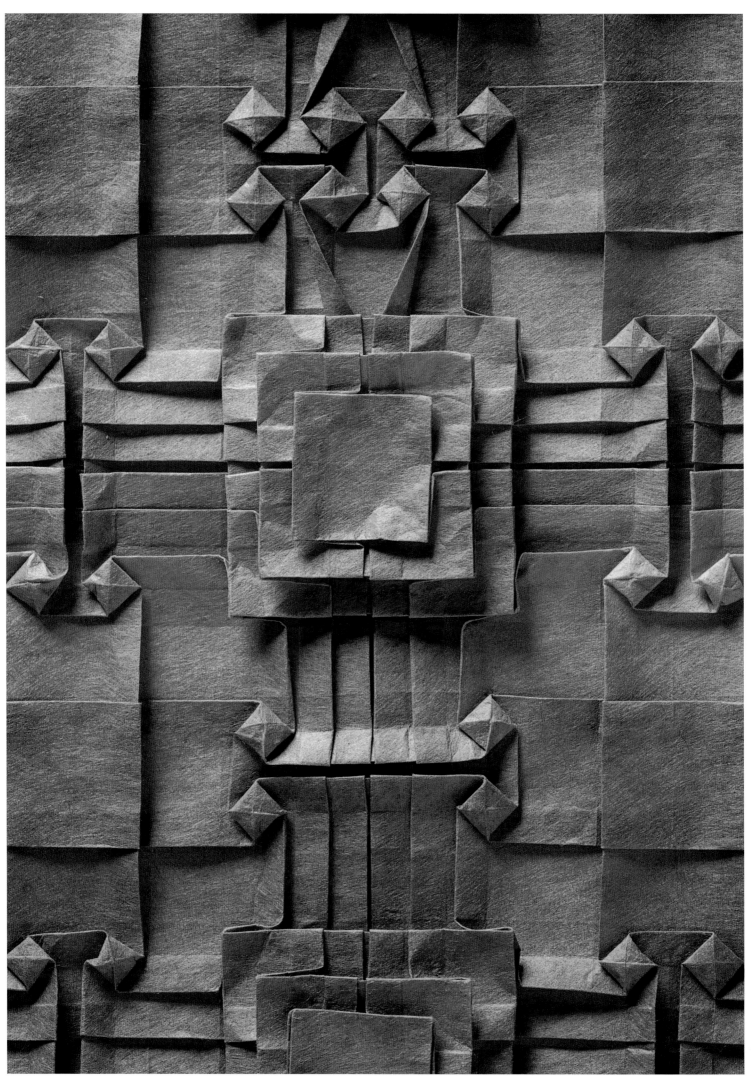

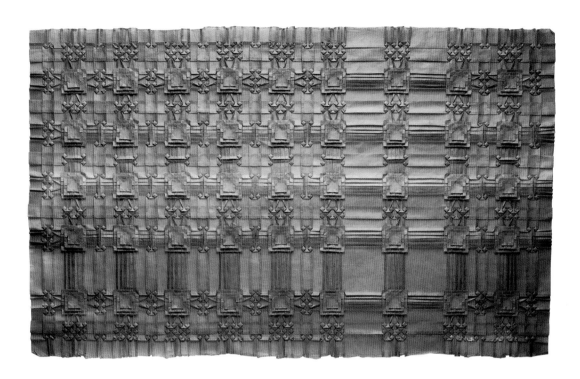

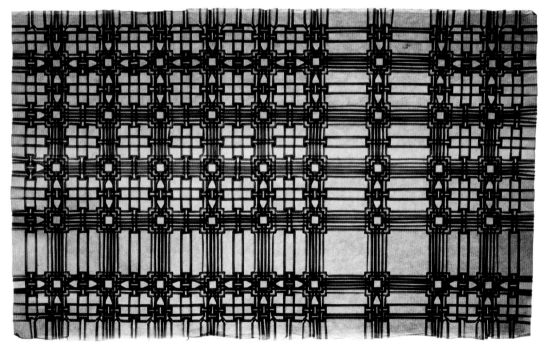

CITY
MIXING TECHNIQUE

● 41 x 24.8 inches (1040 x 630 mm)
PAPER Washi/Hamada, Kochi

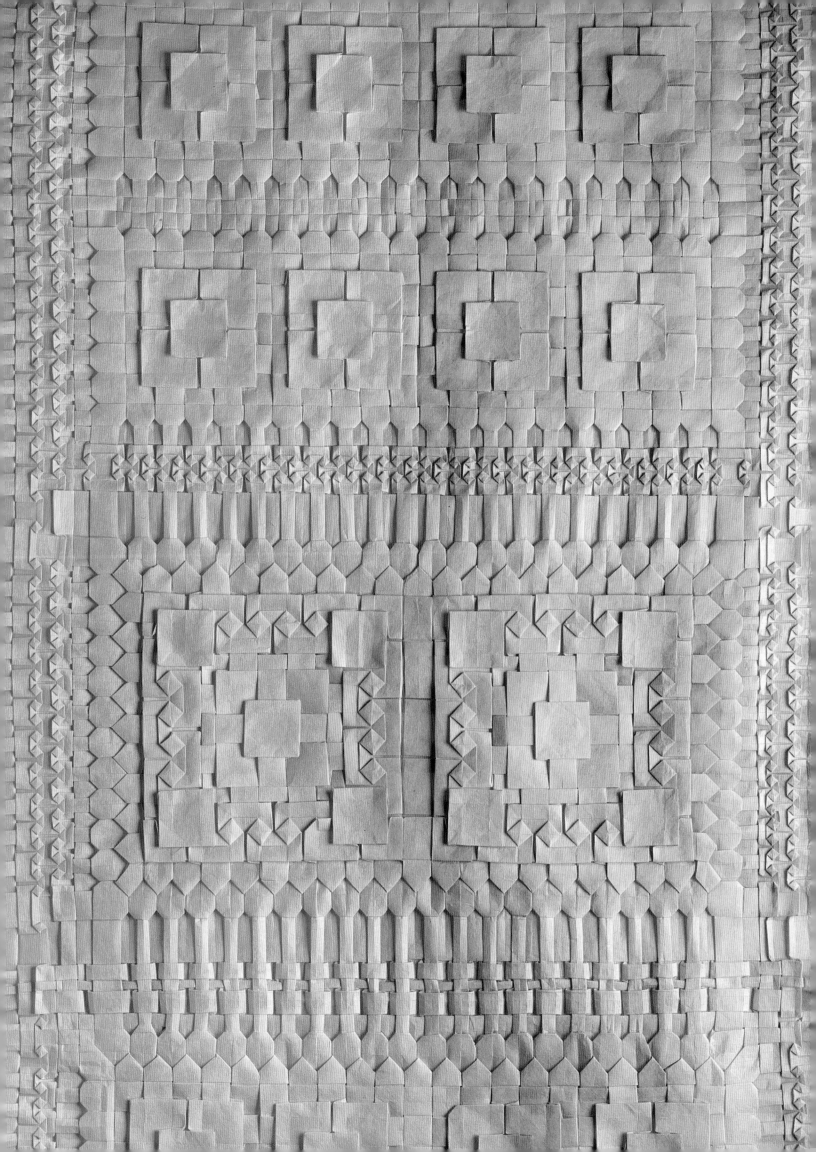

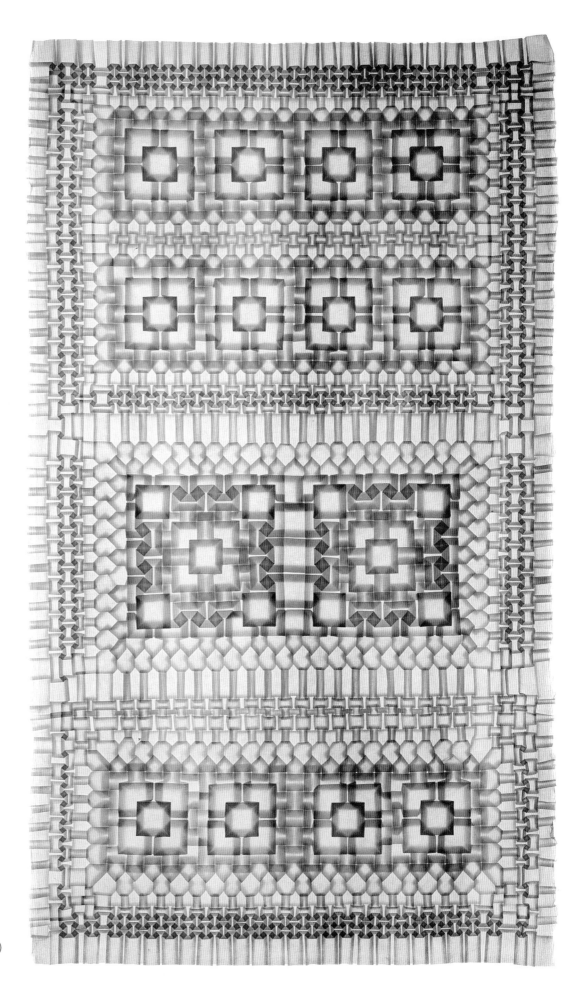

**GOLDEN AUTUMN
MIXING TECHNIQUE**

● 24.6 x 42.1 inches (625 x 1070 mm)
PAPER Washi/Hamada, Kochi

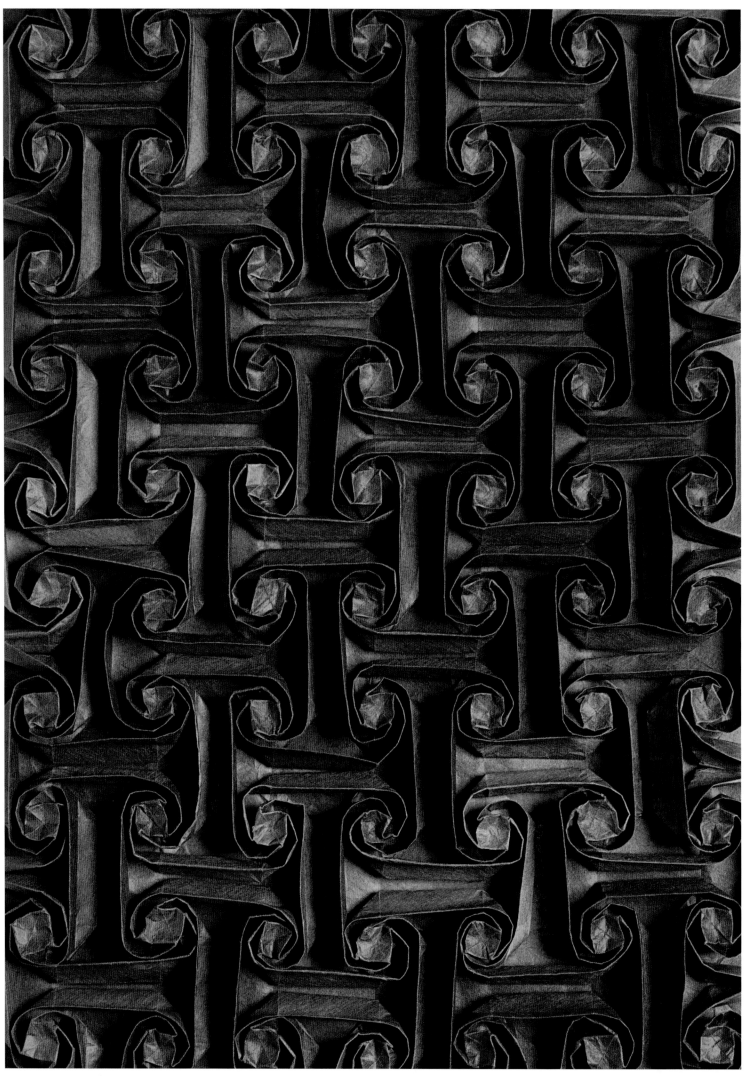

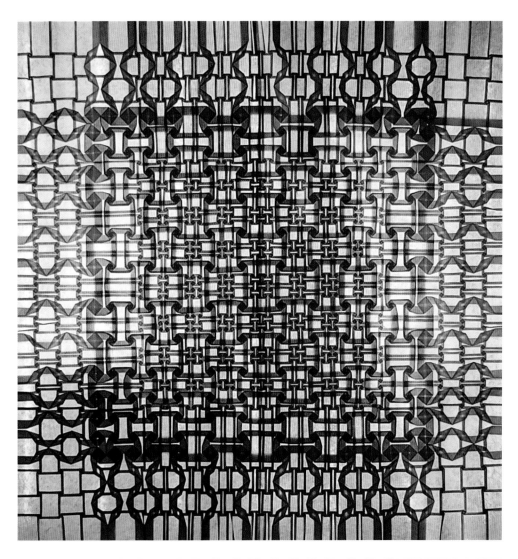

CANNED SPIRALS
 14.2 x 12.6 inches (360 x 320 mm)
PAPER Washi/Hamada, Kochi

RAINBOW
Tunagu Exhibition in Kokusai Pulp
& Paper Co. Ltd, Tokyo, Japan
(Frame) 43.3 x 43.3 inches
(1100 x 1100 mm)
PAPER Washi/Hamada, Kochi

AERIAL CLOUD
Tunagu Exhibition in Kokusai Pulp
& Paper Co. Ltd, Tokyo, Japan
(Frame) 43.3 x 43.3 inches
(1100 x 1100 mm)
PAPER Washi/Hamada, Kochi

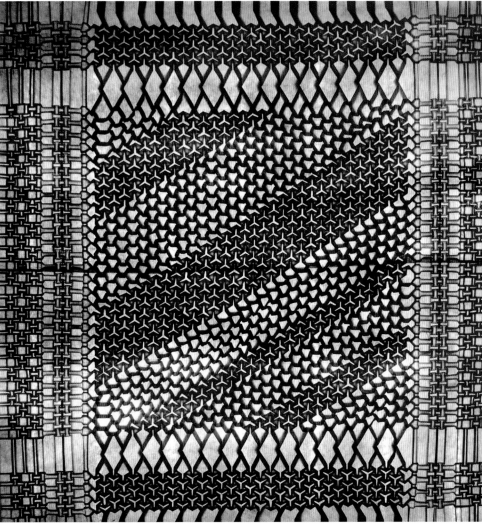

MARINE PARK
MIXING TECHNIQUE
23 x 42.5 inches (585 x 1080 mm)
PAPER Washi/Hamada, Kochi

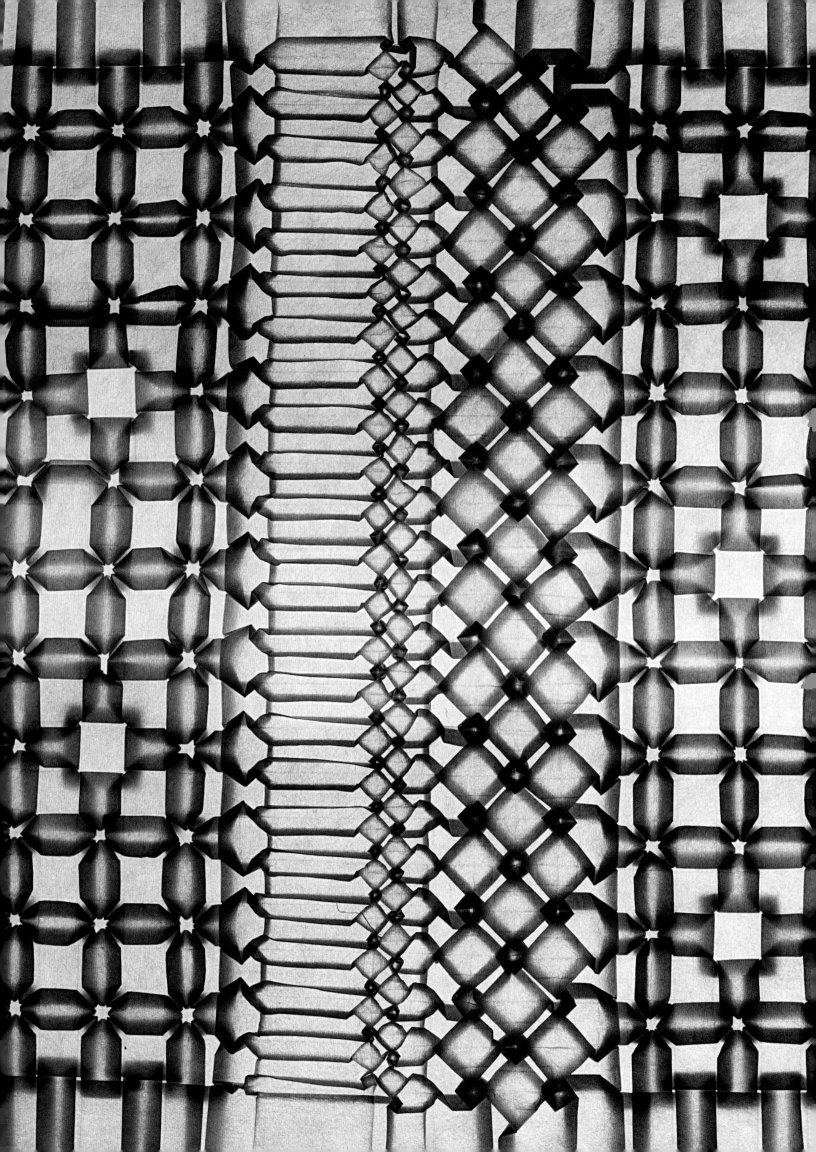

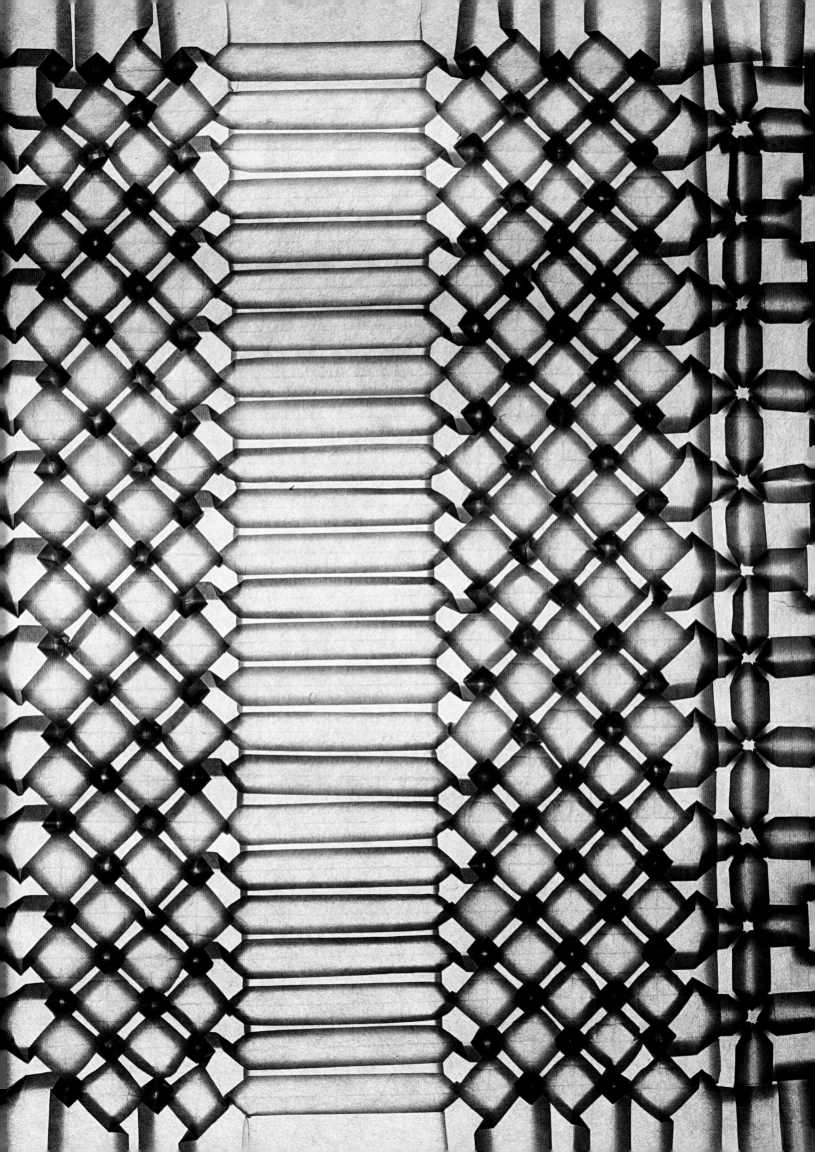

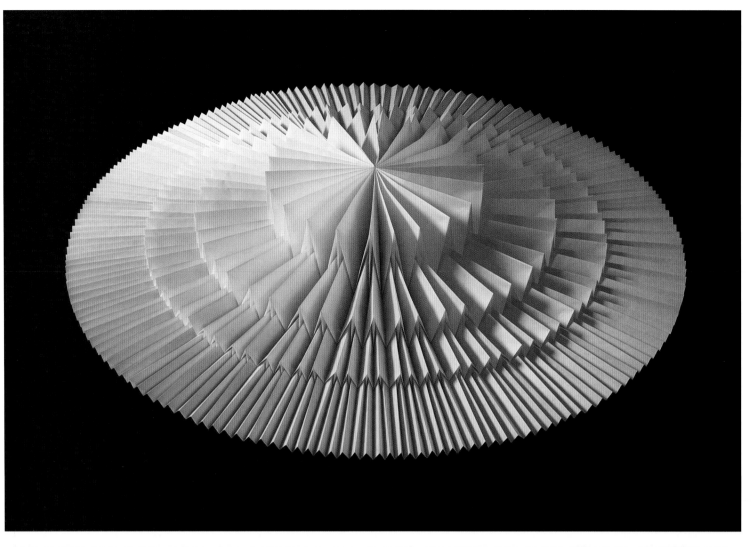

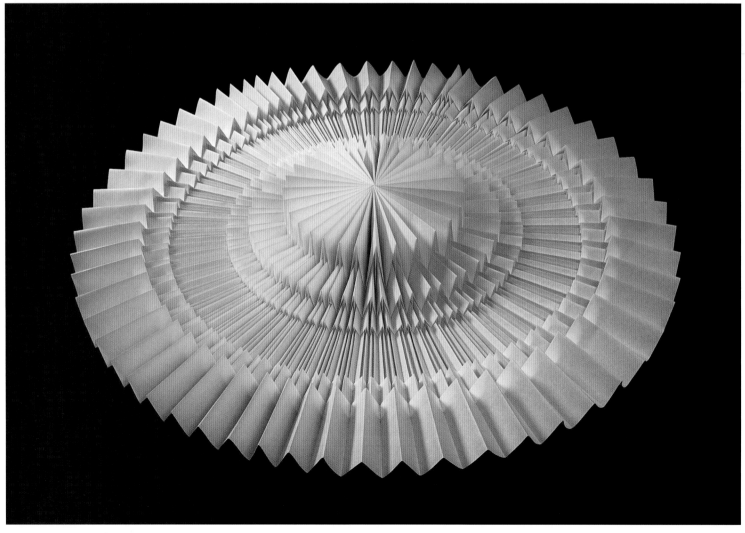

CHAPTER 3
INFINITE FOLDS

In this chapter we illustrate a folding technique for making indefinitely repeating fractal folds. The process calls for subdivision—dividing folds in half, then in half again. However, it is possible to fold them in three or more parts and thus generate a variety of motifs.

The infinite folds presented here are characterized by the fact that once formed, they can be flattened or fanned out. A long series of them can be shaped into a circle or sinuous coil. Moreover, the angle of the fold can vary to some extent, and thus lead to myriad shapes. **(TF)**

MODELING WITH SWALLOW 45
WHIRL 2
Height x Diameter
9.4 x 53.2 inches (240 x 1350 mm)

MODELING WITH SWALLOW 45
WHIRL 3
Height x Diameter
7.9 x 51.2 inches (200 x 1300 mm)

MODELING WITH SWALLOW 45
WHIRL 1
Height x Diameter
7.9 x 53.4 inches (200 x 1356 mm)

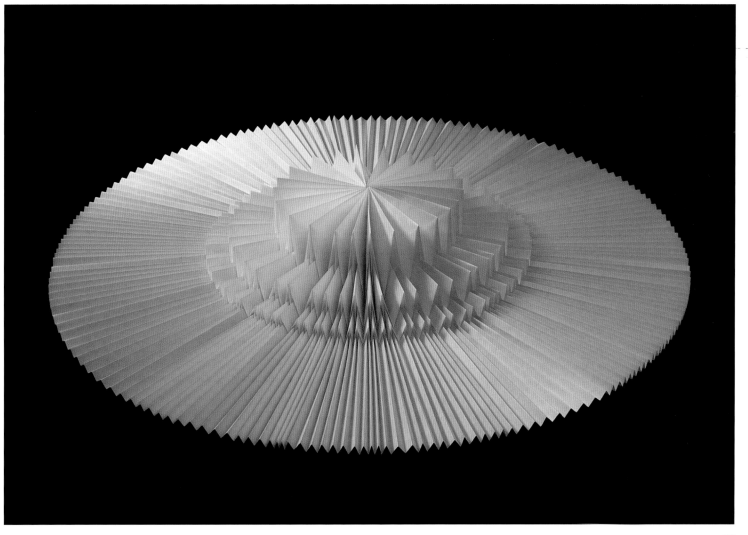

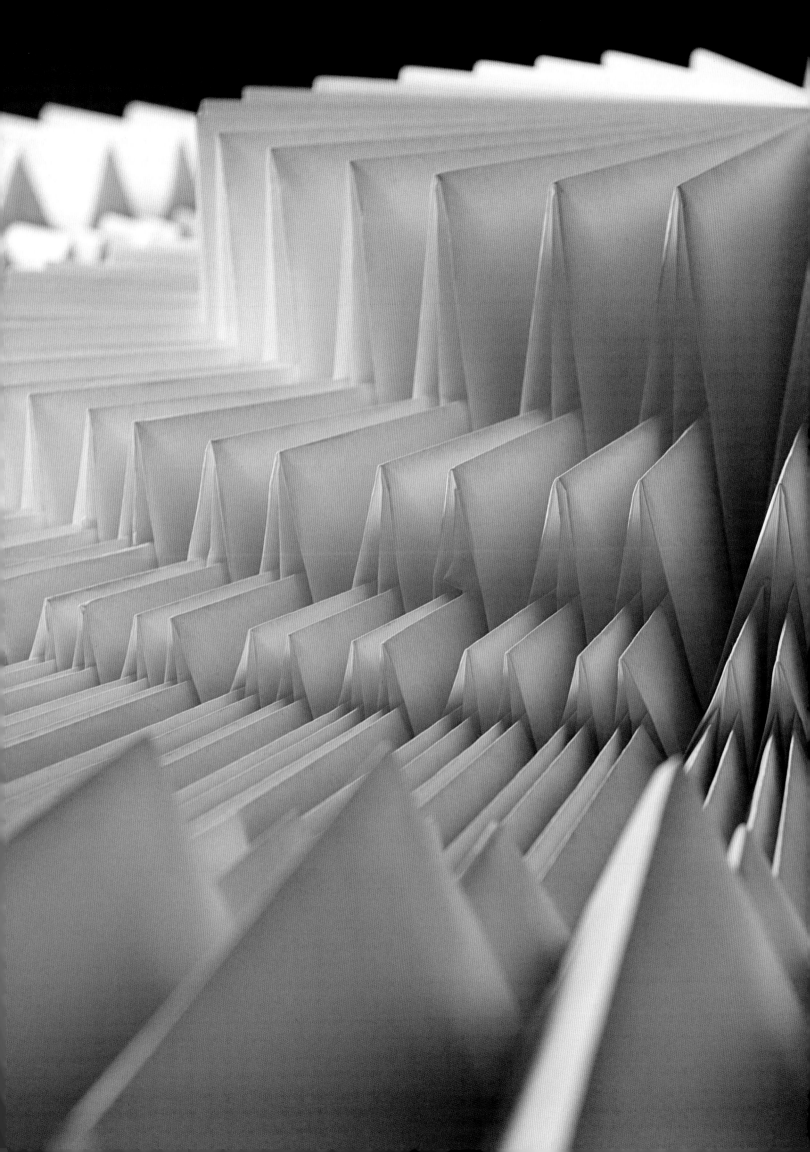

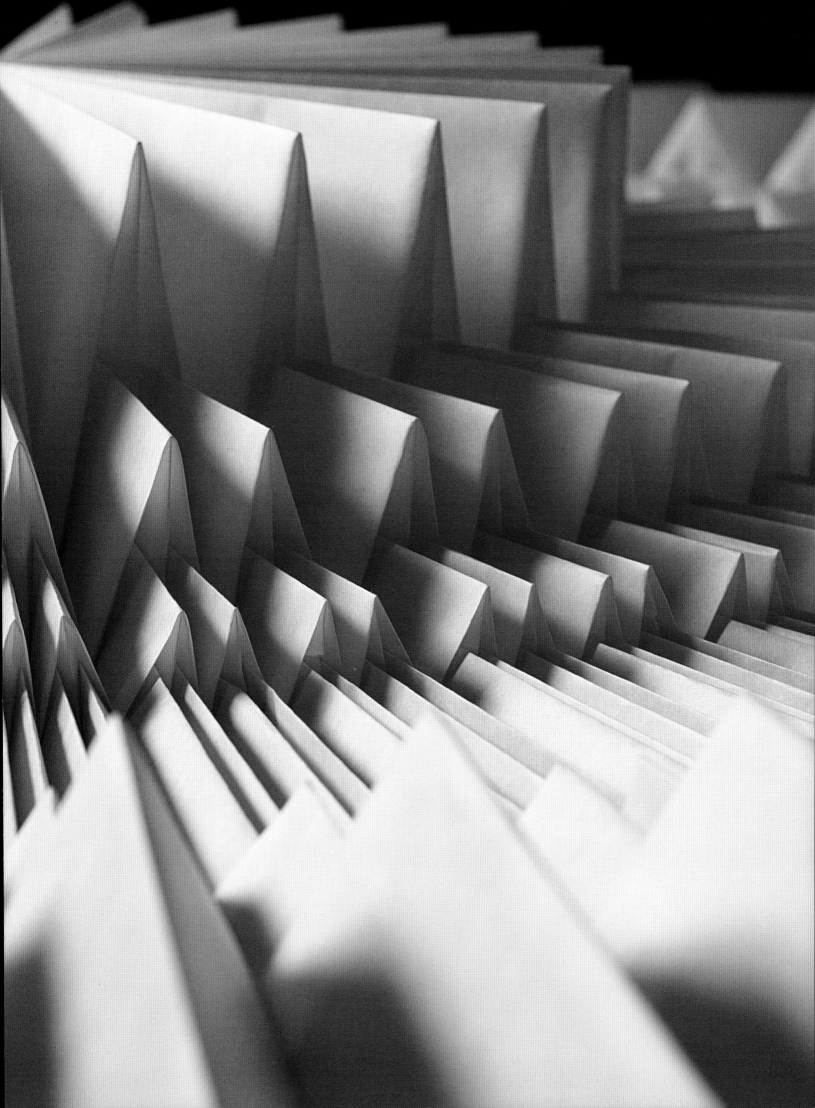

● One of the first exhibitions of infinite folds in Europe took place in 2015 at the Schafhof Gallery in Freising, Germany. It was here that Tomoko Fuse took up the challenge of a display that occupied a 5,380-square foot (500-square meter) ground-floor space. Preparations for the installation took her six months. Fuse's favorite material is *shōji* paper, generally used for walls and sliding panels in Japanese homes, where it is replaced each year.

Fire-resistant, hence more rigid, this type of paper lends itself to folding and is available in rolls of 3.2 feet (1 meter) in height and 98.4 feet (30 meters) in length. The theme in this case was the Japanese rock garden. The artist represented it through sequences of folds of diminishing size in which each level was half that of the previous one, in a kind of fractal process. The sequences of larger folds were allowed to meander, like rivers or winding paths, while the others were arranged into perfect circular structures. It is difficult for someone who has not seen a work of this size to envision it. Traditional origami is made out of square sheets 6 x 6 inches (15 x 15 centimeters) in size. However, when it comes to infinite folds, as the term implies, the dimensions of the sheets know no limits.

To those traveling to Japan, I recommend a visit to Ryōanji, the Zen temple in Kyoto known for its rock garden. Standing before Tomoko Fuse's infinite folds, one feels transported into an imaginary space much like that of a sacred one, in which it is impossible not to submit to a meditative frame of mind and experience great peace and tranquility. **(DB)**

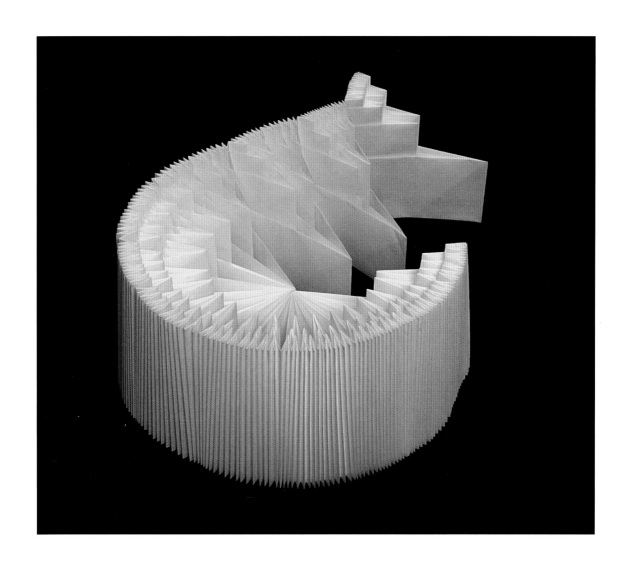

MODELING WITH SWALLOW 45
CIRCULAR STUMP

Height x Diameter
9 x 19.3 inches (230 x 490 mm)

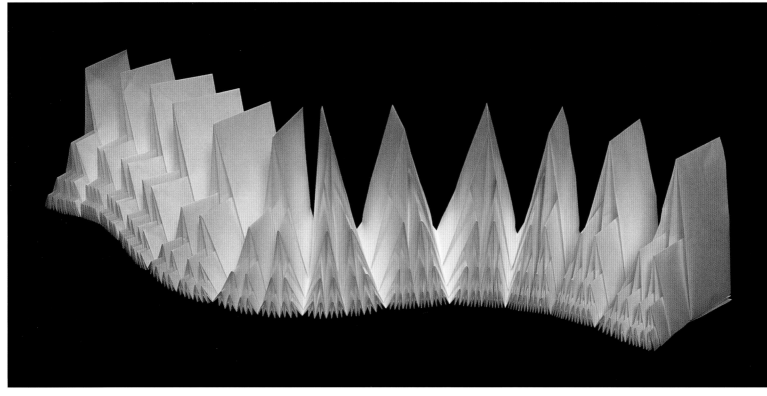

MODELING WITH SWALLOW 45
SHIRAKAWA HOUSE—TRIPARTITA

◀ Width x Length x Height
9.3 x 18.9 x 14.2 inches (235 x 480 x 360 mm)

MODELING WITH SWALLOW 45
SHIRAKAWA HOUSE—QUADRIPARTITA

▶ Width x Length x Height
7.9 x 18.9 x 13.8 inches (200 x 480 x 350 mm)

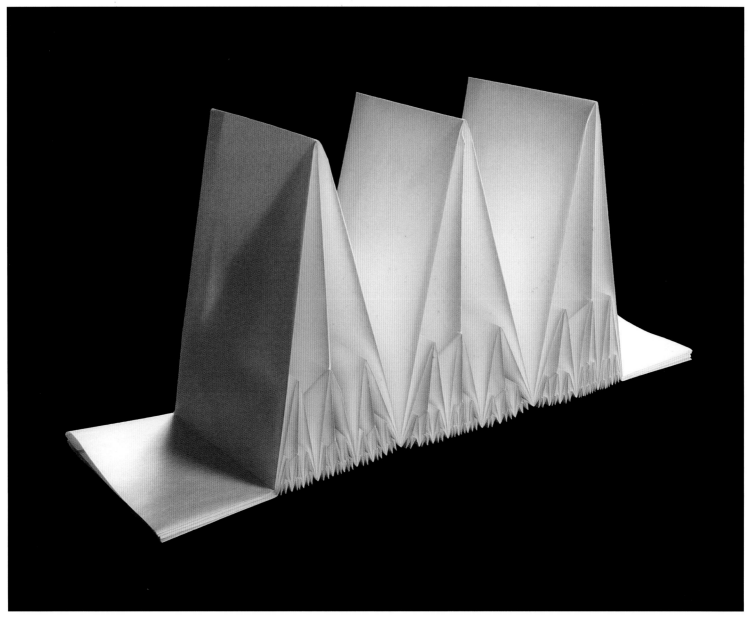

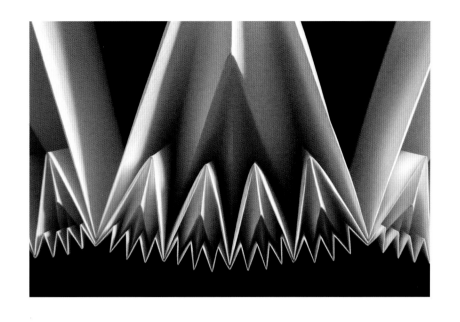

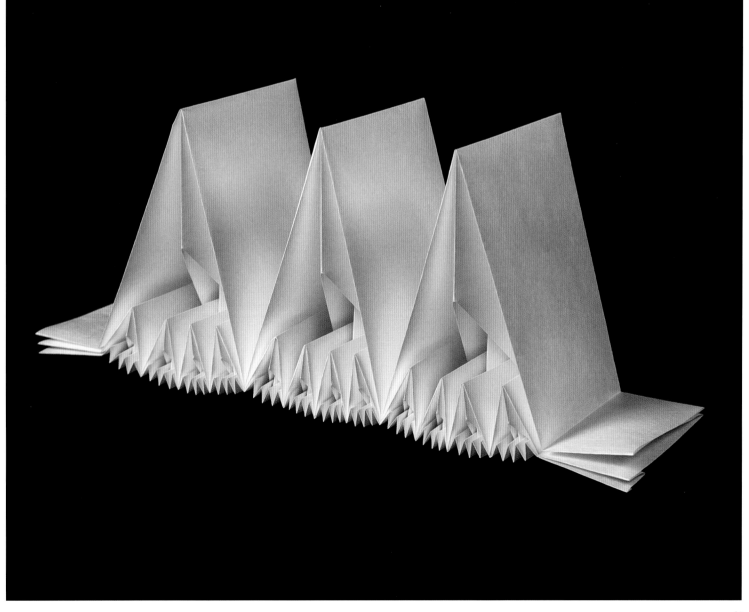

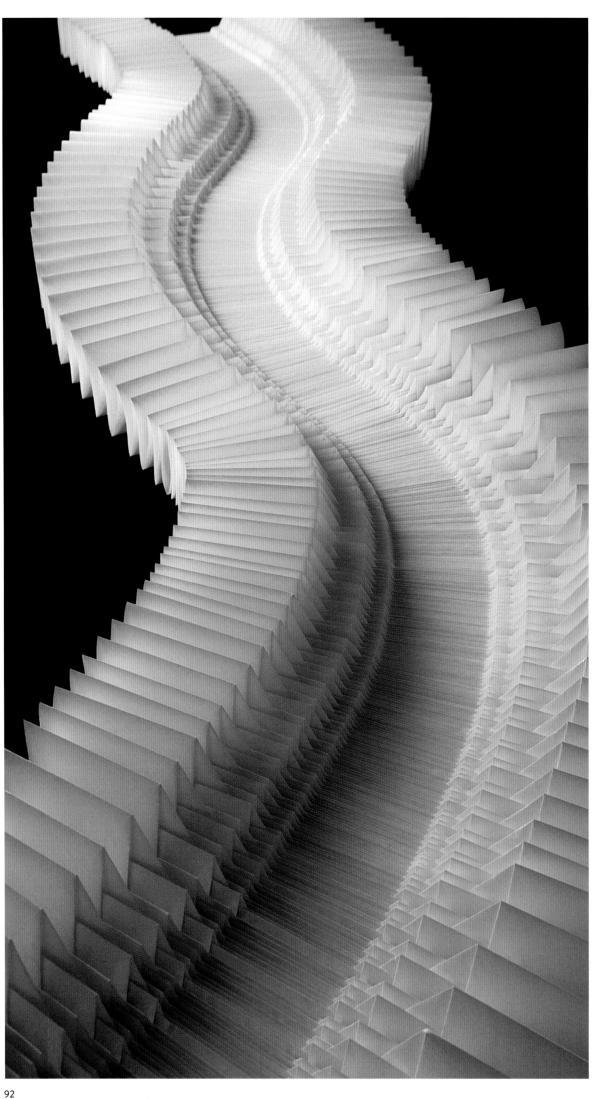

MODELING WITH
SWALLOW 45
RIVER

Height x Diameter
4.7 x 28 inches
(120 x 710 mm)

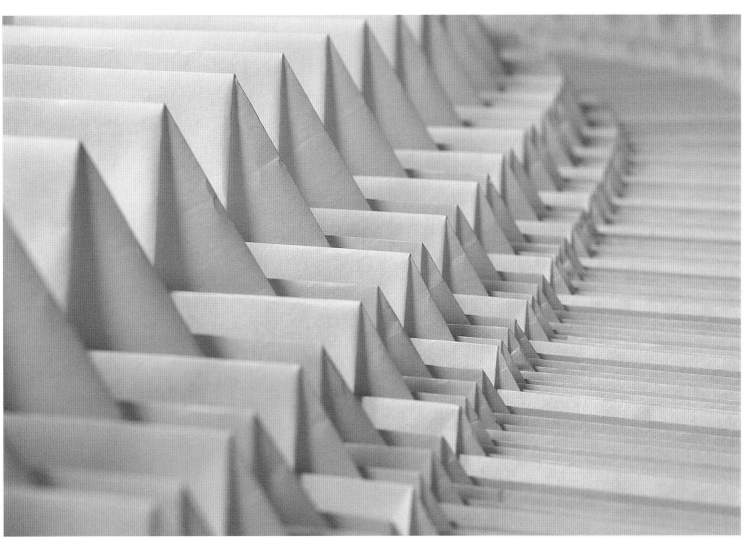

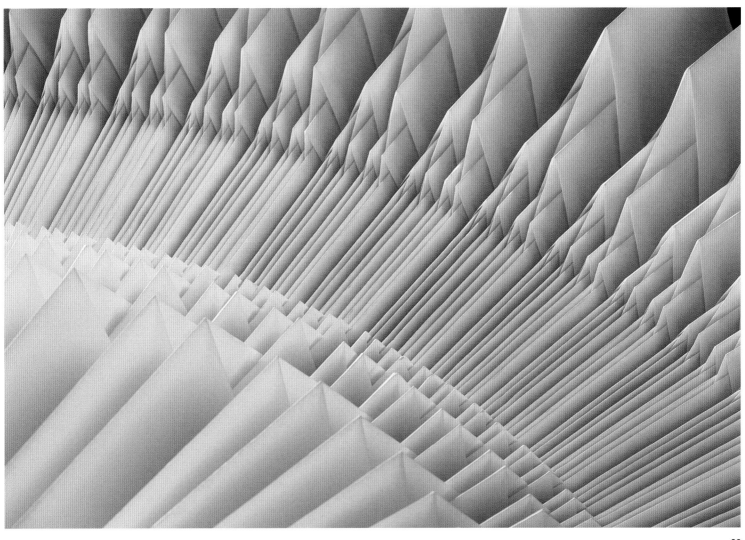

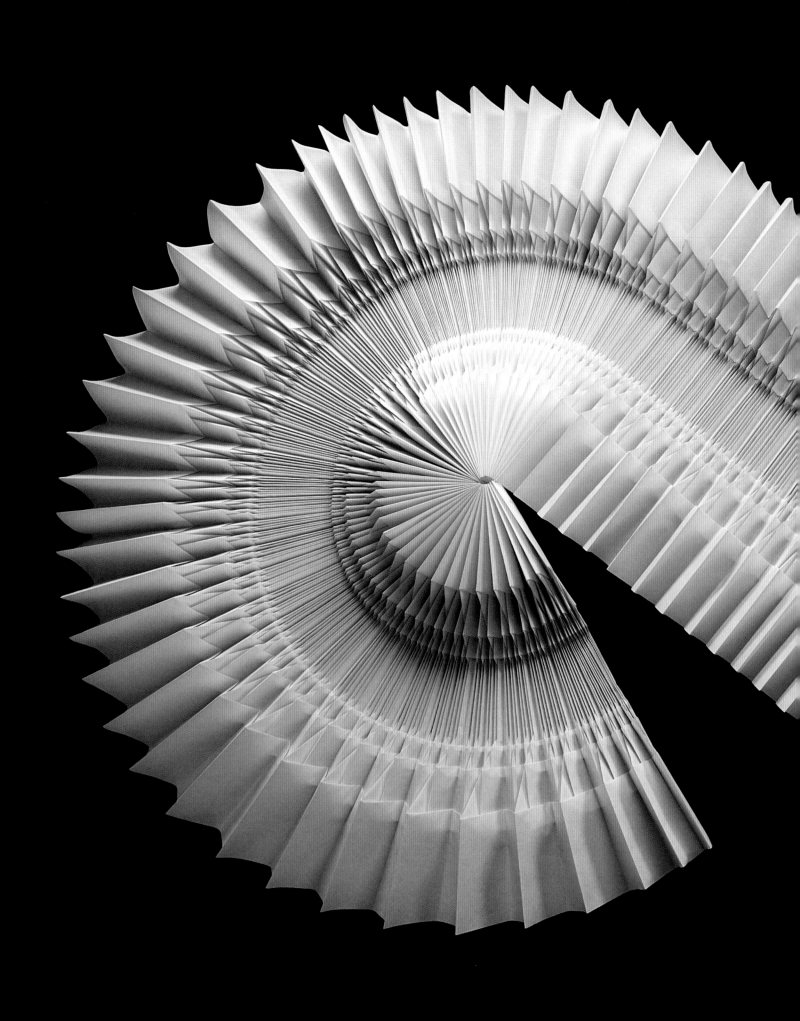

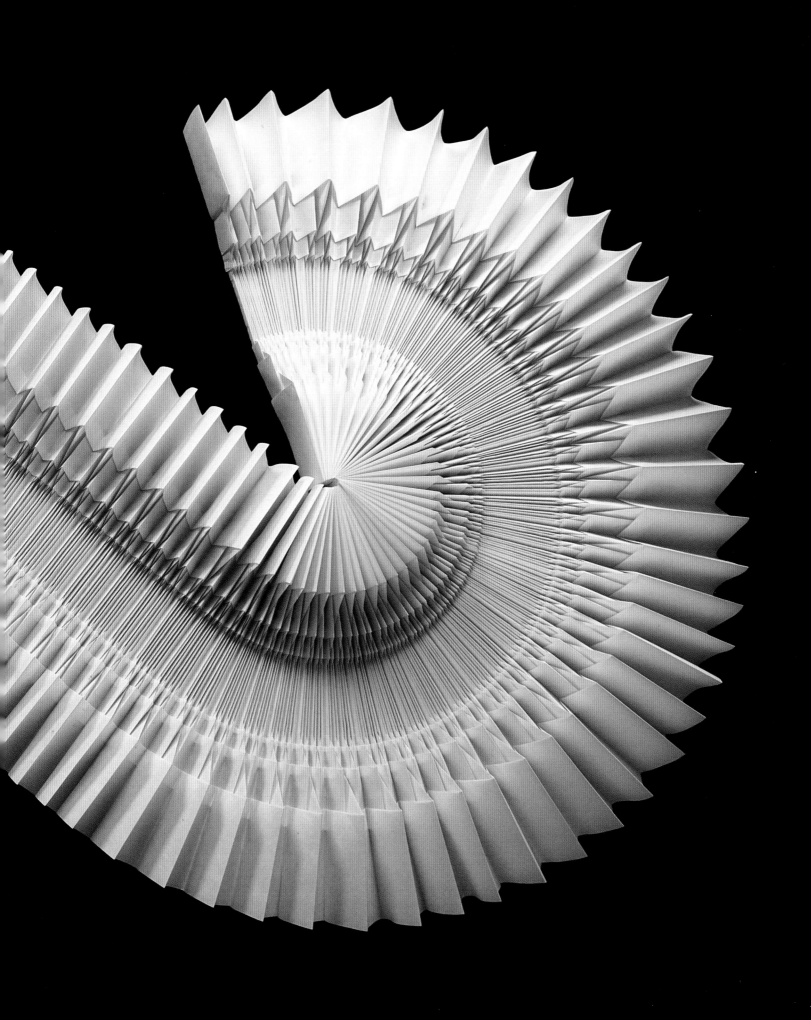

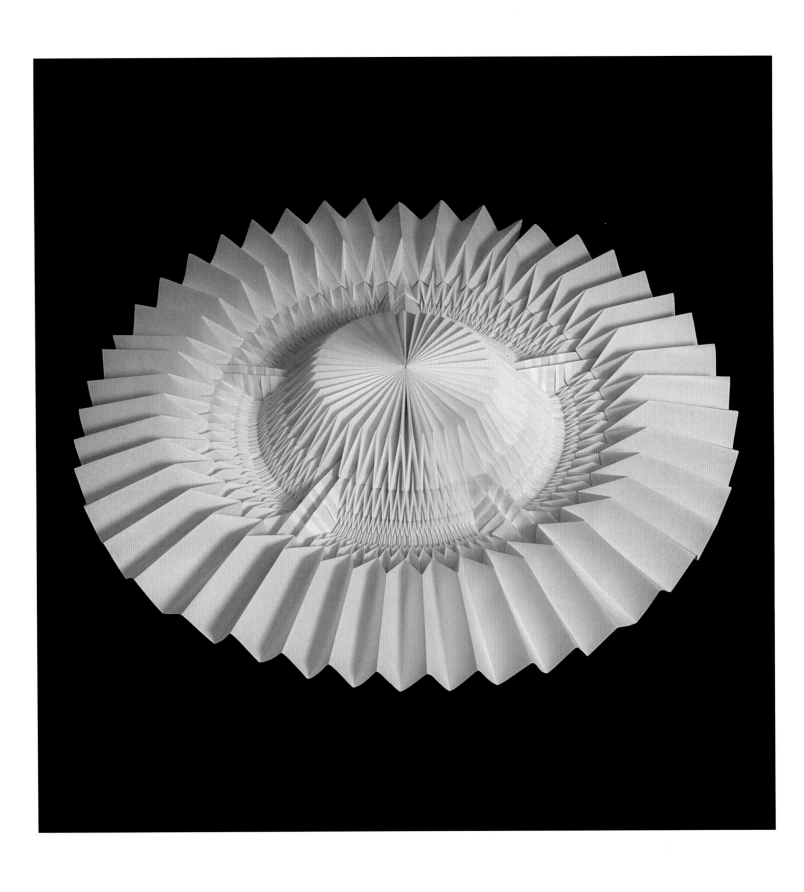

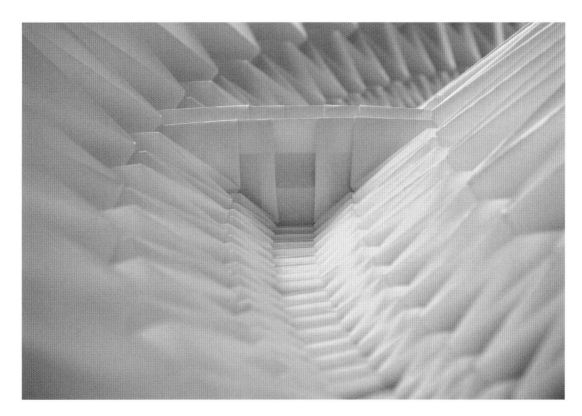

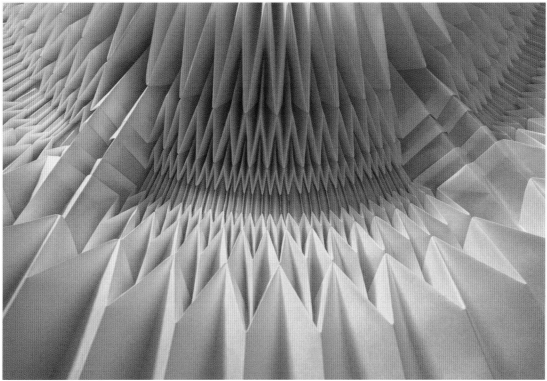

MODELING WITH ARROWHEAD 45
WHIRL UFO

● Height x Diameter
6 x 55.1 inches (150 x 1400 mm)

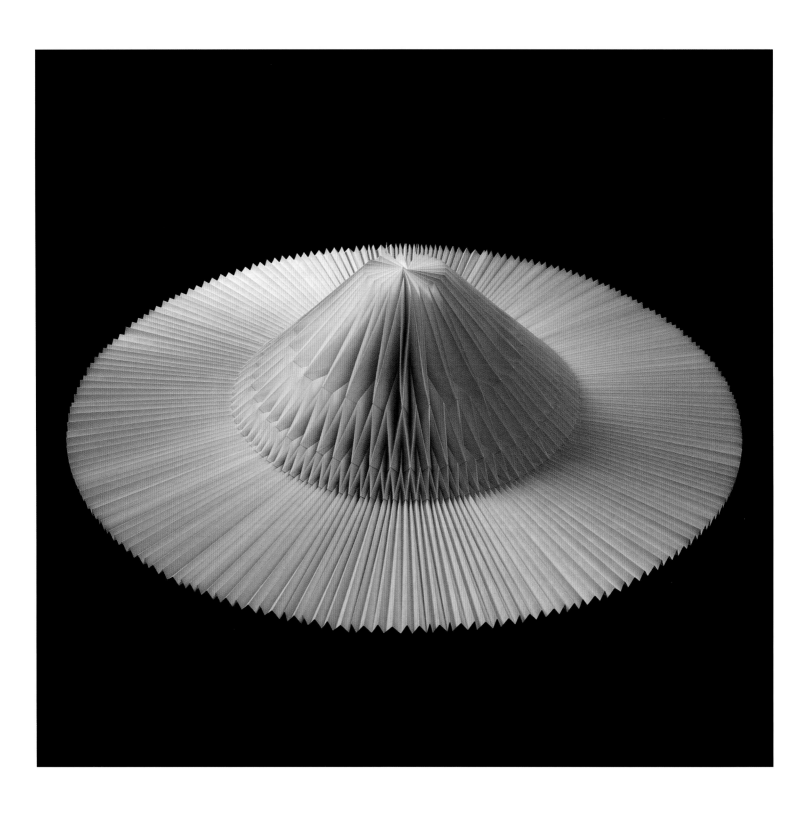

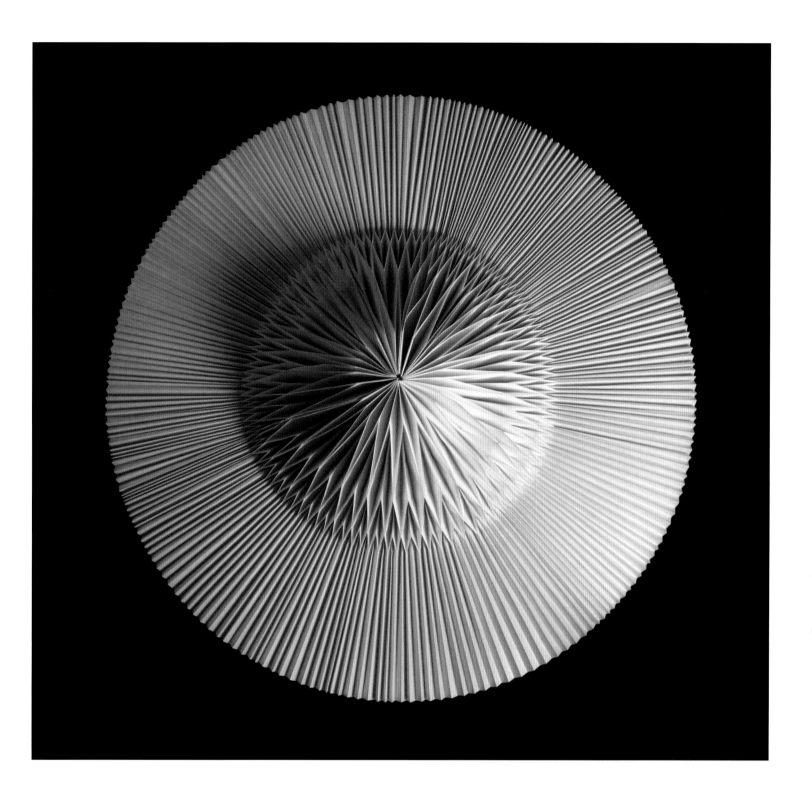

MODELING WITH ARROWHEAD 45 MOUNTAIN 1

Height x Diameter
11 x 53.5 inches
(280 x 1360 mm)

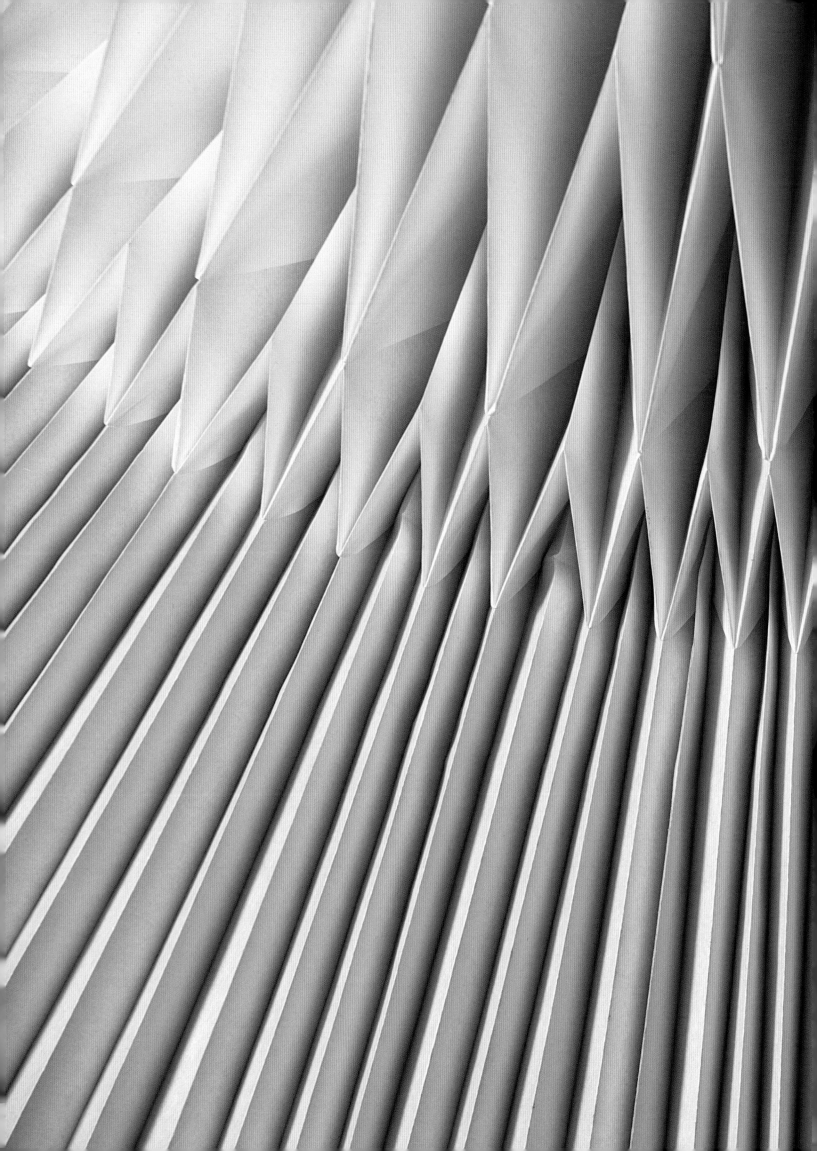

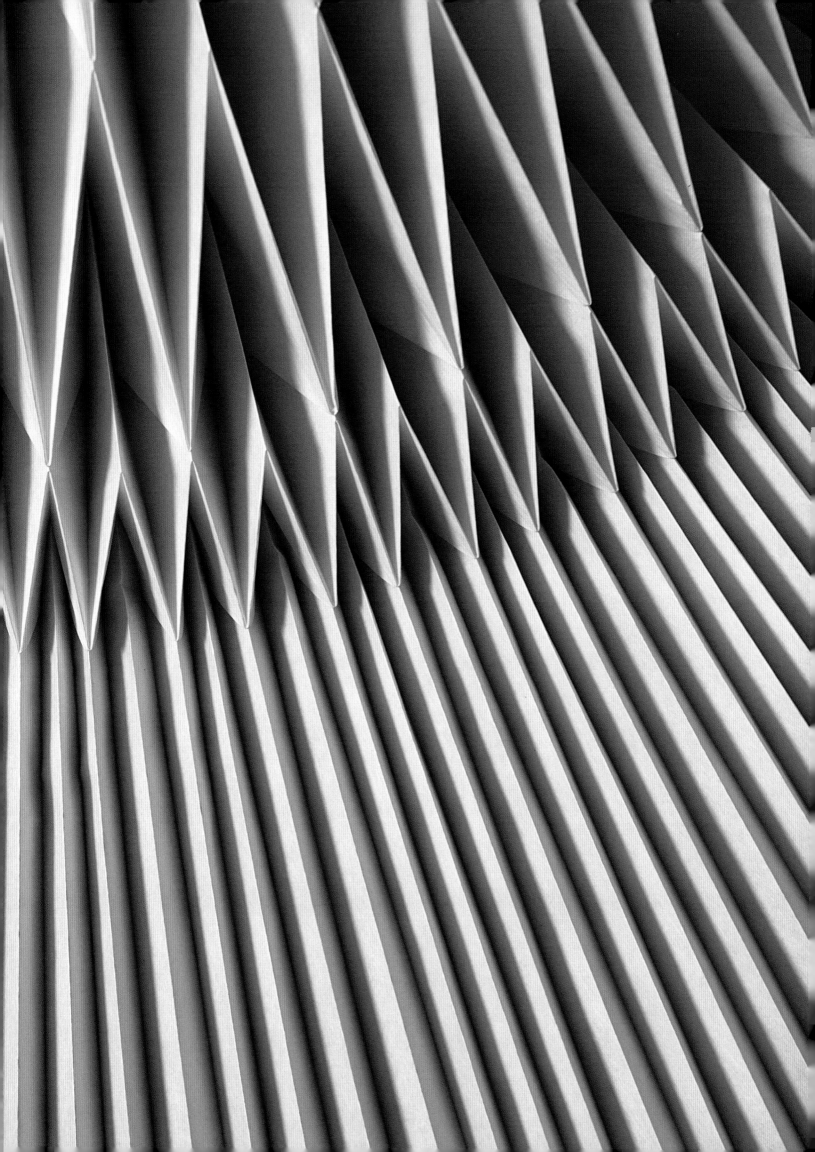

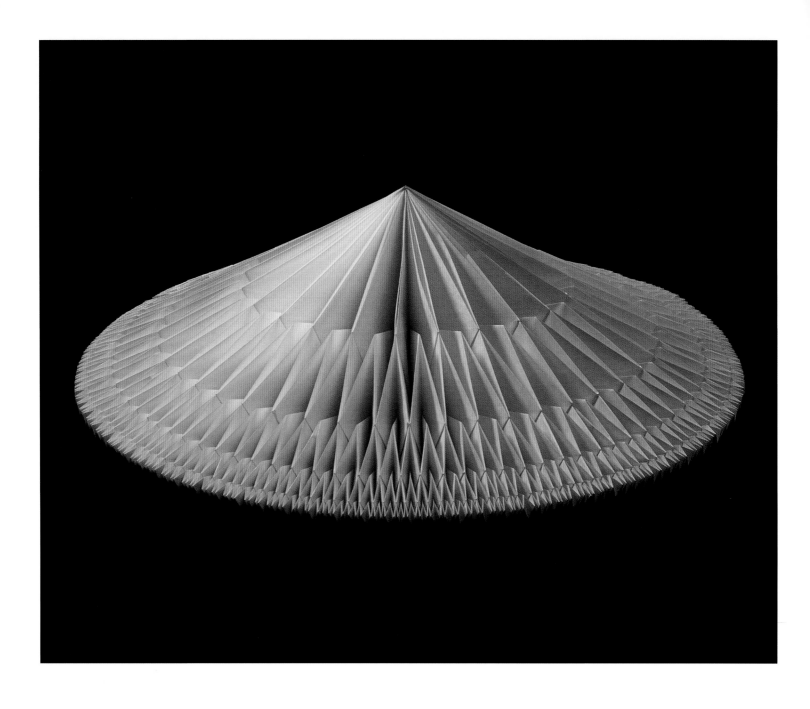

**MODELING WITH ARROWHEAD 45
MOUNTAIN 3**

◖ Height x Diameter
12.6 x 51.2 inches
(320 x 1300 mm)

**MODELING WITH ARROWHEAD 45
MOUNTAIN 2**

◗ Height x Diameter
13.4 x 45.7 inches
(340 x 1160 mm)

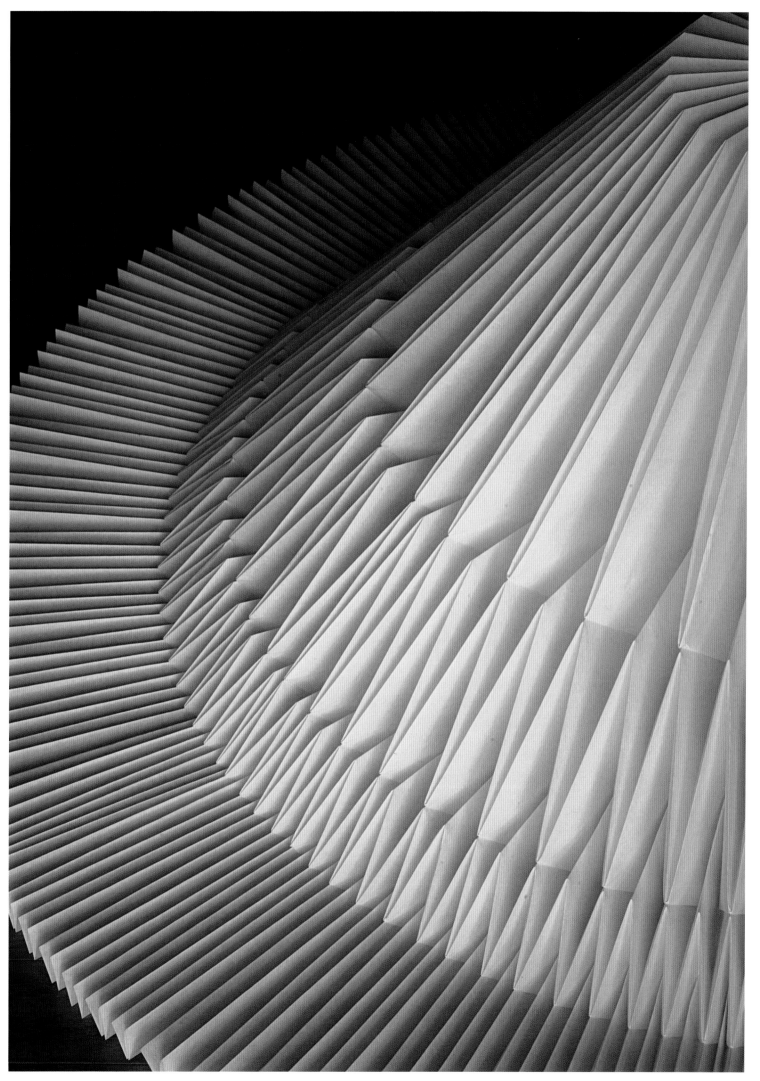

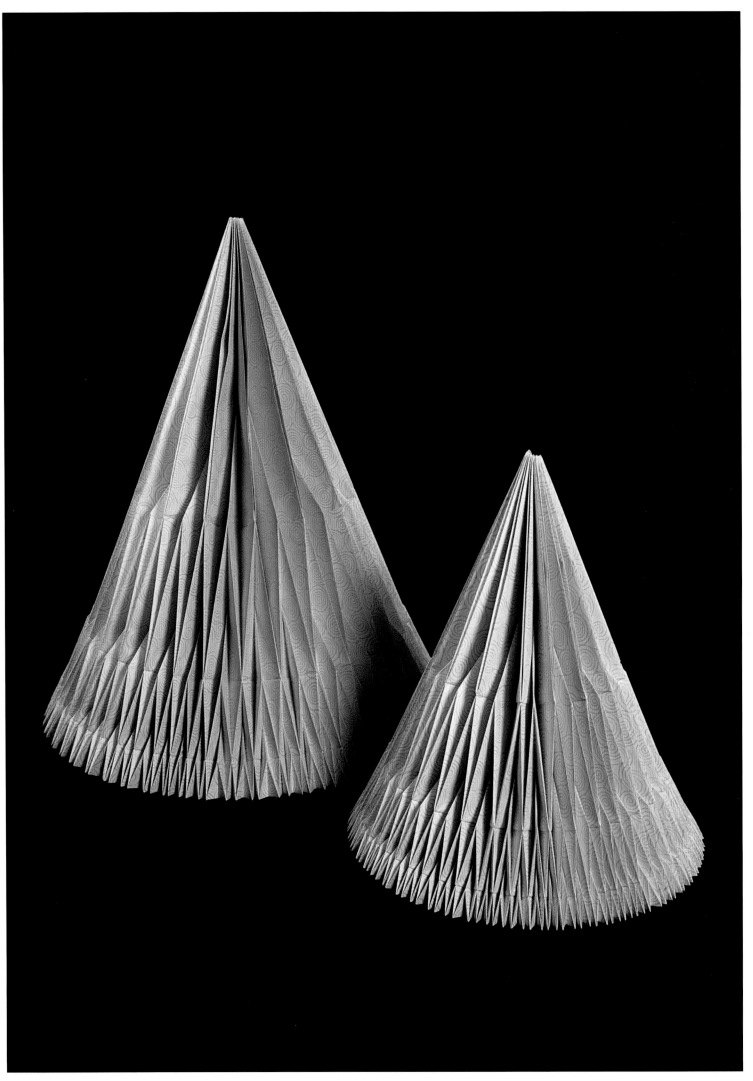

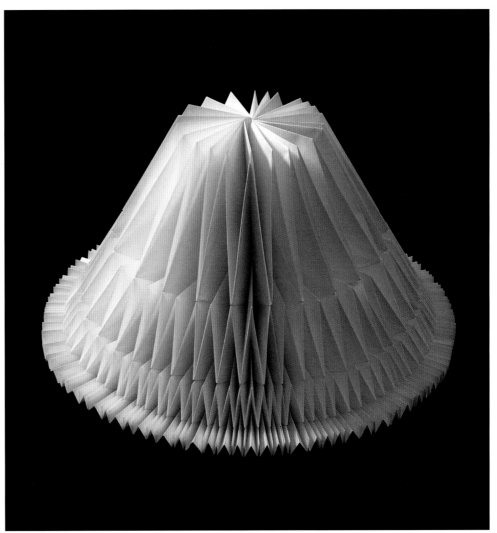

MODELING WITH ARROWHEAD 68
SHARP MOUNTAIN 1 (BIG)

◖ Height x Diameter
49.6 x 36.2 inches
(1260 x 920 mm)

MODELING WITH ARROWHEAD 65
SHARP MOUNTAIN 2 (SMALL)

◖ Height x Diameter
39.7 x 29 inches
(1008 x 736 mm)

MODELING WITH ARROWHEAD 60
MOUNTAIN 4

◗ Height x Diameter
14.2 x 27.6 inches
(360 x 700 mm)

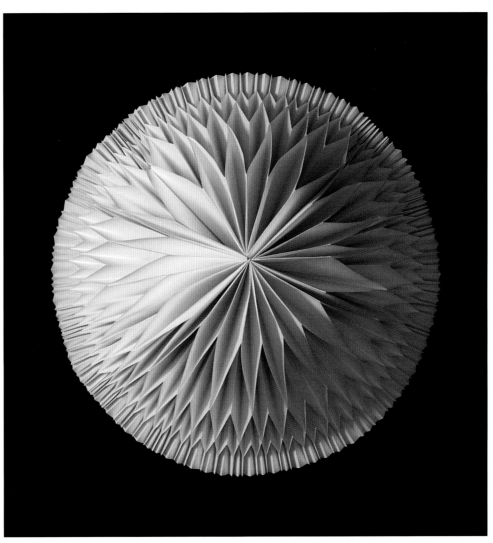

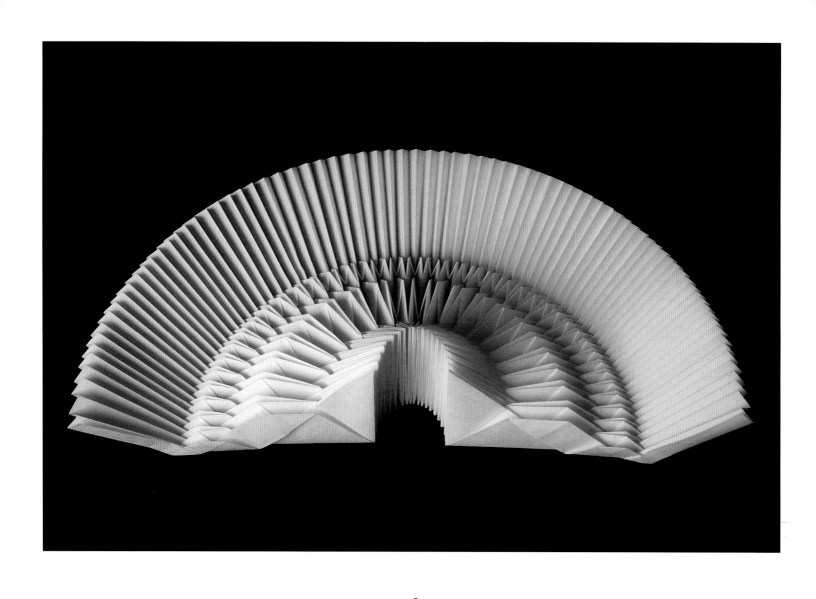

MODELING WITH ARROWHEAD 45
FANCY PLEATS

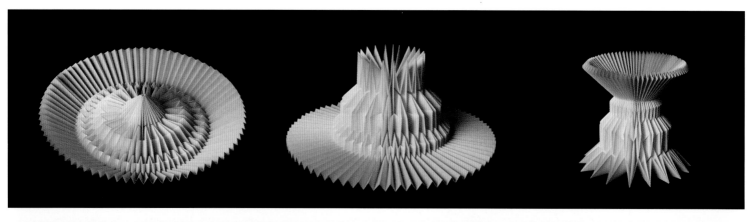

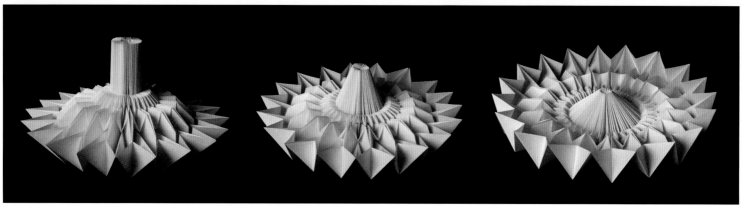

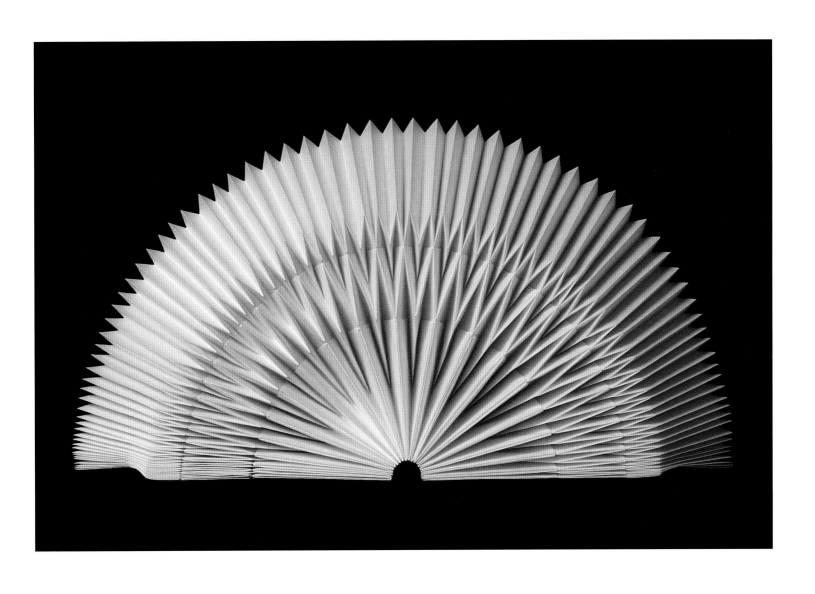

Height x Diameter
8.1 x 6.7 inches (207 x 170 mm)

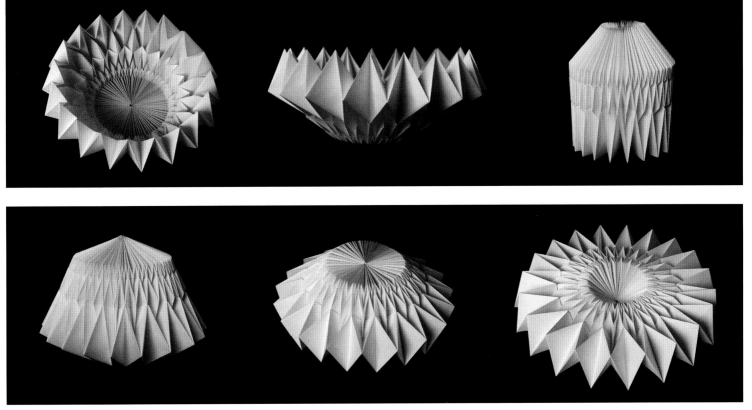

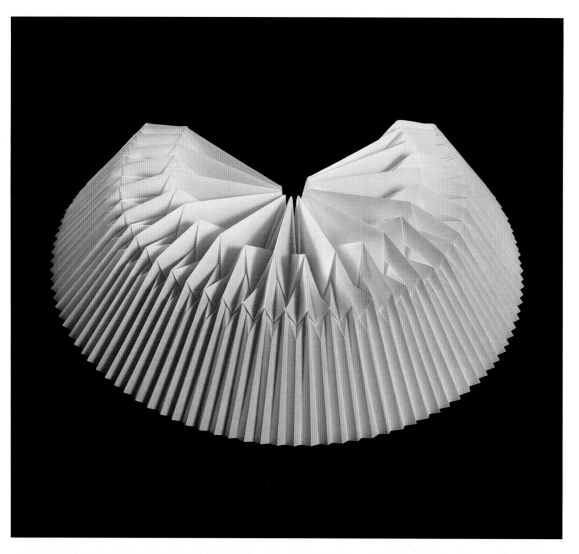

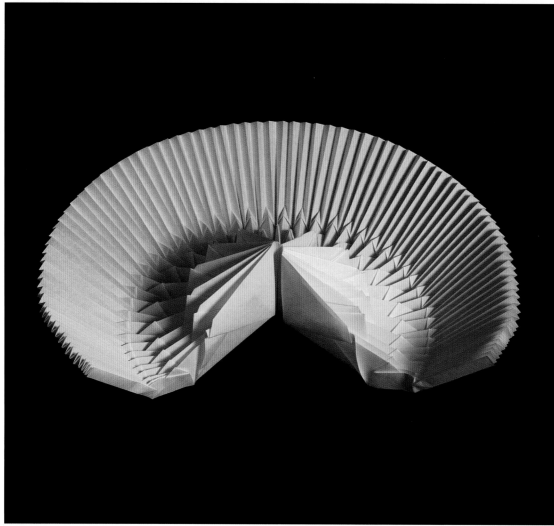

MODELING WITH DOUBLE TUCK 45 COLOSSEUM

- Height x Diameter
 6.5 x 22 inches
 (165 x 560 mm)

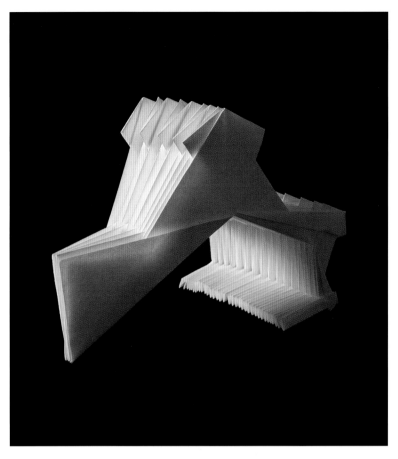

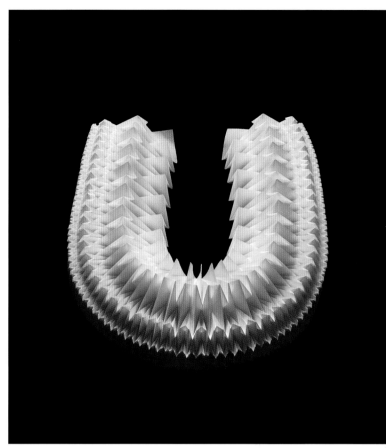

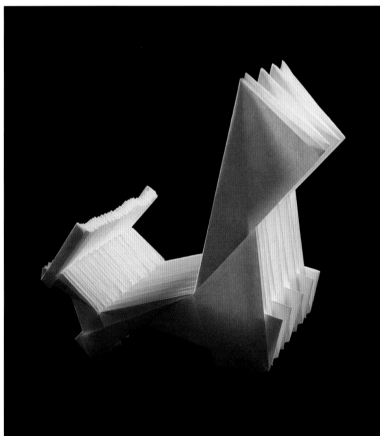

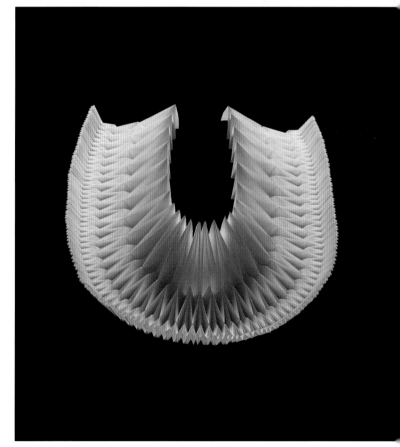

MODELING WITH
CONSECUTIVE TUCK 50
TUCK TUCK

◖◗ Width x Length x Height
5.5 x 13.4 x 13.2 inches (140 x 340 x 335 mm)

MODELING WITH
CONSECUTIVE TUCK 50
FERN SEEDLINGS

◗◖ Width x Height
6.7 x 33.5 inches (170 x 850 mm)

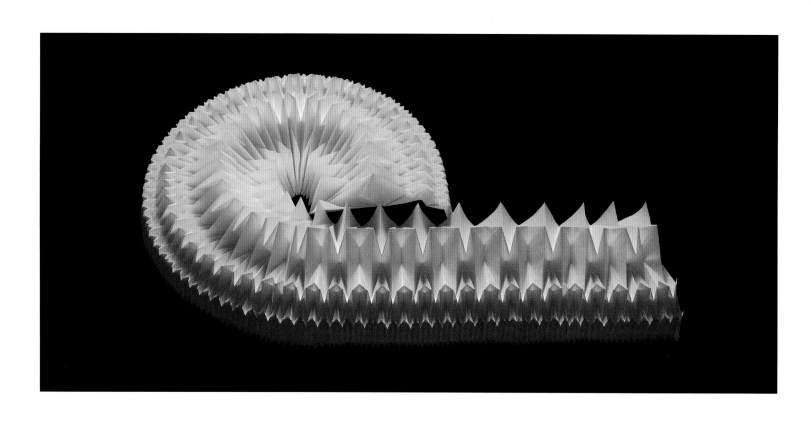

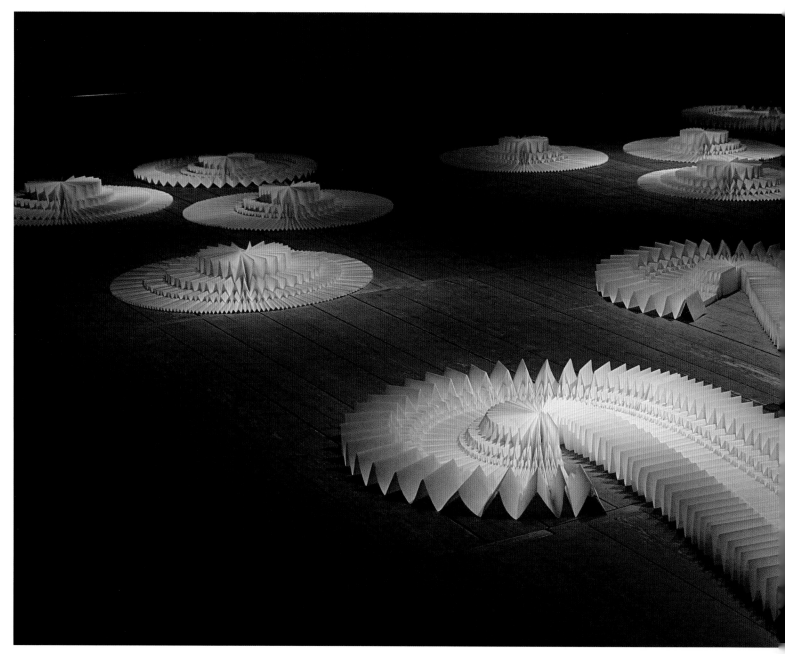

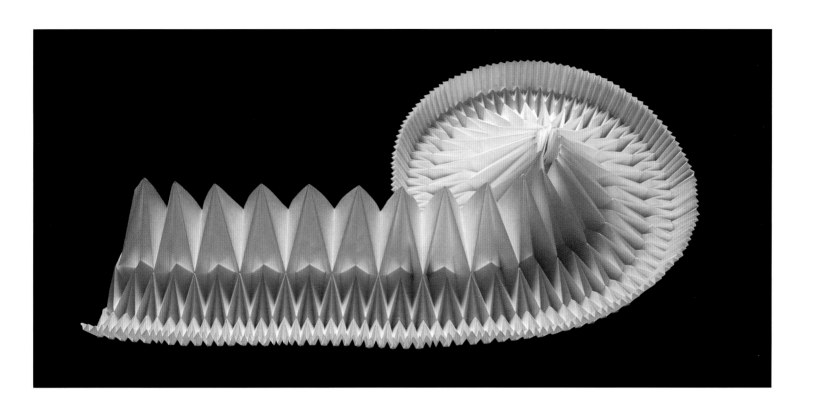

MODELING WITH CONSECUTIVE TUCK 50
FERN SEEDLINGS

◗ Width x Height
6.7 x 33.5 inches (170 x 850 mm)

PAPER GARDEN BY INFINITE FOLDING

◖ European House of Art Upper Bavaria,
Schafhof, Freising, Germany, 2015

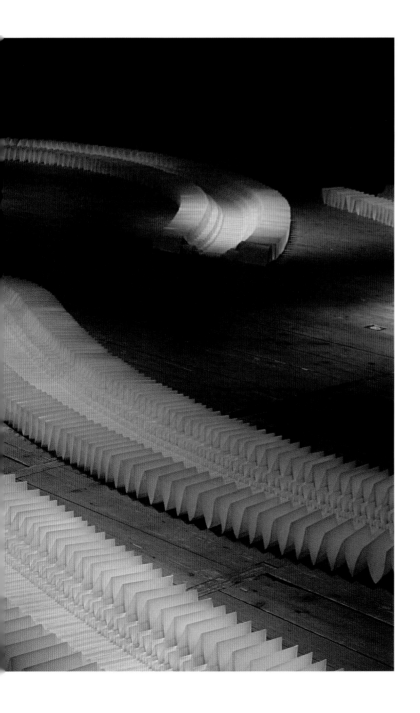

JAPANESE ROCK GARDEN
BY INFINITE FOLDING

⬯ Japan Alps Art Festival, Omachi,
Japan, 2017

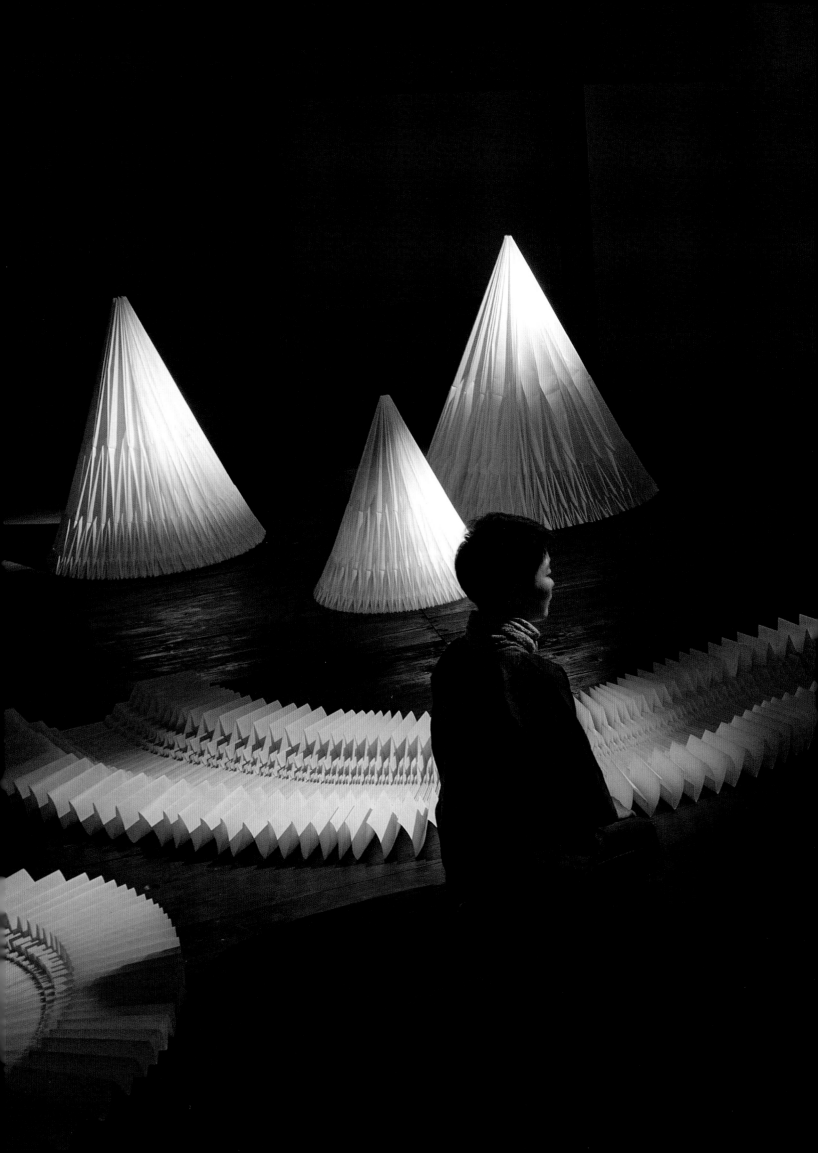

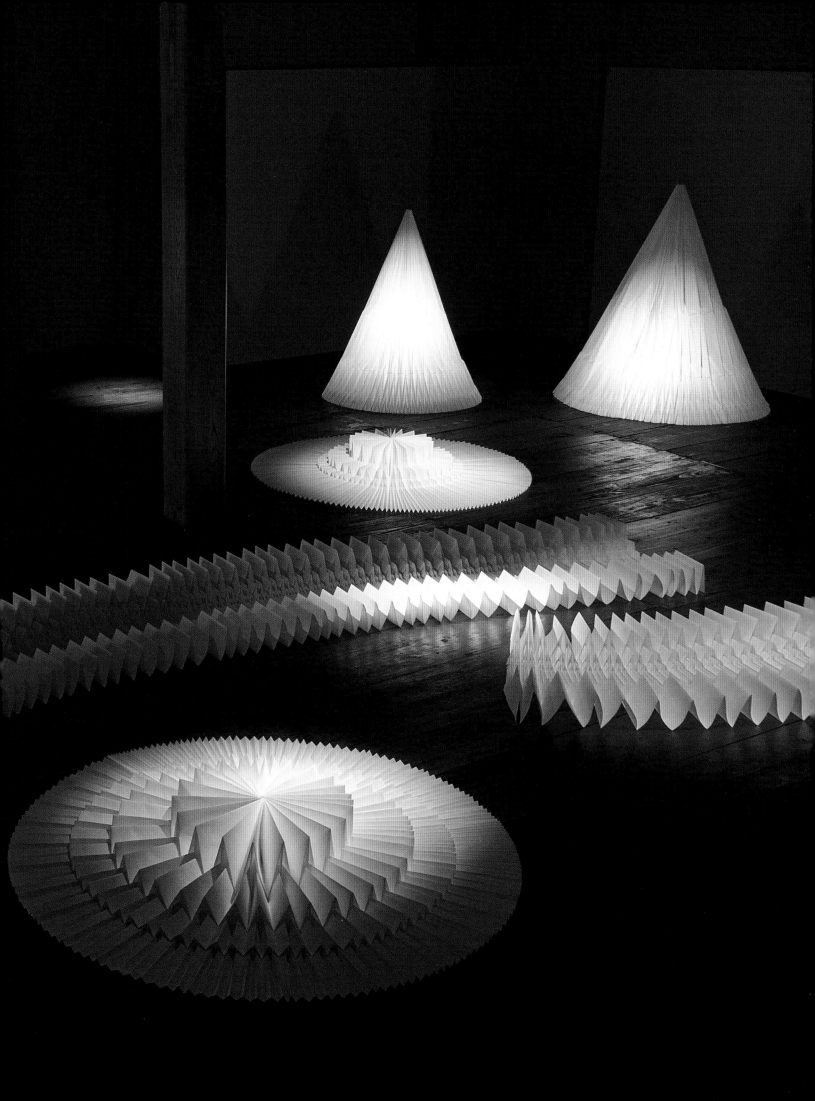

CHAPTER 4
REPETITIVE FOLDING

Here is a simple technique that can nonetheless lead to incredible shapes if used for sequential or consistent groups of folds.

In this chapter we have brought together creations of various kinds: tubular models and those made out of superimposed or multilayer folds (including infinite bisected folds)—models that, like textiles, are constructed from various types of intersecting horizontal and vertical folds and display the same pattern whether viewed from the front or back.

Tubular models, which can be lengthened or shortened, curled or rolled up, create the impression of living creatures.

Since infinite folding is likewise a form of repetitive folding, models made from infinite bisected folds not included in the previous chapter can be found here. **(TF)**

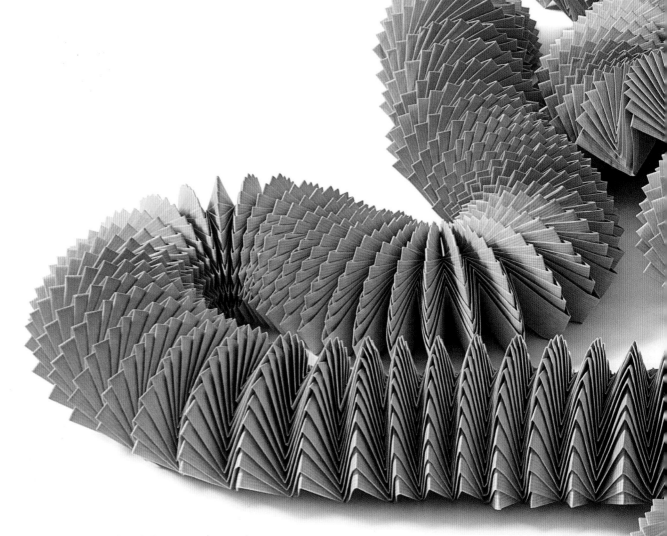

SNAKE 1
- Width x Height
 5.3 x 3.7 inches
 (135 x 95 mm)

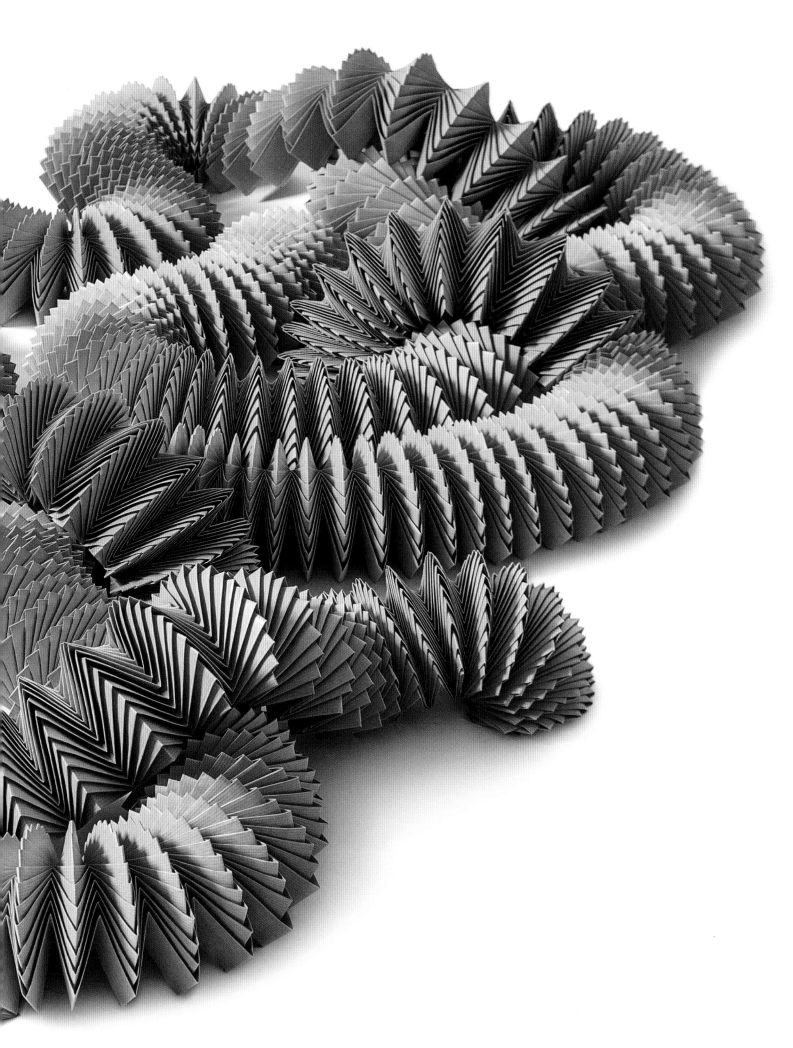

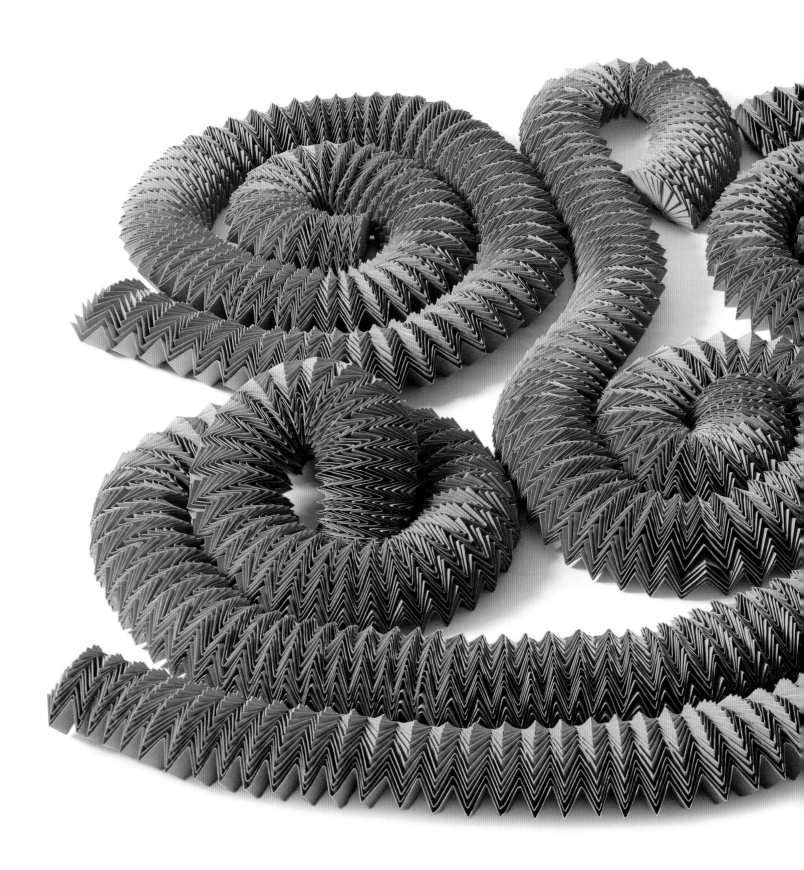

SNAKE 2

- Width x Height
 3.9 x 2.4 inches (100 x 60 mm)

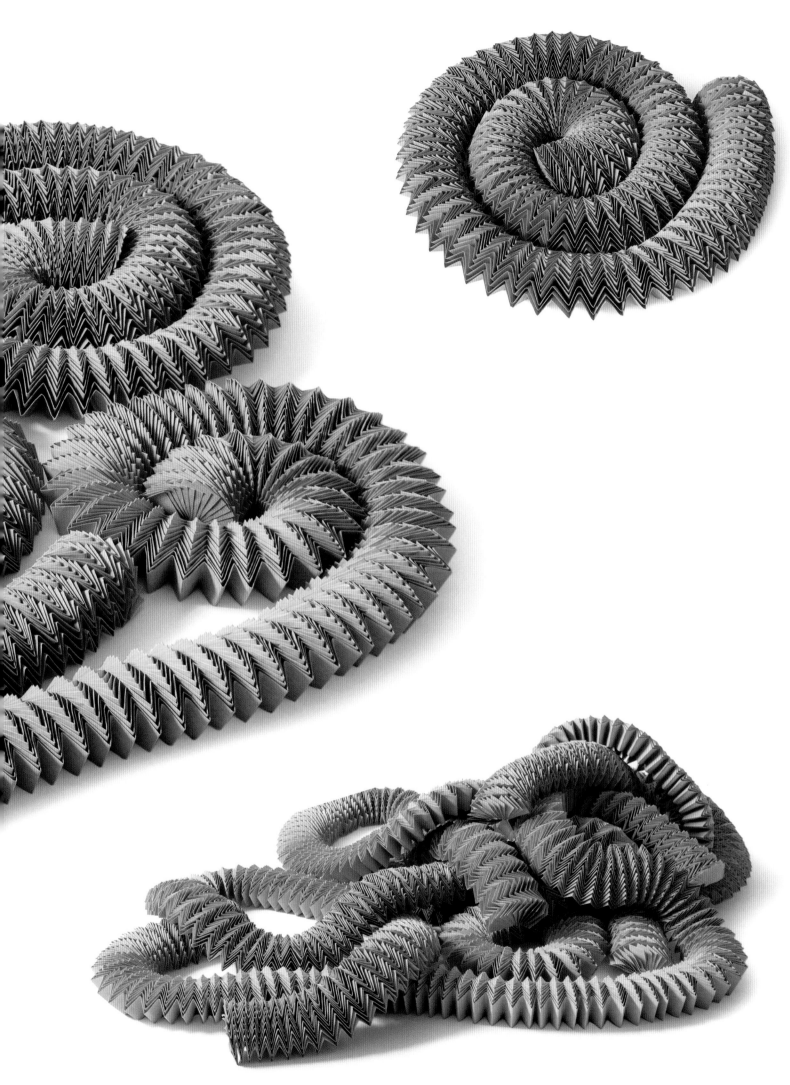

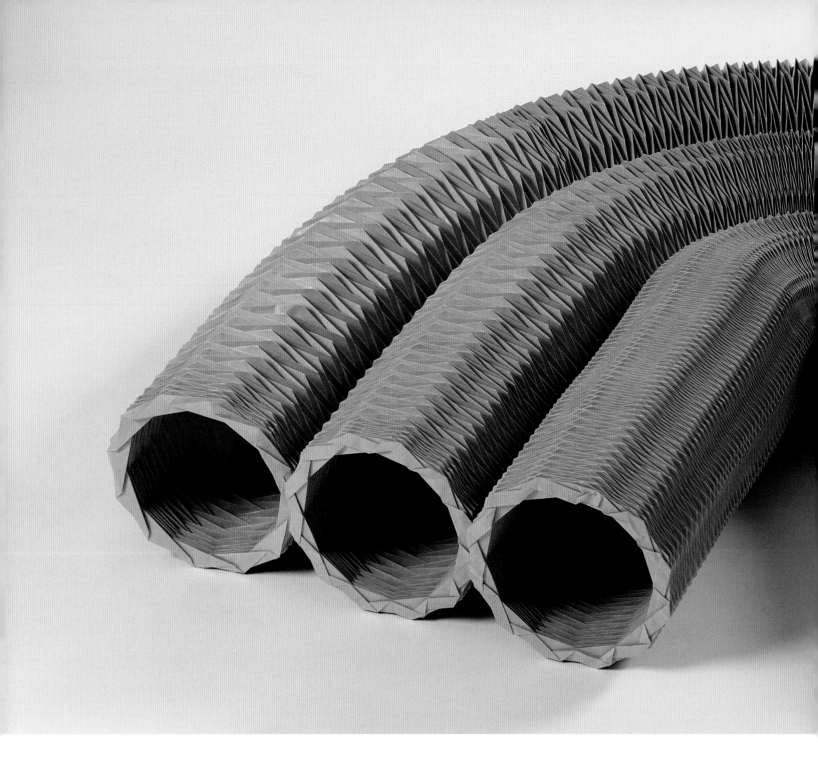

● The definition of "repetitive folding" may give rise to some misunderstanding. Tomoko Fuse's work actually has nothing to do with repetitiveness. Her natural inclination, in fact, is to explore all possible variants of every concept or technique. Her serpentine forms emerge from stretched folds or from corrugation. Some consist of semicircular sections, others are tubular. In effect, they evoke the contortions of reptiles, entangled cables, gigantic rigatoni.... Repetitive folding can also generate flat forms. Enormous sheets of paper, for example, can be shaped into foamy waves to create a churning seascape. Whenever Tomoko Fuse creates a warp out of strips, what emerges are tapestries of variegated texture, with patterns of light and shadow. In some of her other works, polygonal scales are arranged in a decorative curve, the outline of a ram's head, rotating spheres.A basic origami maneuver is the so-called "mountain fold," a figurative term for a convex fold that creates a sort of ridge on a sheet's surface. I recall my first visit—about 25 years ago—to Fuse's beautiful home in the woods near Omachi in the prefecture of Nagano, in the Japanese Alps. By this point, I already knew a Japanese expression that perfectly captured these types of places: *yama mata yama* (mountains and even more mountains). No expression could serve as a more appropriate title for one of these works as it describes not only the shape of many of Fuse's creations but also the beautiful place that surrounds her and that exerts a strong and steady impact on her origami. **(DB)**

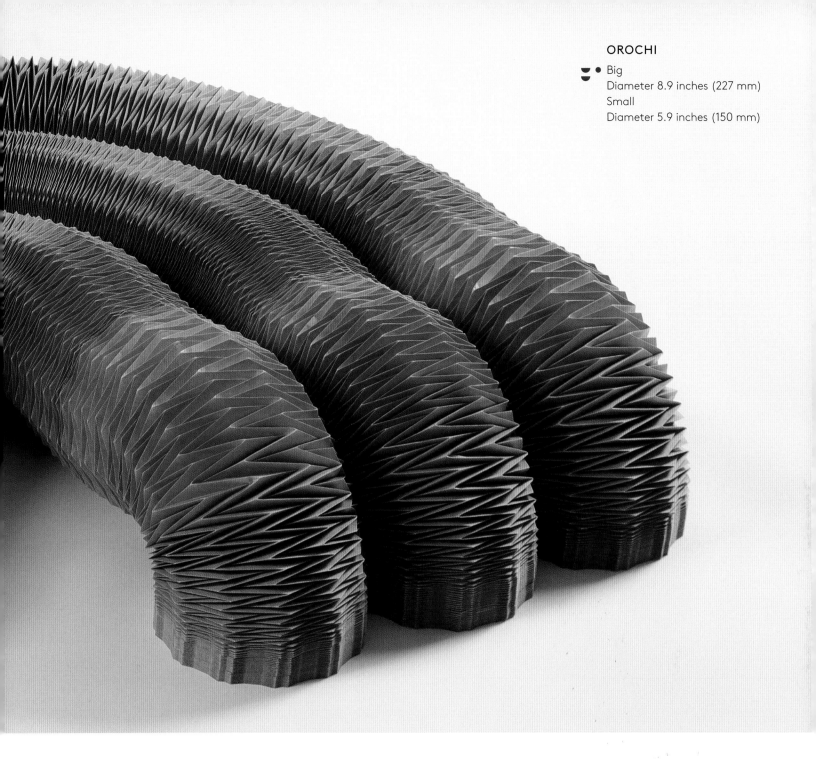

OROCHI

◡◡ ● Big
Diameter 8.9 inches (227 mm)
Small
Diameter 5.9 inches (150 mm)

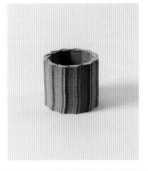
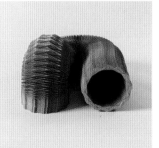
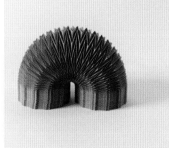
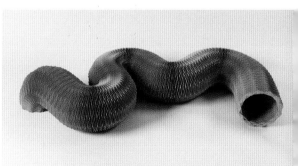
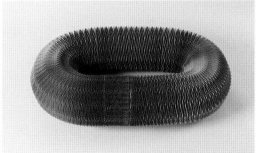
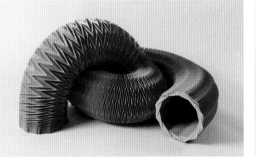
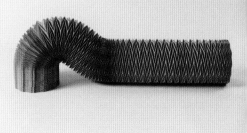

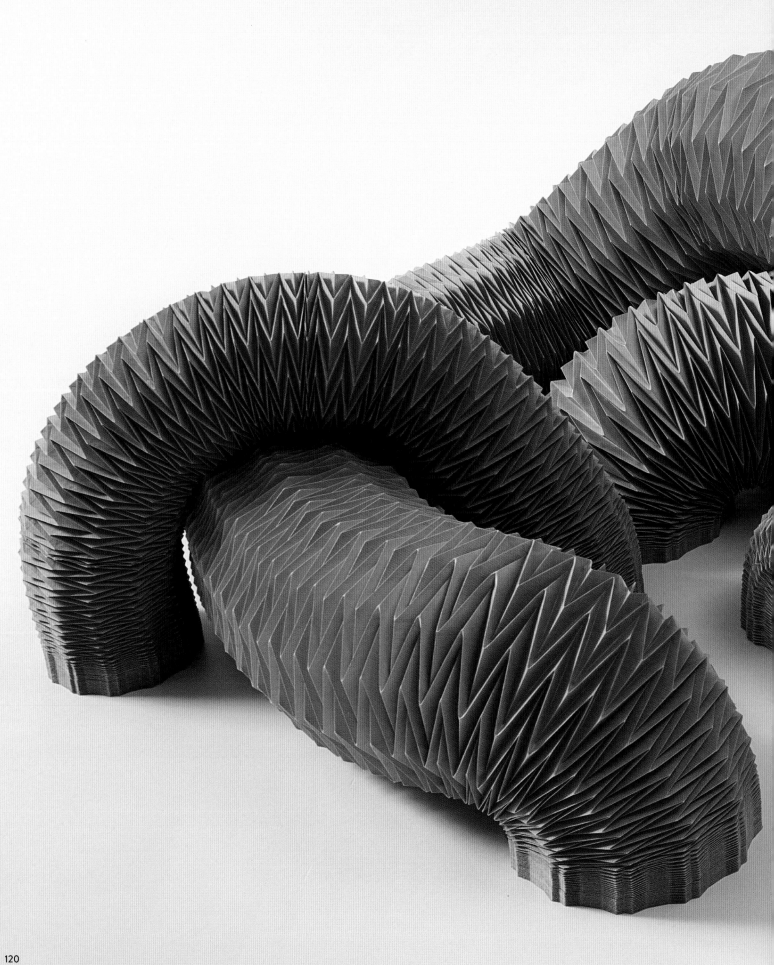

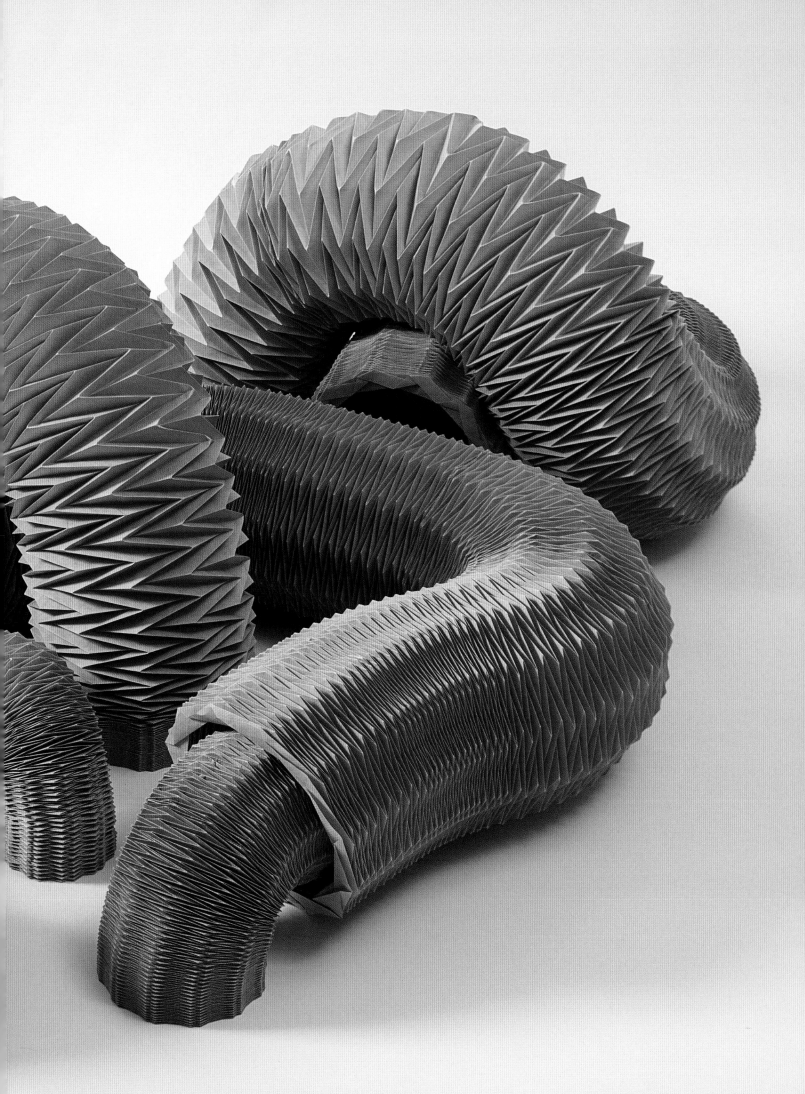

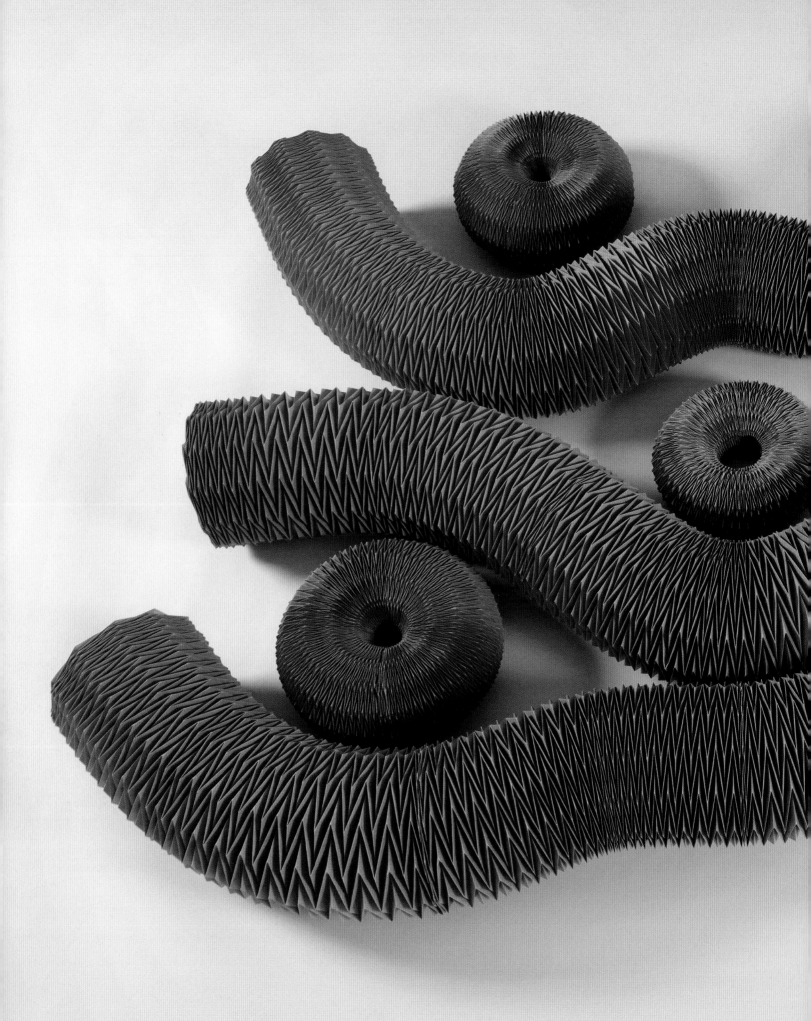

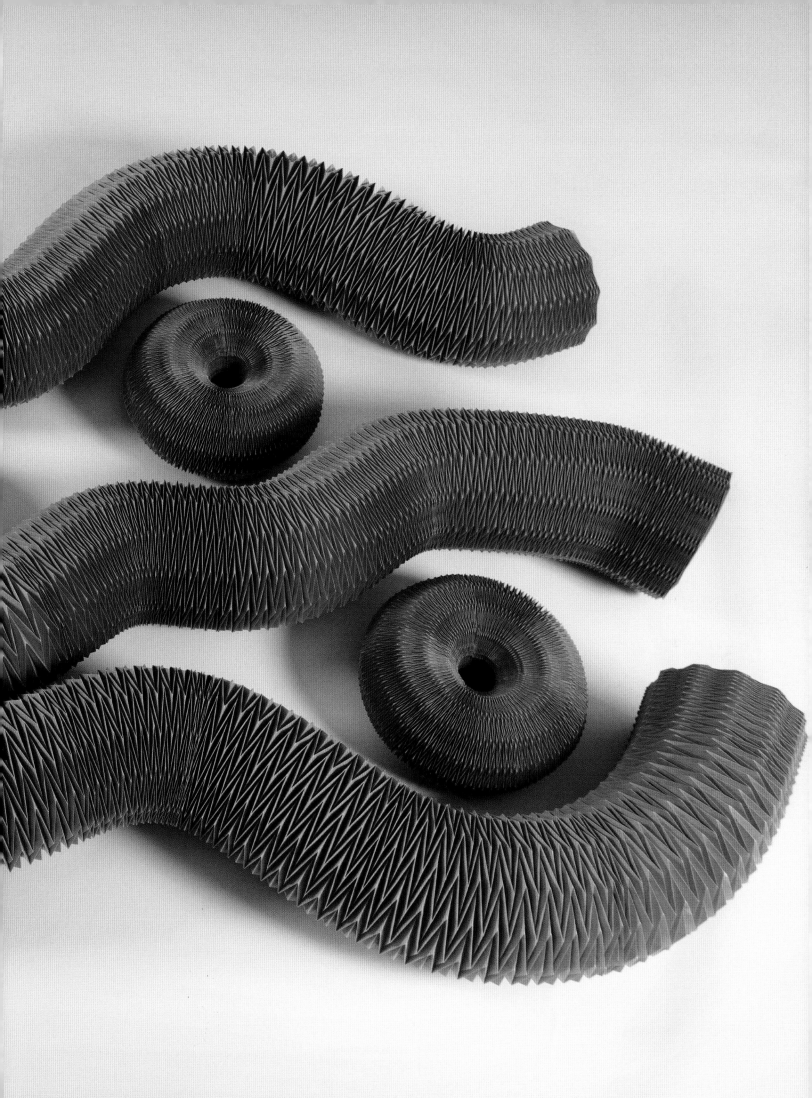

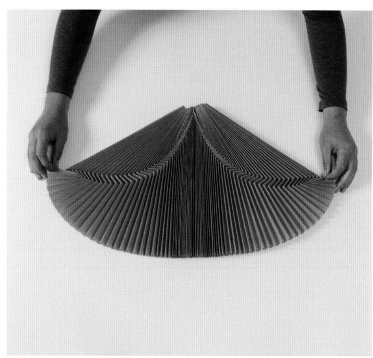
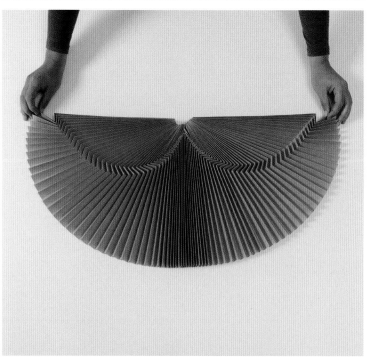
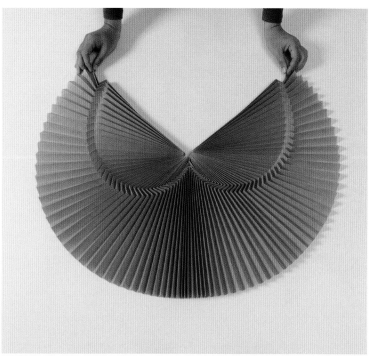
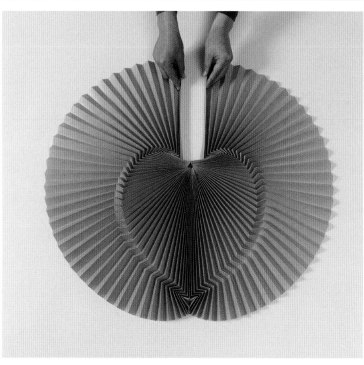
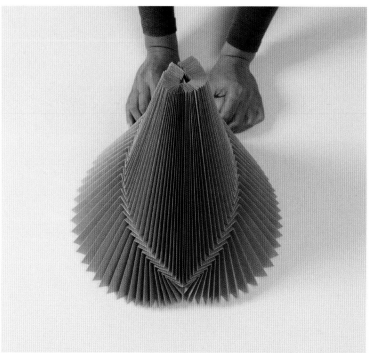

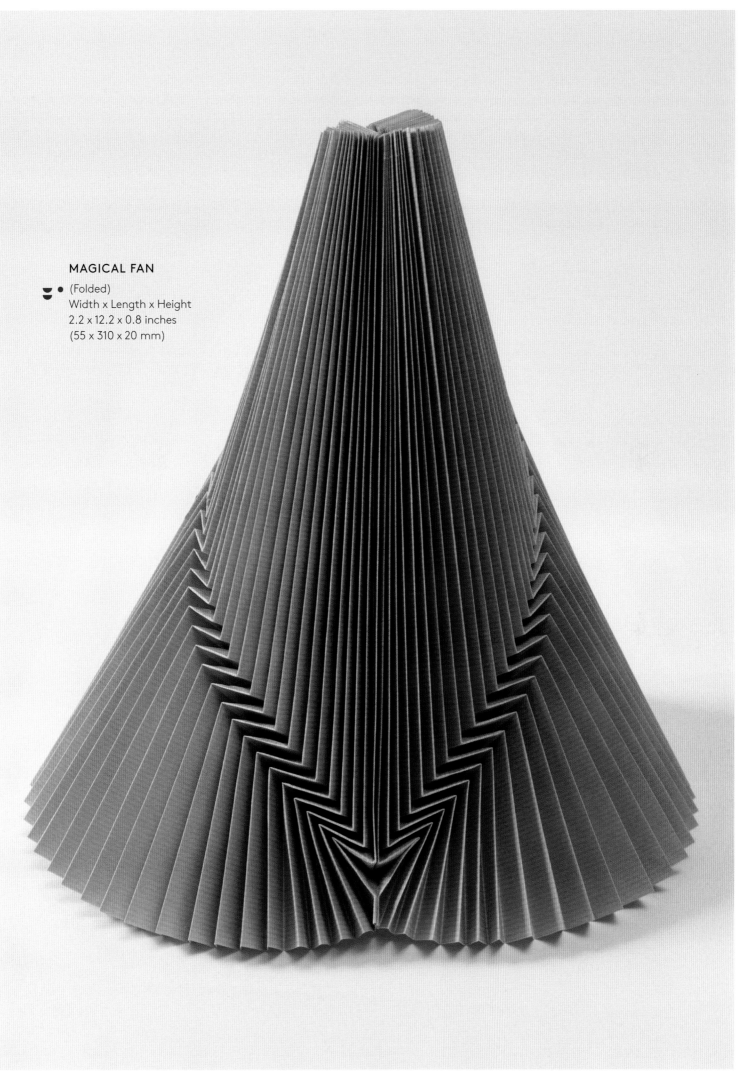

MAGICAL FAN

(Folded)
Width x Length x Height
2.2 x 12.2 x 0.8 inches
(55 x 310 x 20 mm)

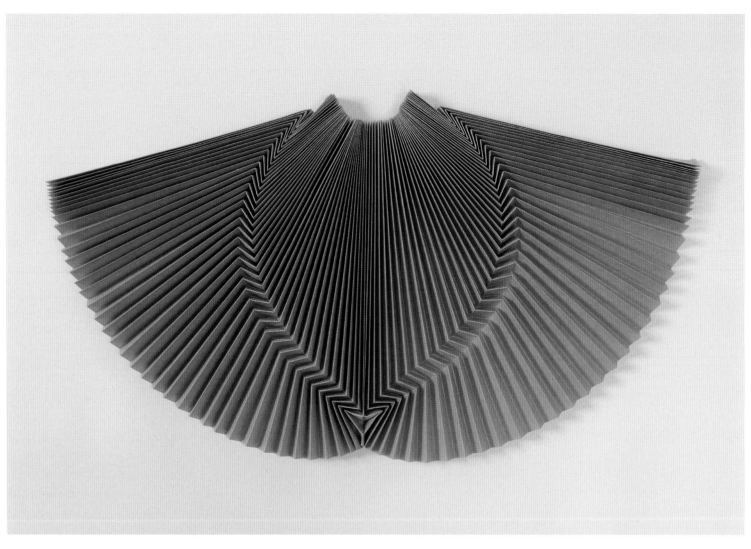

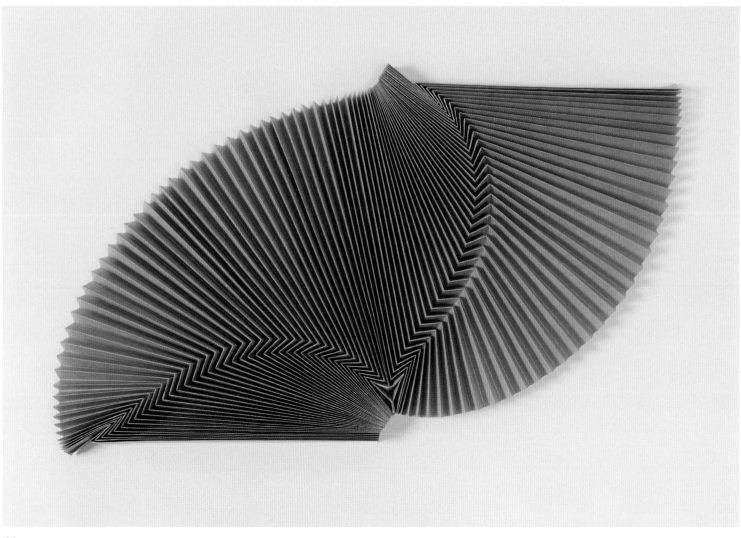

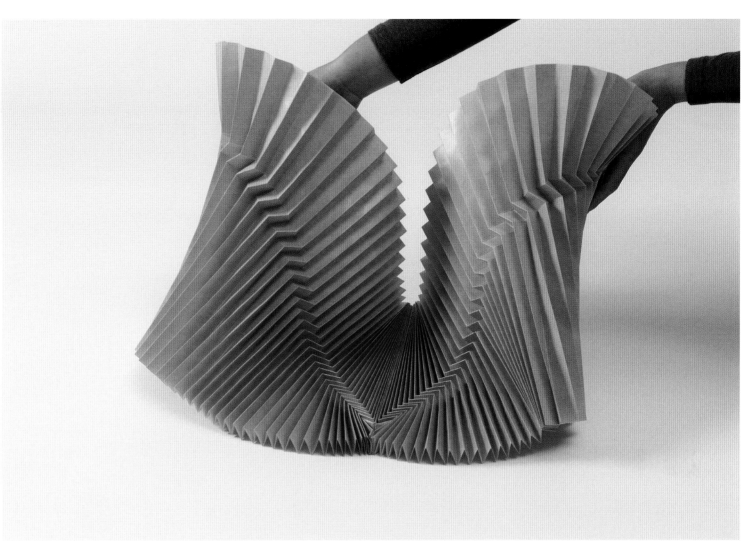

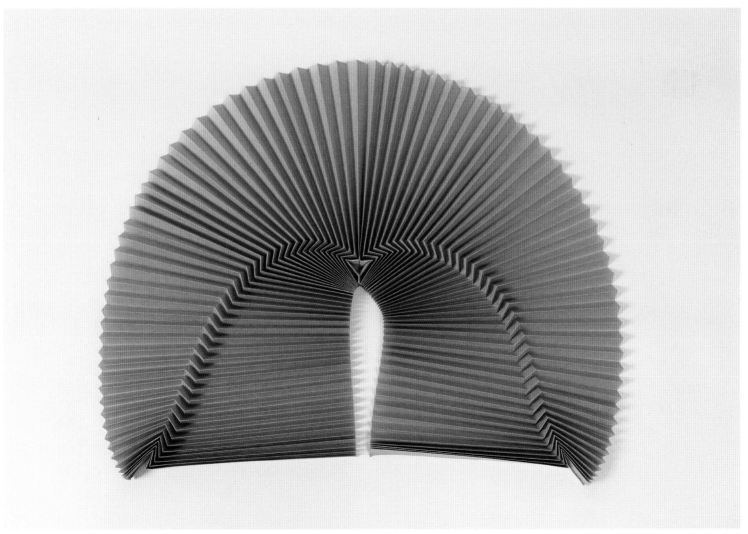

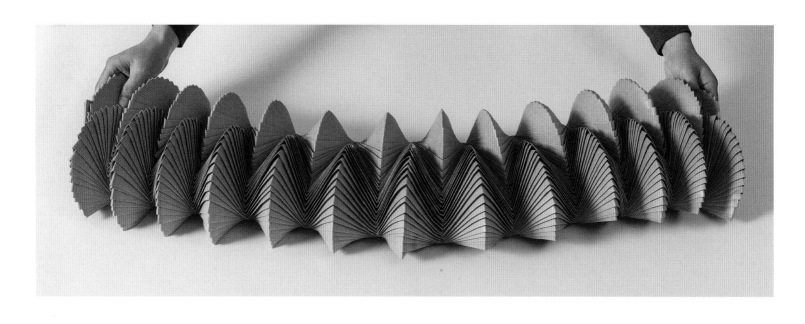

DOUBLE FAN
Width x Height
10.2 x 5.1 inches (260 x 130 mm)

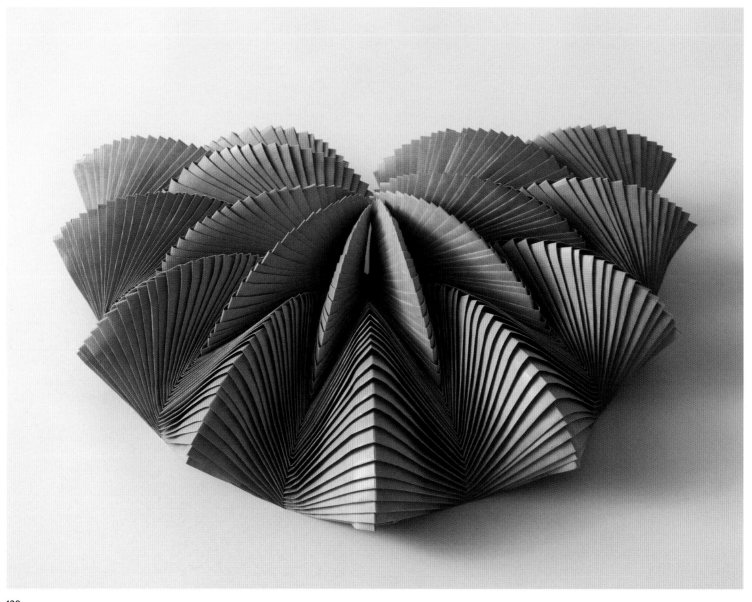

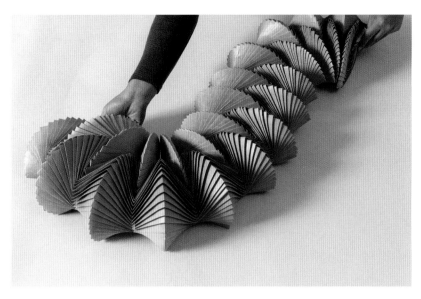
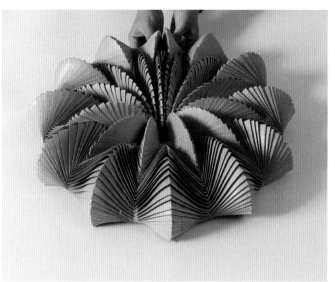

CAN STRETCH, SHRINK, LOOP, CHANGE SHAPE....

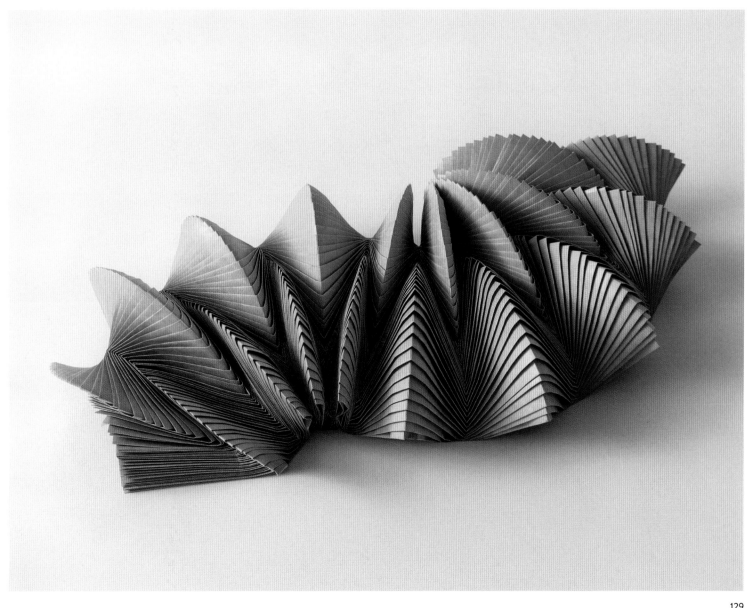

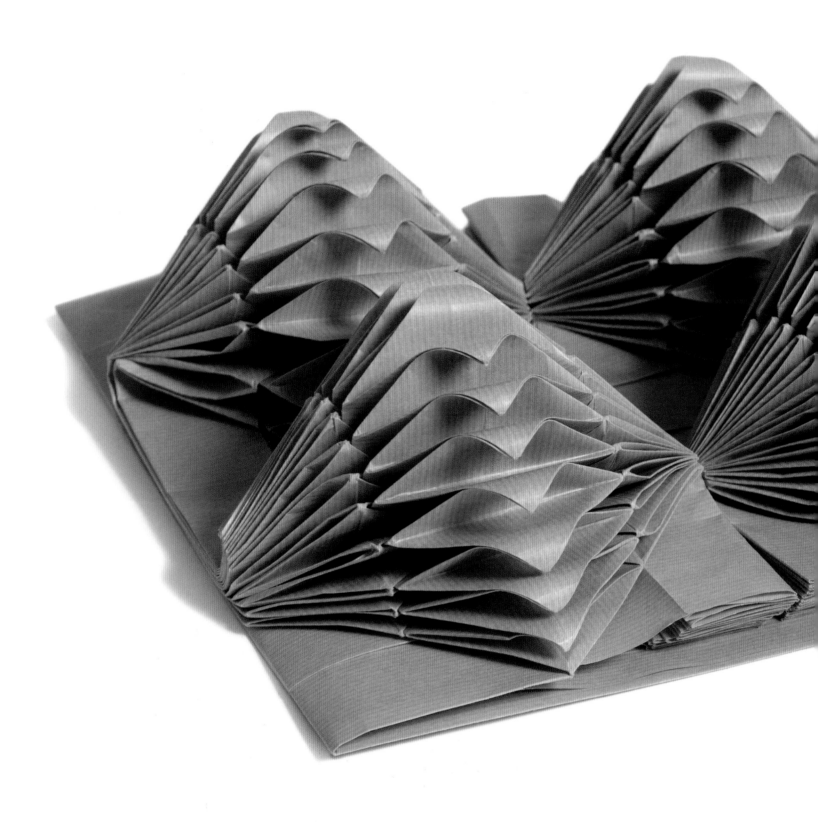

MULTIPLE FOLDING
SIX WAVES

- Width x Length x Height
 11.6 x 17.1 x 3.3 inches
 (295 x 435 x 85 mm)

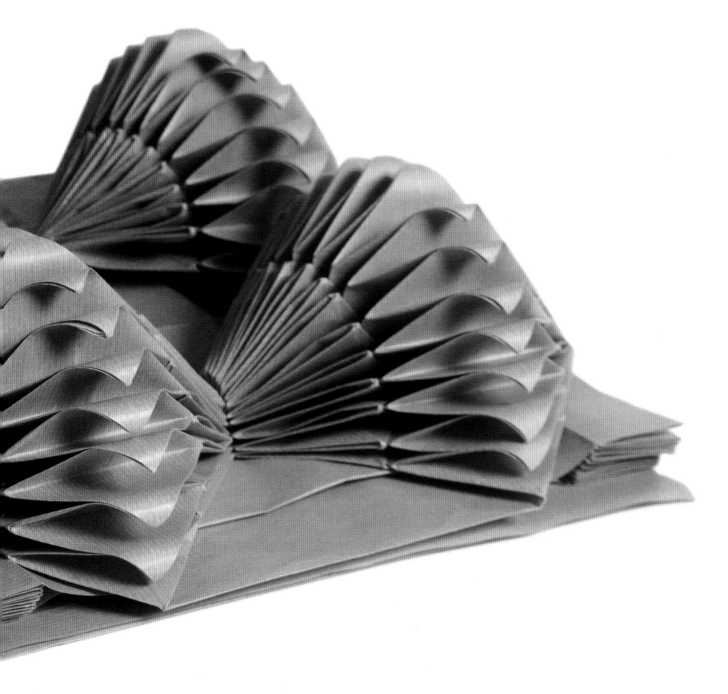

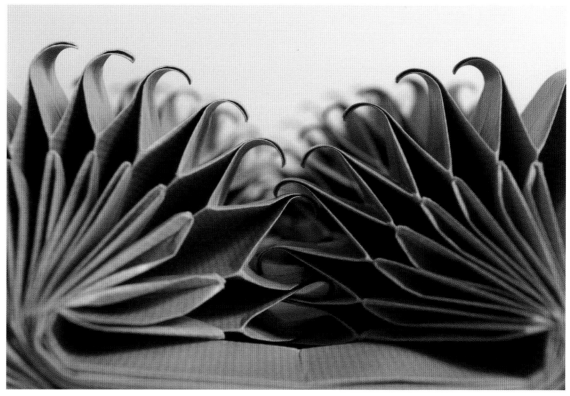

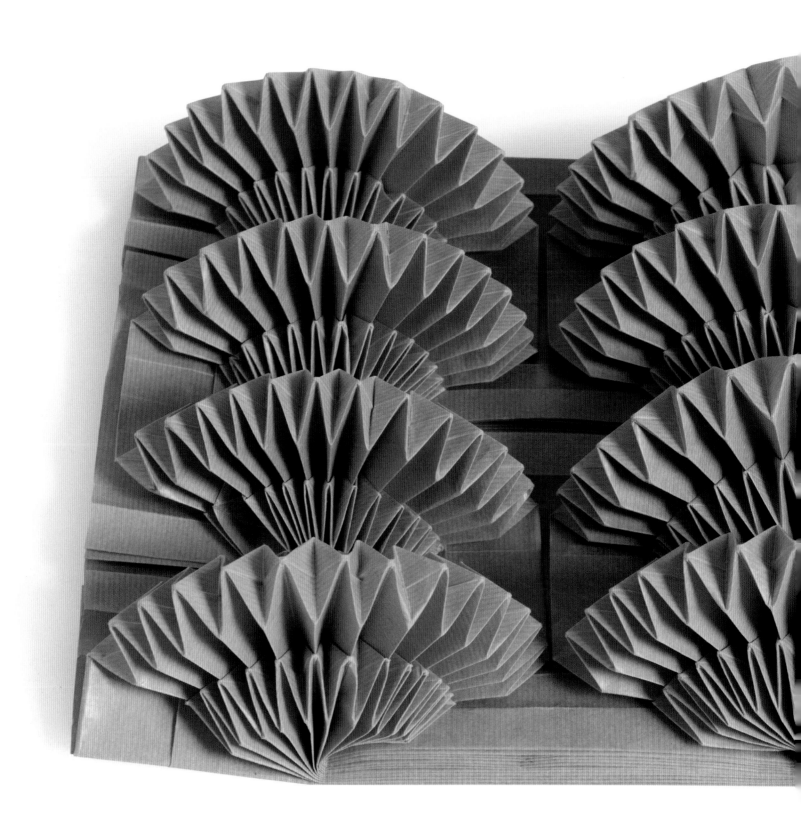

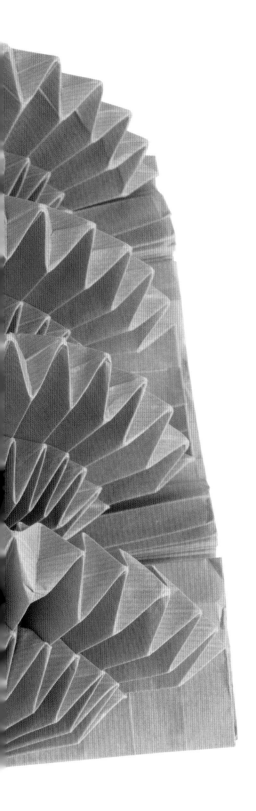

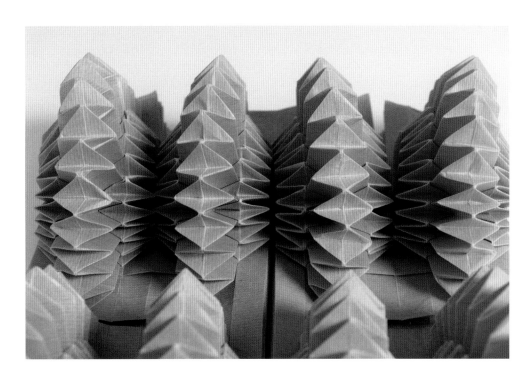

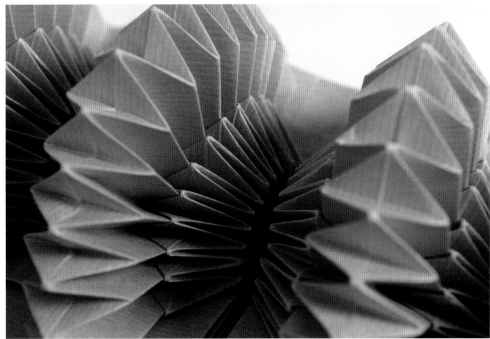

MULTIPLE FOLDING
BUBBLES

- Width x Length x Height
 14.6 x 11.2 x 3.9 inches
 (370 x 285 x 100 mm)

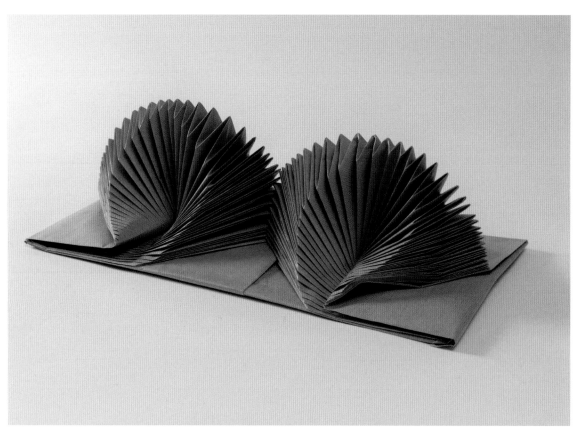

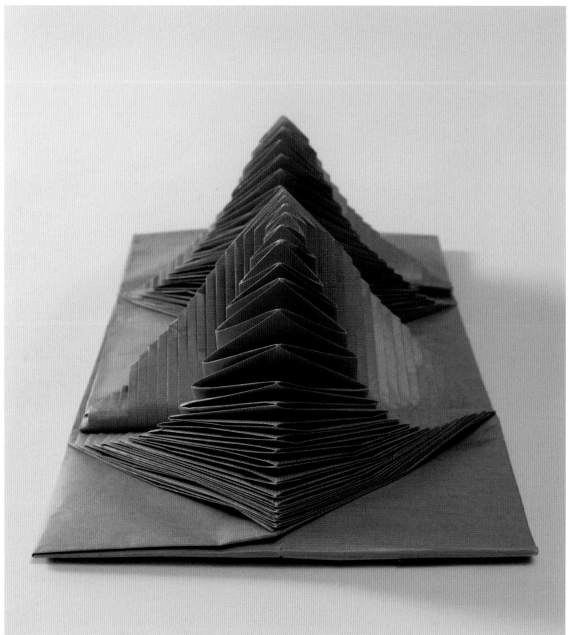

TWIN FAN
SIDE BY SIDE

◀ Width x Length x Height
22.2 x 11.6 x 7.1 inches
(565 x 295 x 180 mm)

TRIPLE FAN
VERTICAL ROW

▶ Width x Length x Height
11.8 x 33.7 x 8.3 inches
(300 x 855 x 210 mm)

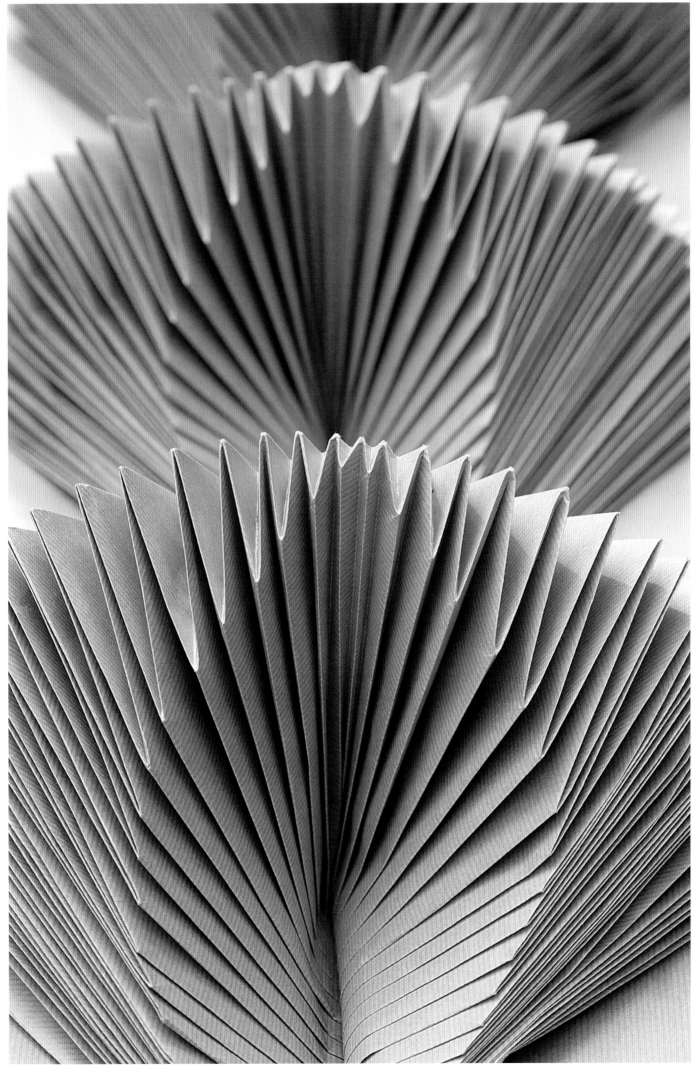

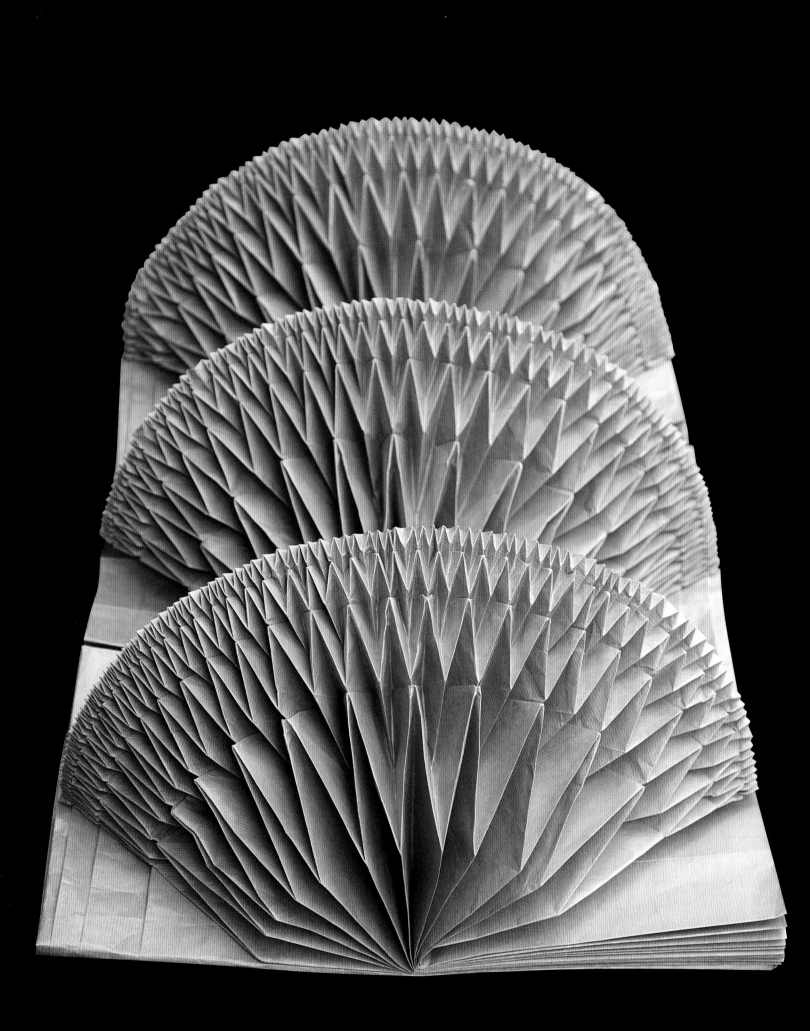

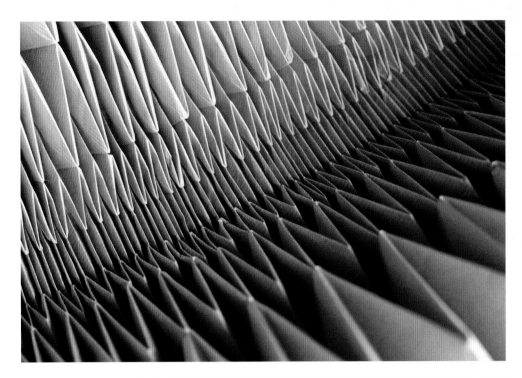

ARROWHEAD INFINITE FANS

- Width x Length x Height
 18.5 x 31.9 x 9.4 inches
 (470 x 810 x 240 mm)

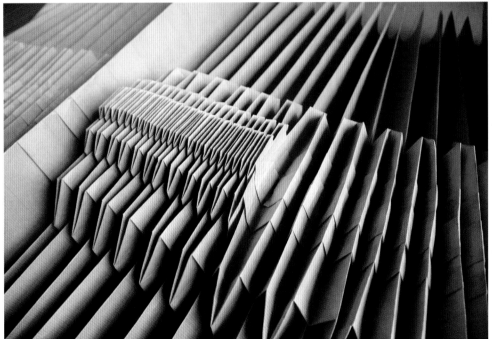

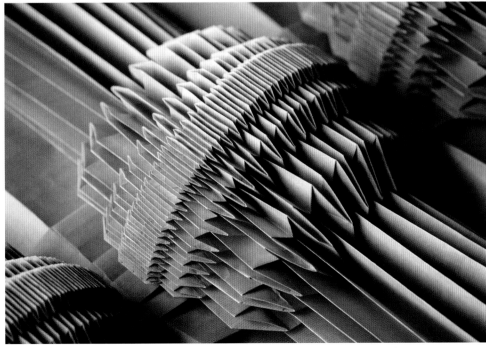

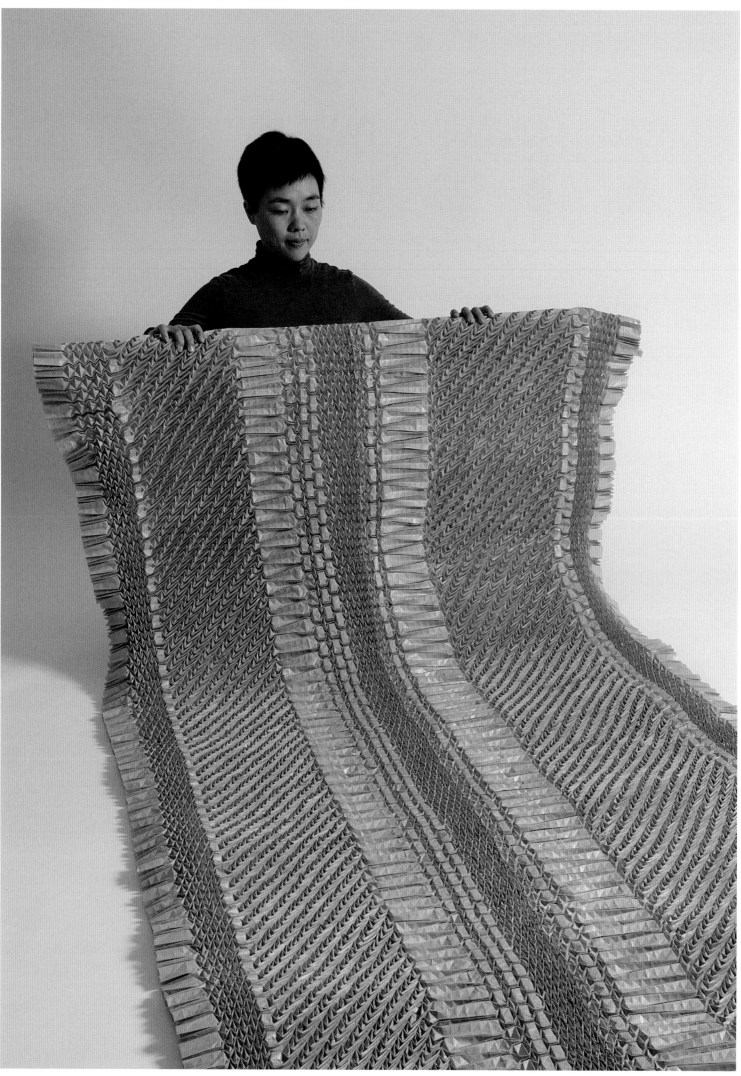

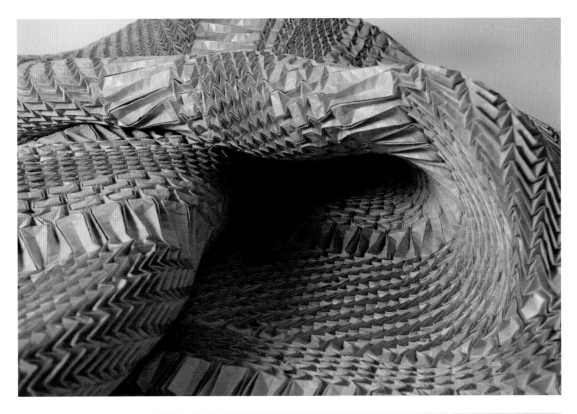

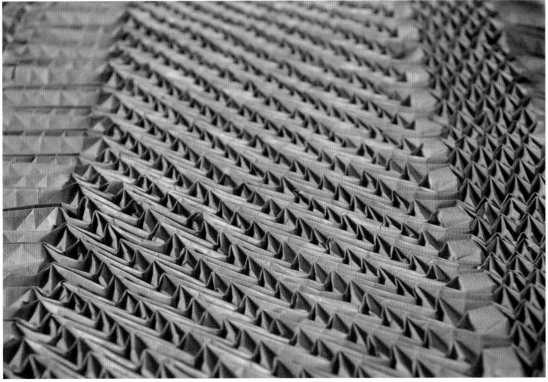

CHIDORI PATTERN—WAVELIKE
Width x Length
48 x 94.5 inches (1220 x 2400 mm)

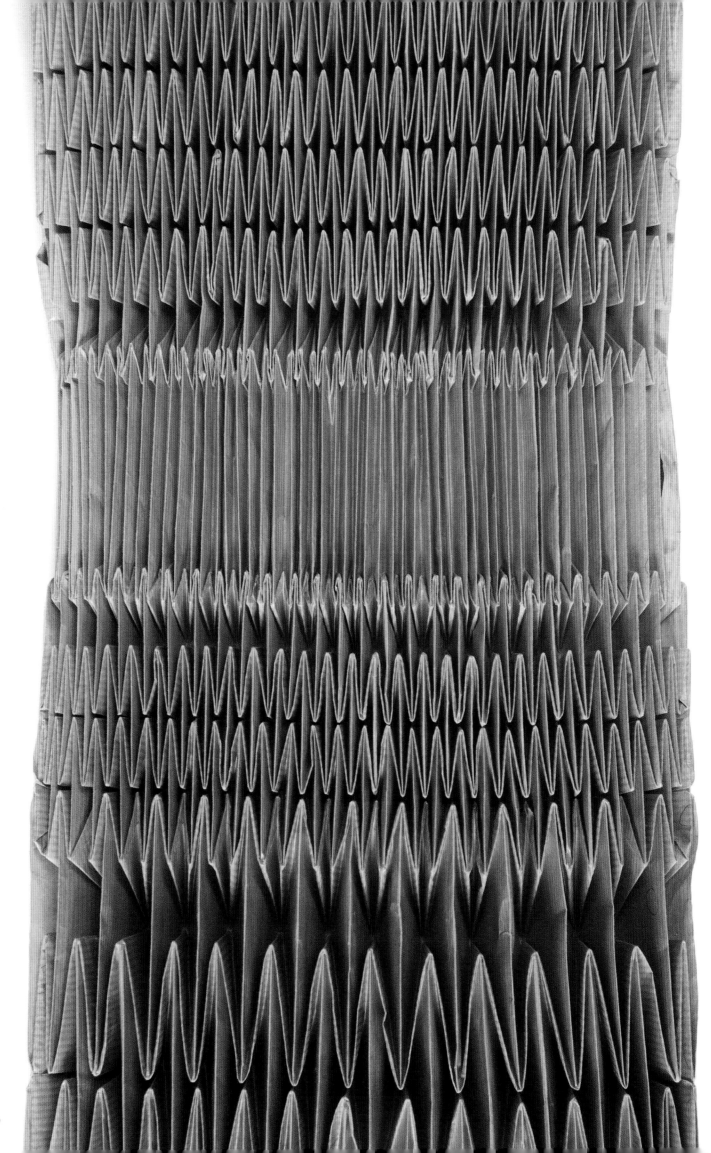

MOUNTAIN
AFTER MOUNTAIN

● Width x Length x Height
34.3 x 9.8 x 3.1 inches
(870 x 250 x 80 mm)

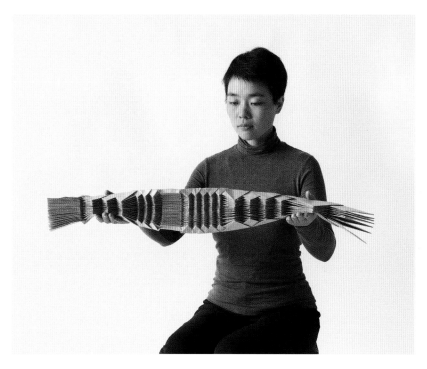

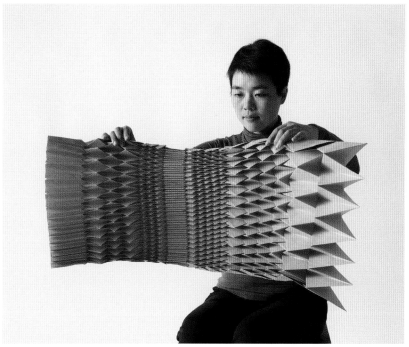

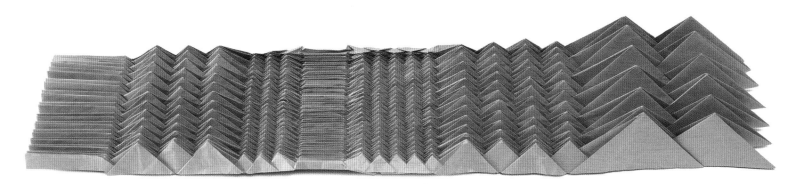

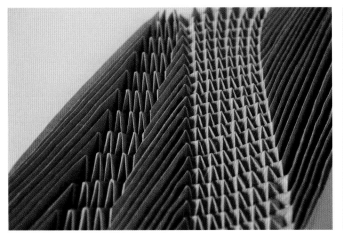 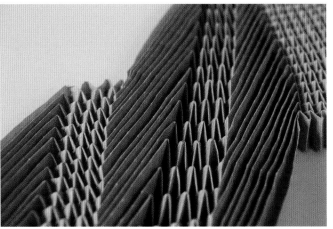

BEAM OF LIGHT

Width x Length x Height
23.6 x 6.7 x 0.8 inches
(600 x 170 x 20 mm)

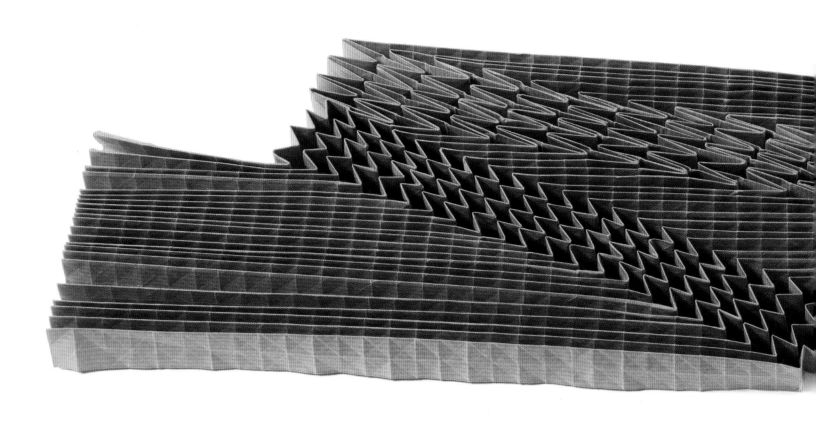

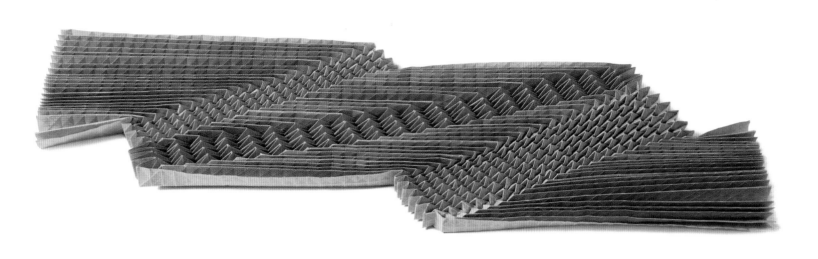

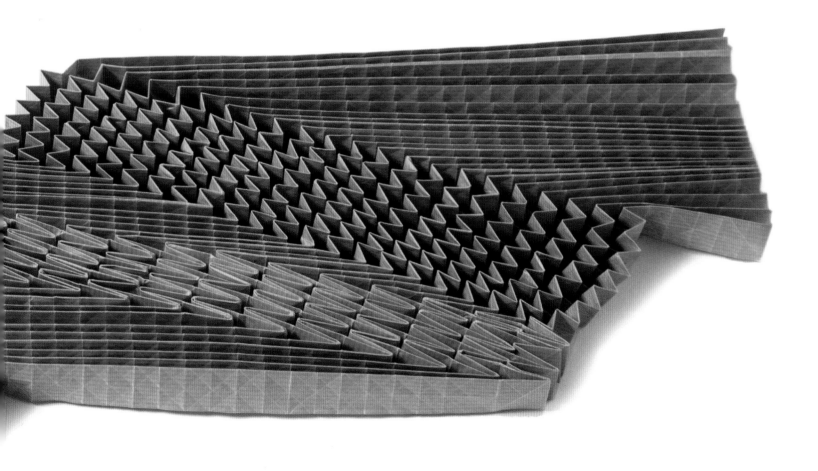

MULTIPLE FOLDING
TAPESTRY

⬱ Width x Length
25 x 14.2 inches
(635 x 360 mm)

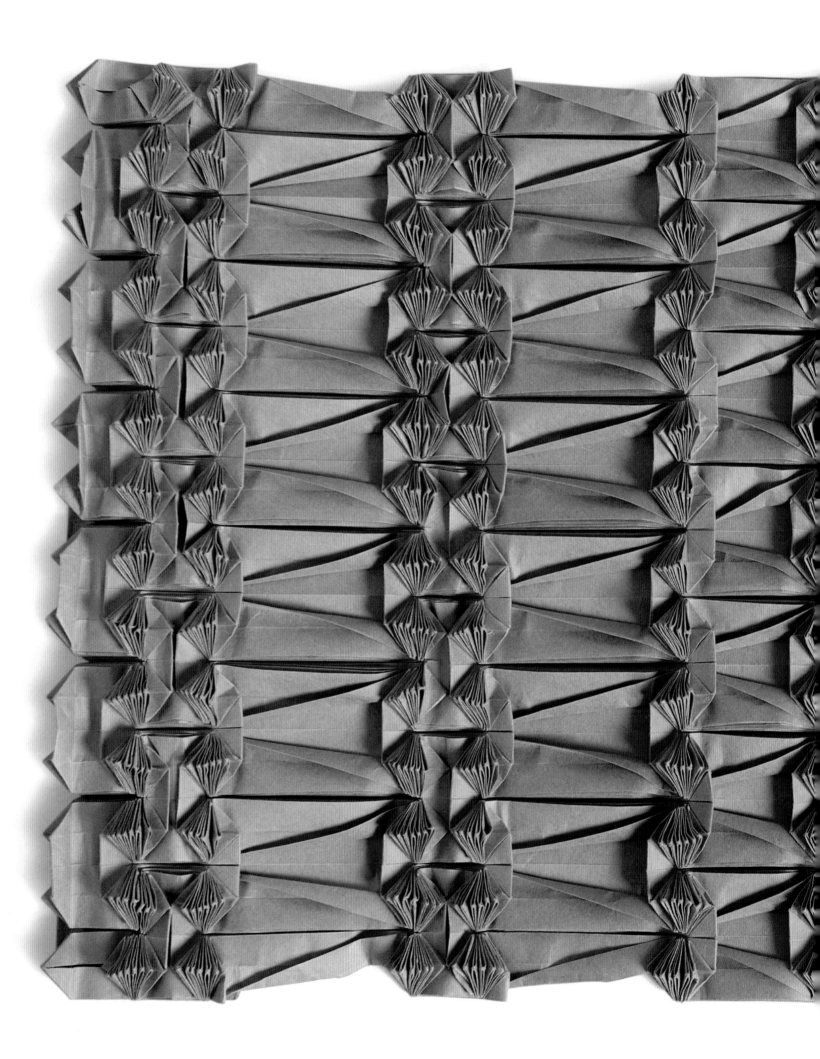

144

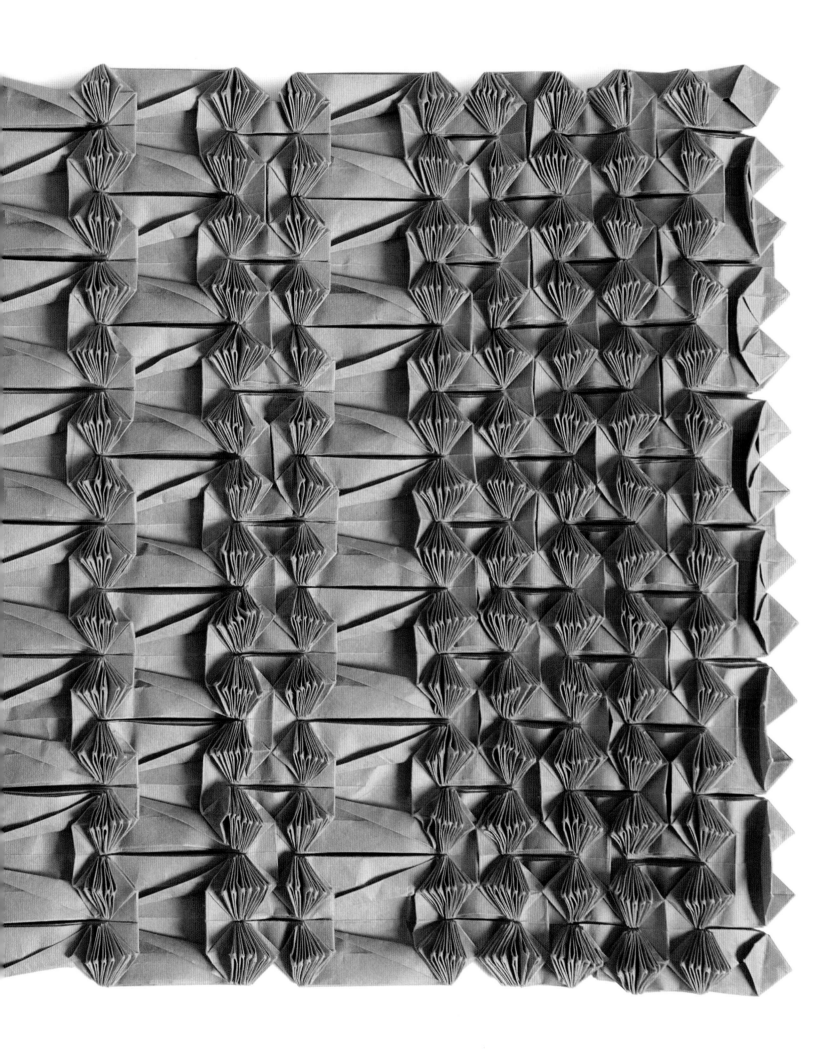

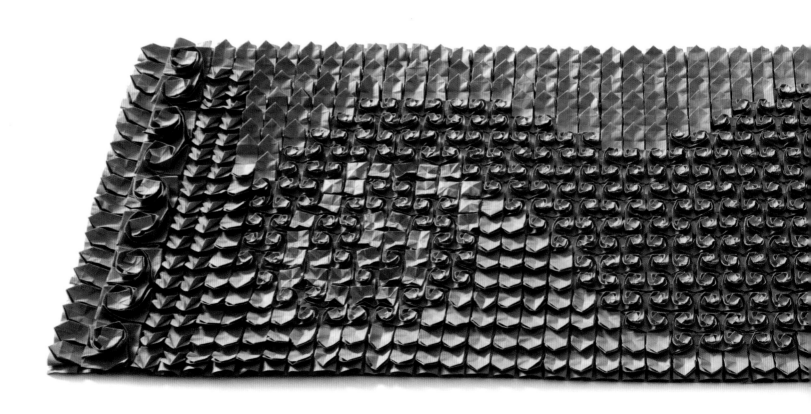

MULTIPLE FOLDING WOVEN

Width x Length
38.2 x 13.4 inches
(970 x 340 mm)

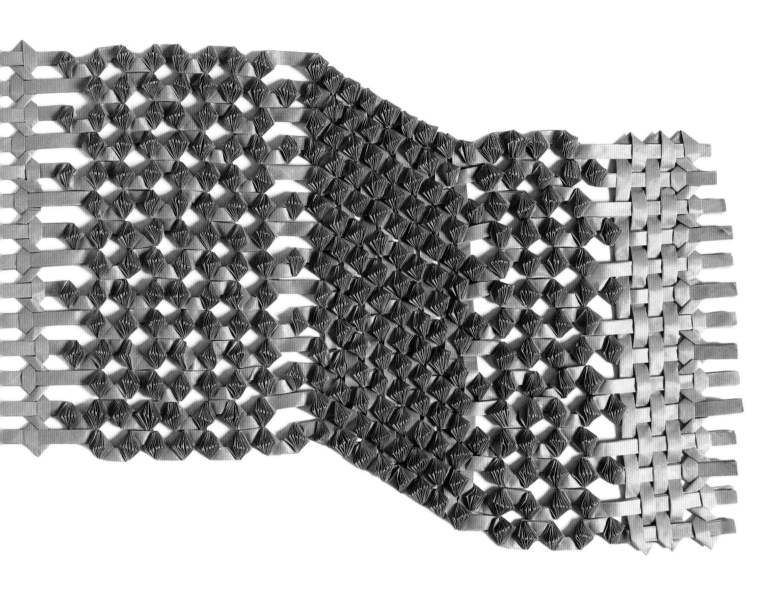

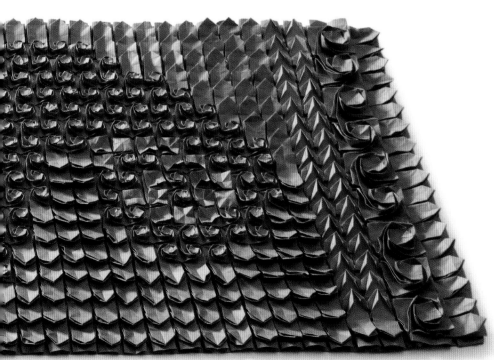

SCALES

☛ Width x Length
40.2 x 18.1 inches
(1022 x 460 mm)

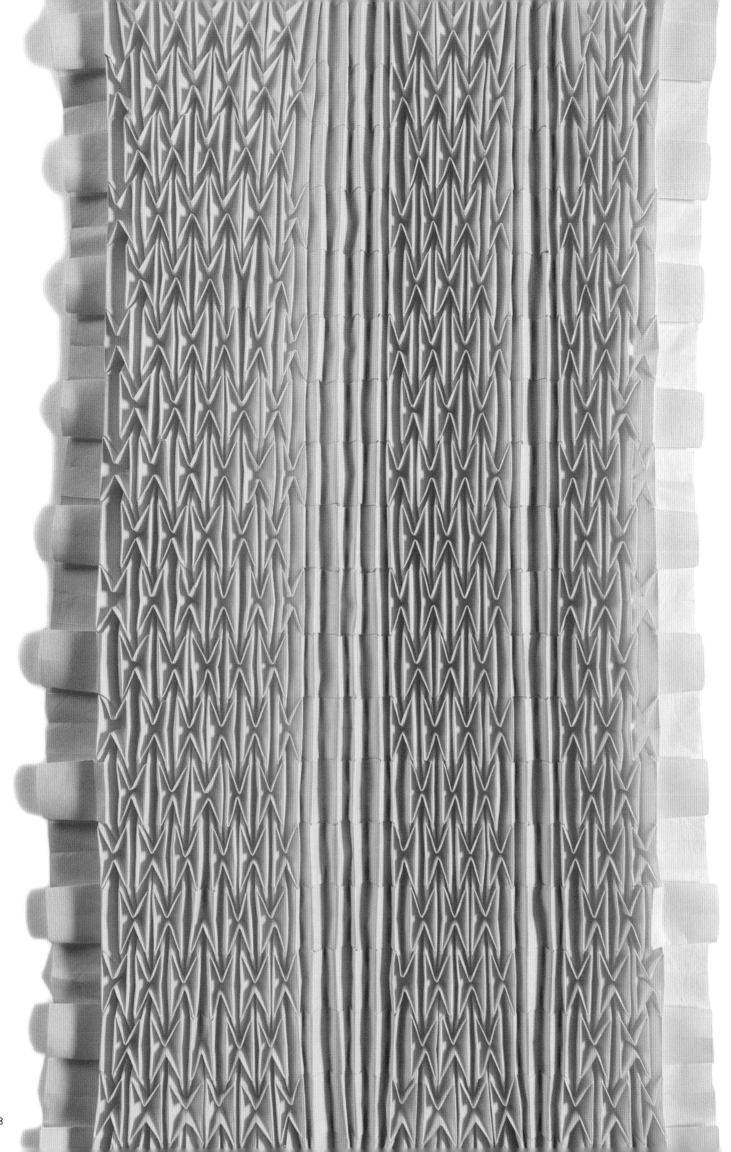

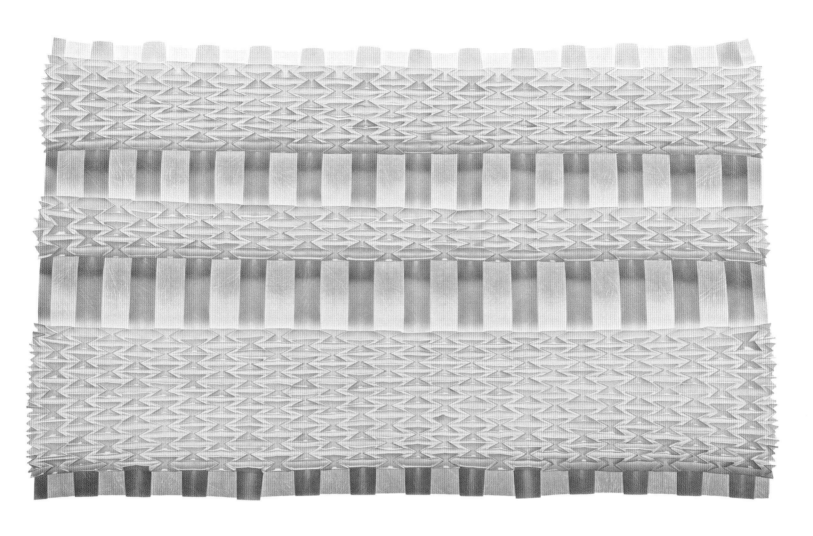

BRAIN 2

Width x Length x Height
22.4 x 12.4 x 0.4 inches
(570 x 315 x 10 mm)

BRAIN 1

◀ Width x Length x Height
8.7 x 15.4 x 0.4 inches
(220 x 390 x 10 mm)

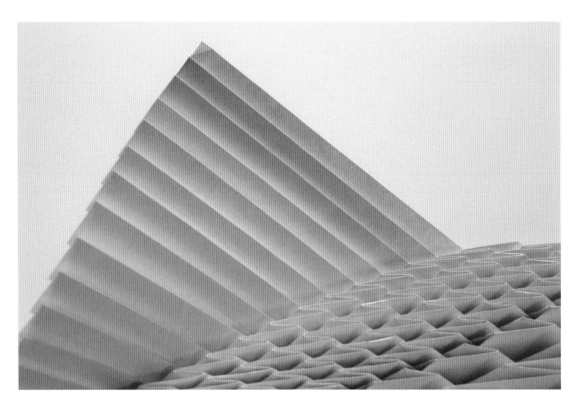

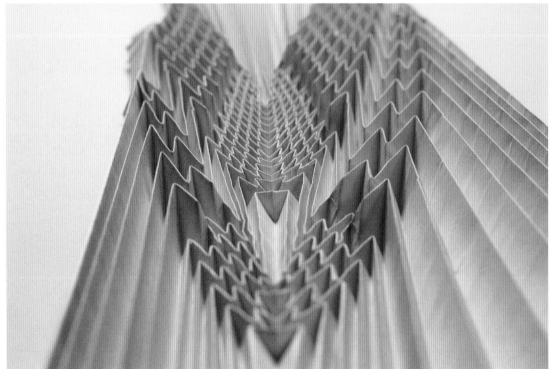

PINK WAVE

△ Width x Length x Height
6.3 x 12.4 x 4.7 inches
(160 x 315 x 120 mm)

SALMON

▽ Width x Length x Height
6.7 x 29.1 x 0.8 inches
(170 x 740 x 20 mm)

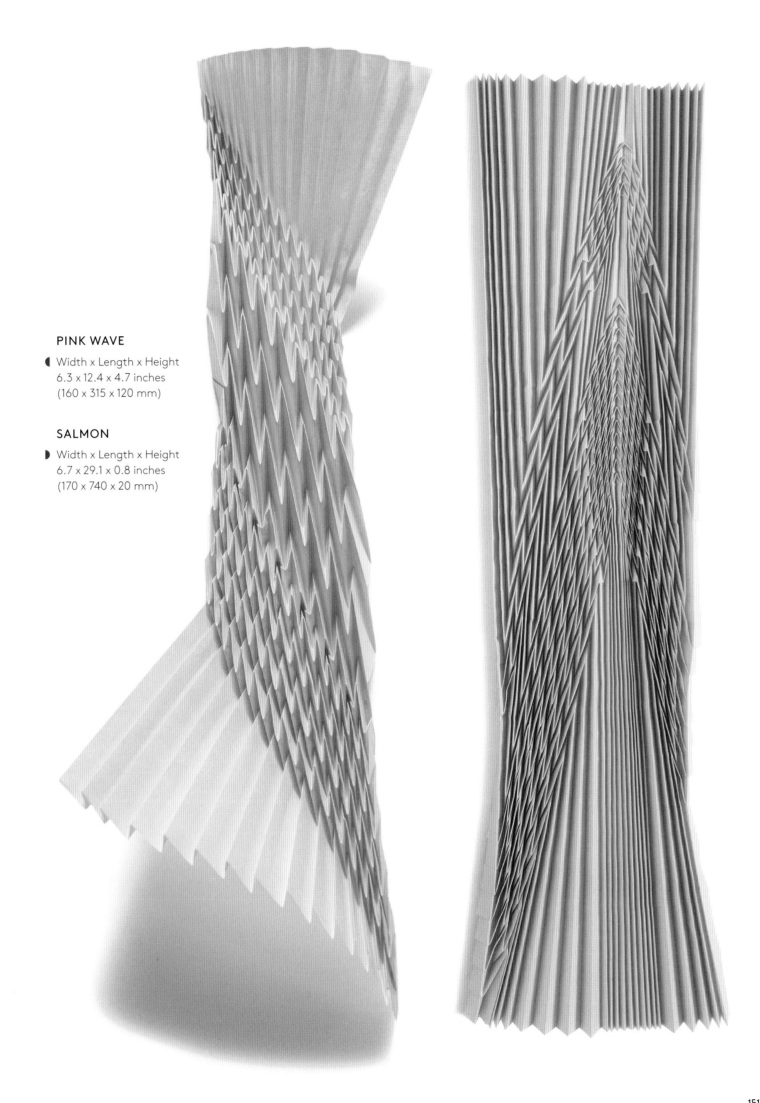

PINK WAVE

◖ Width x Length x Height
6.3 x 12.4 x 4.7 inches
(160 x 315 x 120 mm)

SALMON

◗ Width x Length x Height
6.7 x 29.1 x 0.8 inches
(170 x 740 x 20 mm)

TRIANGULAR WAVE

◒ Width x Length x Height
21.1 x 5.9 x 1.5 inches
(535 x 150 x 38 mm)

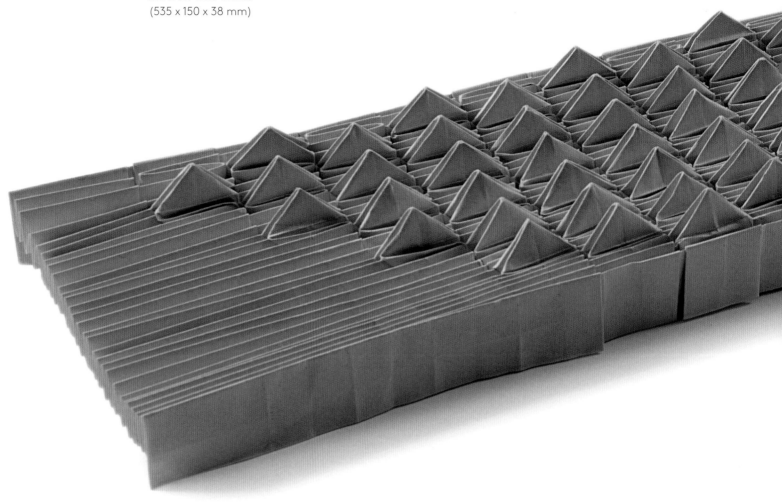

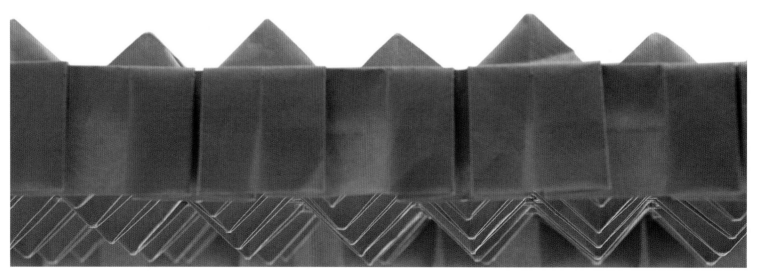

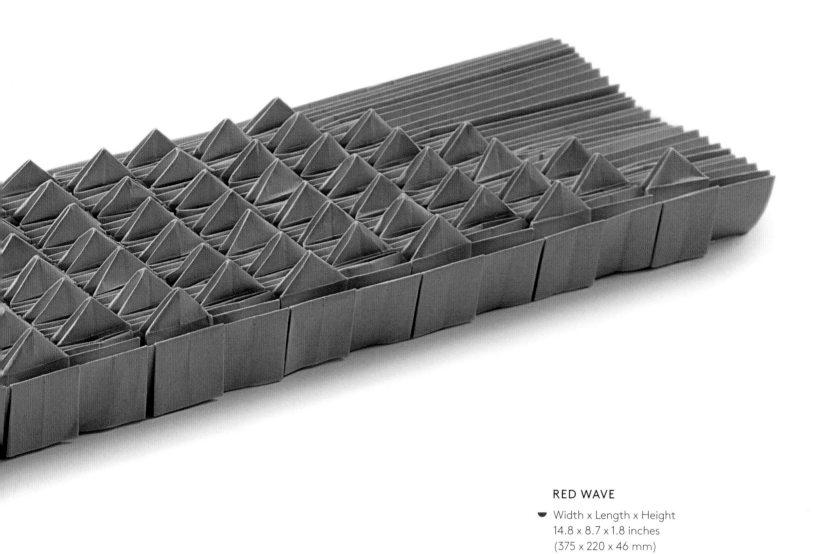

RED WAVE

⬤ Width x Length x Height
14.8 x 8.7 x 1.8 inches
(375 x 220 x 46 mm)

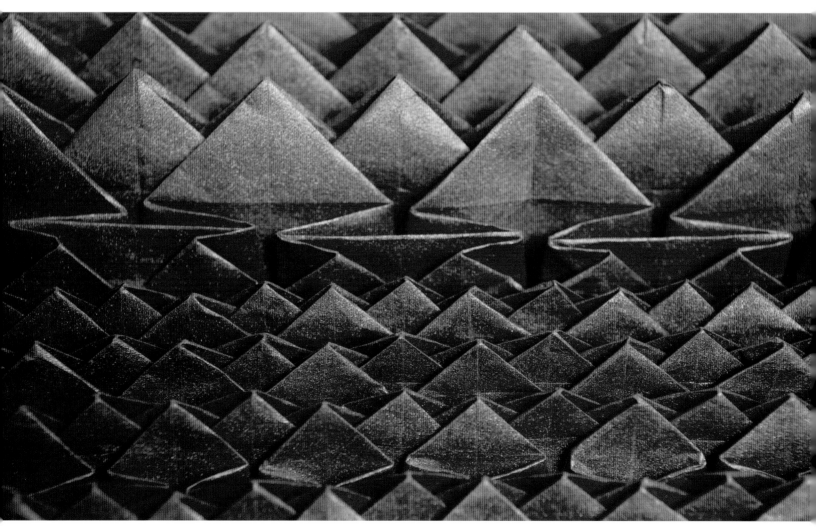

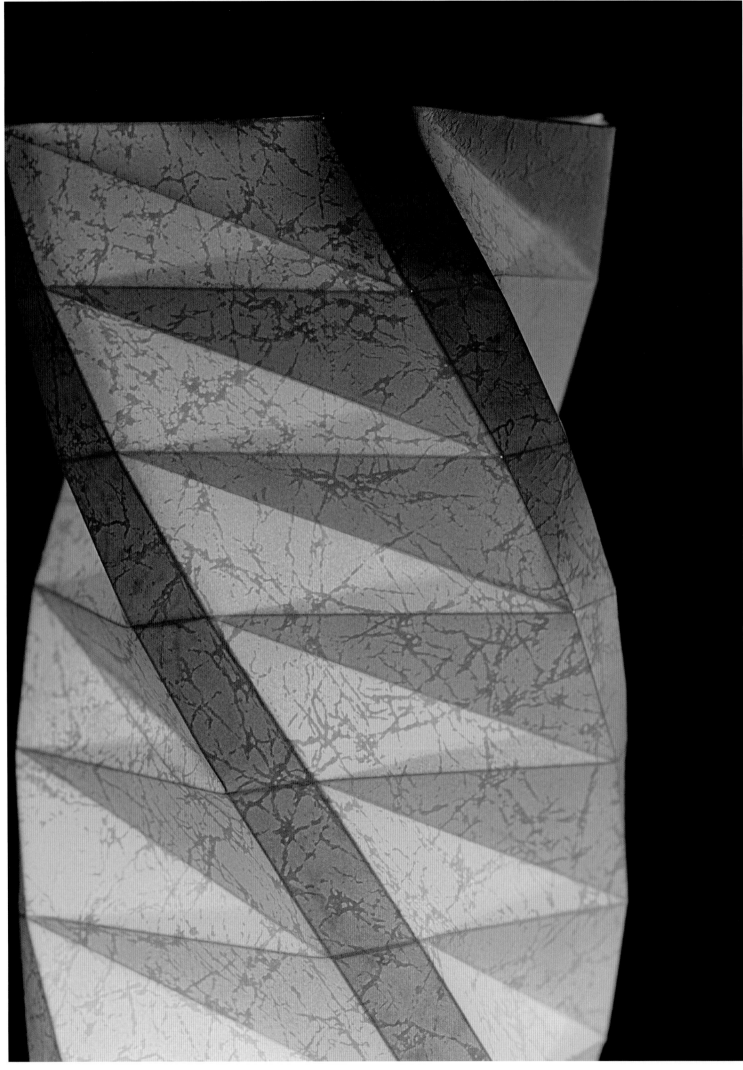

THE LIGHT BEHIND THE FOLDS

● I am convinced that the combination of paper and light is a perfect one. The paper lets light through while folds generate shaded areas that make it possible to control the luminous flux.

In Japan, *shōji*—sliding partitions constructed from a grid of thin wooden strips to which sheets of translucent paper are applied—are used to separate the rooms of a home or its interior from the outside. The paper allows external light to filter through while dimming and softening it, which is why we call it *akari shōji*, or "luminous *shōji*." Traditional lanterns (*chōchin*) are likewise made out of bamboo and paper, assembled in such a way that they can be folded and closed when not in use. In this chapter you will find lampshades that, like traditional lamps, recall an accordion as well as objects that cannot be folded, but because they are origami, that is, folded paper, can evoke the play of light and shadow. The illumination is provided by LED lights. **(TF)**

TWIST PILLAR
● A: Diameter x Height 3.9 x 7.5 inches (100 x 190 mm)
B: Diameter x Height 4.1 x 9.8 inches (105 x 250 mm)
C: Diameter x Height 3.9 x 11.4 inches (100 x 290 mm)

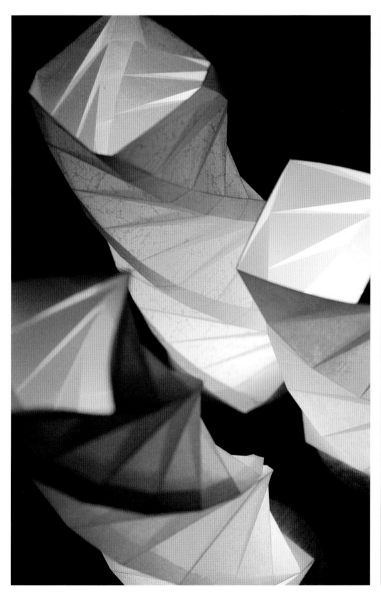

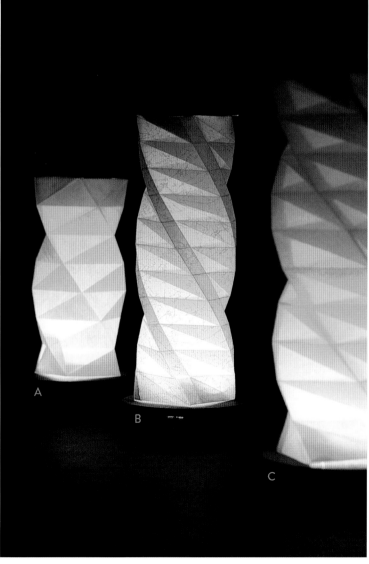

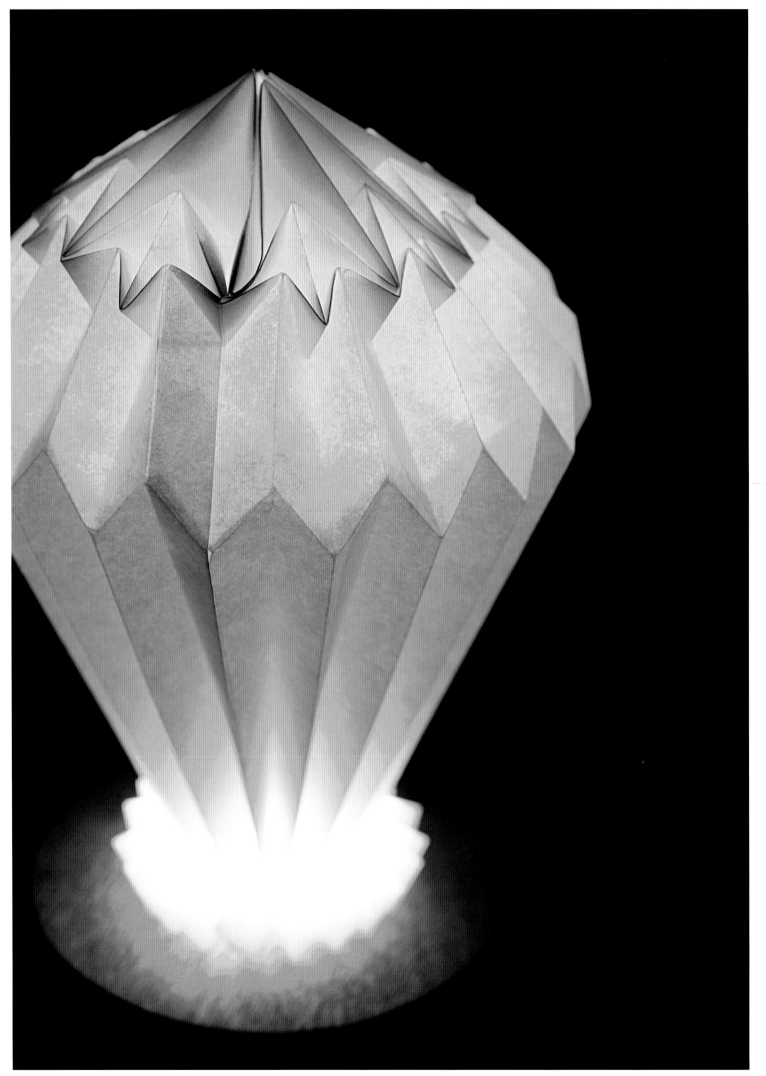

BALLOON
◀ Height x Diameter
11.4 x 5.5 inches
(290 x 140 mm)

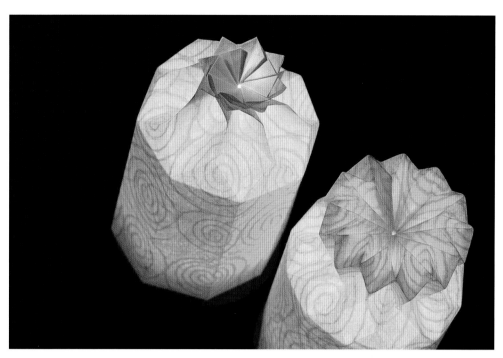

DOME FLOWER
◣▶ Height x Diameter
6.7 x 4.5 inches
(170 x 115 mm)

DOME STAR BUBBLE
◥▶ Height x Diameter
6.7 x 4.5 inches
(170 x 115 mm)

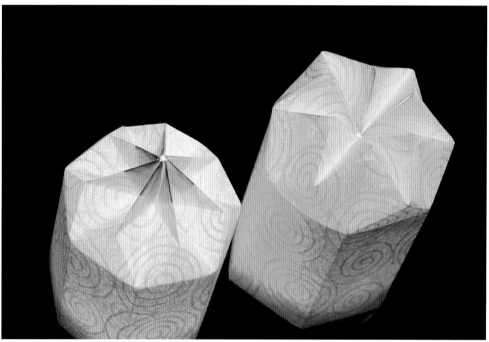

● Tomoko Fuse is a master of various styles of origami and is widely esteemed for her geometric forms, which she makes from individual sheets of paper or by assembling multiple identical modules. Although obviously it is possible to hide oversights and folding mistakes in an origami model, a perfectionist such as Tomoko regards this as unacceptable. The artist is as careful with the construction of the structure as she is with the visible elements. Were she not, the relationship between the tension and force of the various parts would be compromised. The shapes—so precise and crystalline—are wonderful. Although their purity and superficial elegance can be admired, their highly rigorous internal structure remains hidden, and generally does not receive the appreciation it deserves. But all it takes is a light source inside the piece to reveal everything!

Both modular models and those made from a single sheet can serve as functional ceiling or floor lamps. At the same time, many of the tessellations and undulating structures or infinite folds illustrated in the previous chapters can be turned into lamps as well. Tomoko has created elaborate installations with backlit tessellations for restaurants, hotels, and private residences. High-quality Japanese craft paper has a marvelous fibrous texture that is further enhanced by a back light. By the same token, such lamps acquire a completely different look when illuminated from the inside. We suddenly realize that a whole gamut of light gray shadows determined by two or three superimposed layers appears as if by magic at the flip of a switch. **(DB)**

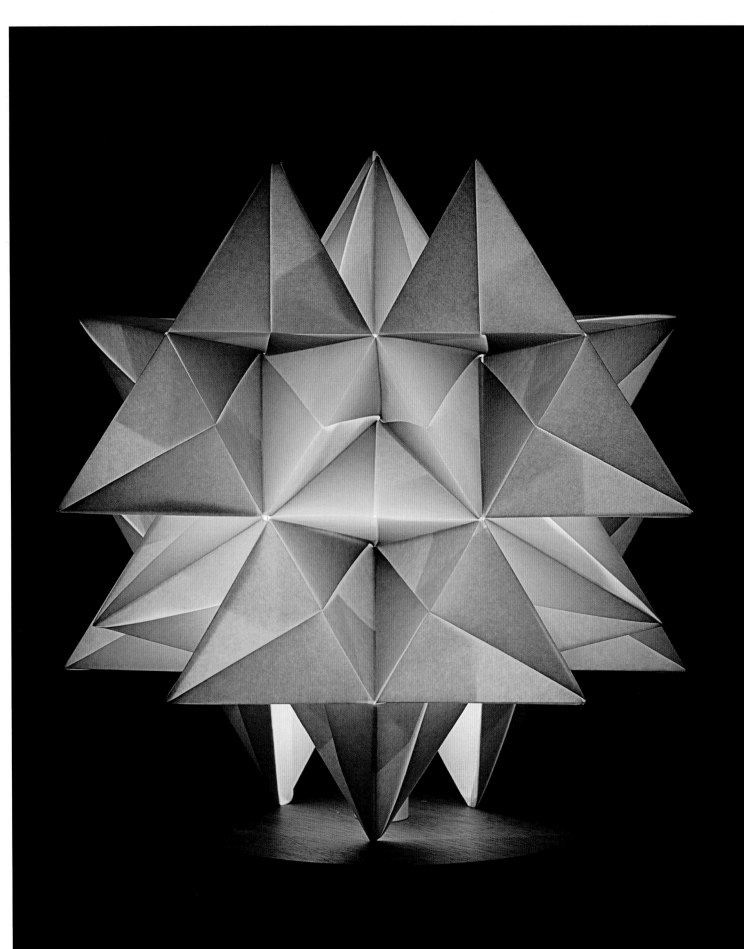

CRYSTAL

Width x Length x Height
8.7 x 8.3 x 8.7 inches
(220 x 210 x 220 mm)

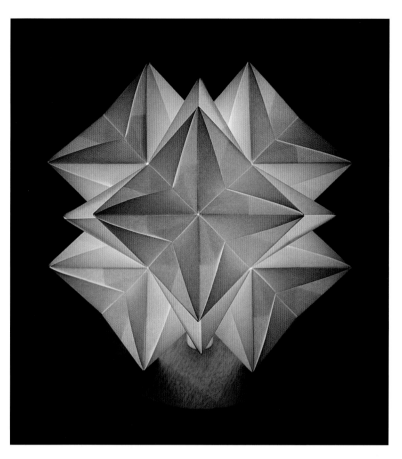

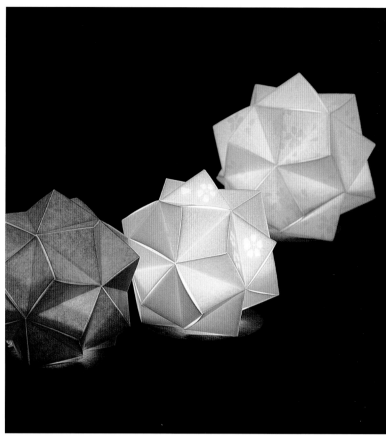

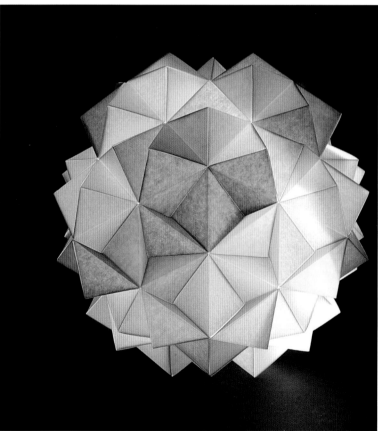

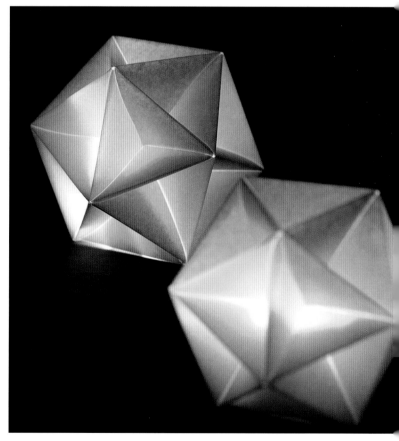

CRYSTAL

◖ Width x Length x Height
8.7 x 8.3 x 8.7 inches
(220 x 210 x 220 mm)

ZIGZAG BRAIDED BALL

◖ Diameter
5.1 inches (130 mm)

ZIGZAG BRAIDED BALL

◗ Diameter
11.6 inches (295 mm)

ZIGZAG BRAIDED BALL

◗ Diameter
8.3 inches (210 mm)

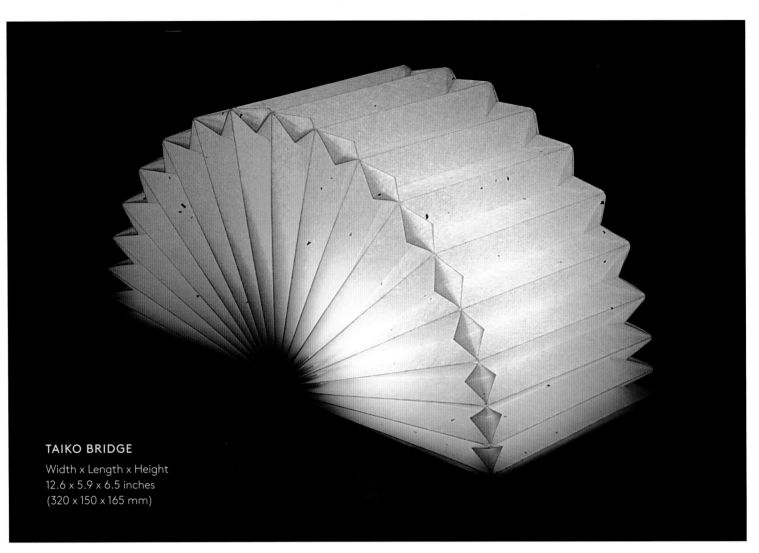

TAIKO BRIDGE

Width x Length x Height
12.6 x 5.9 x 6.5 inches
(320 x 150 x 165 mm)

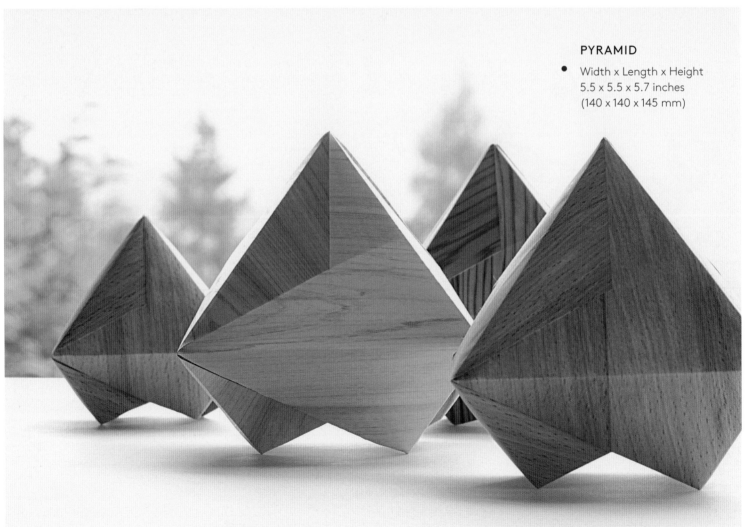

PYRAMID

- Width x Length x Height
5.5 x 5.5 x 5.7 inches
(140 x 140 x 145 mm)

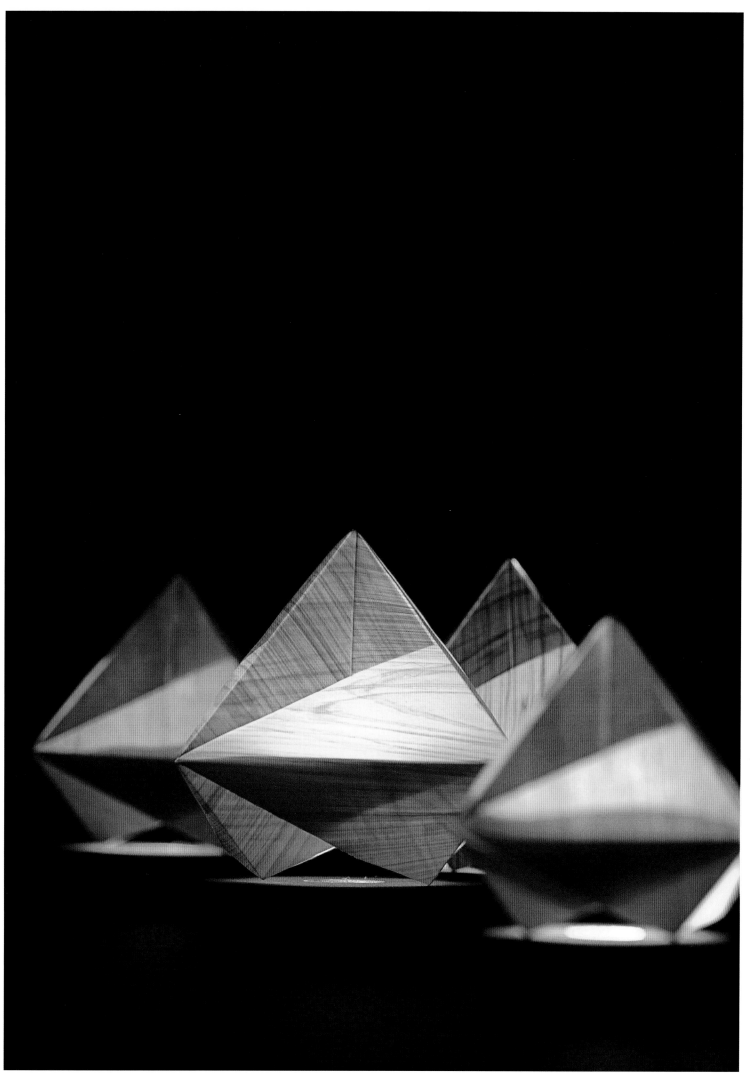

BUCKLING PILLAR

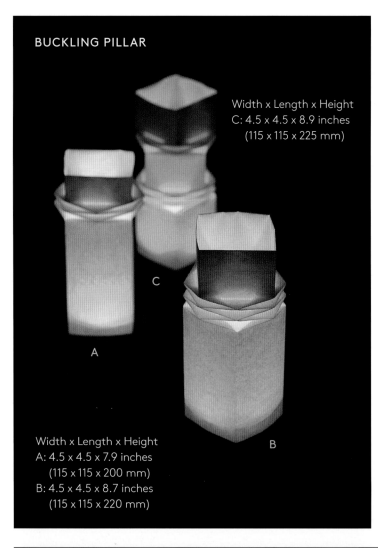

Width x Length x Height
C: 4.5 x 4.5 x 8.9 inches
(115 x 115 x 225 mm)

Width x Length x Height
A: 4.5 x 4.5 x 7.9 inches
(115 x 115 x 200 mm)
B: 4.5 x 4.5 x 8.7 inches
(115 x 115 x 220 mm)

A

B

C

PAGODA

Width x Length x Height
A: 9.8 x 9.8 x 19.2 inches (250 x 250 x 487 mm)
B: 6.7 x 6.7 x 14.8 inches (170 x 170 x 377 mm)

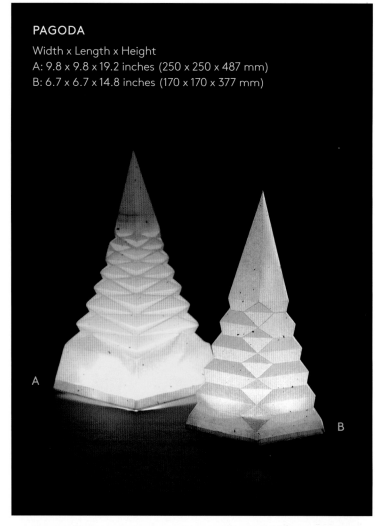

A

B

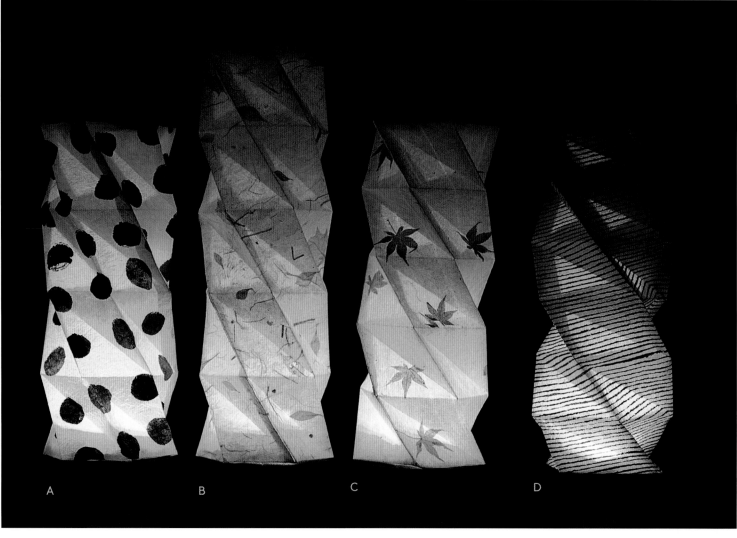

A

B

C

D

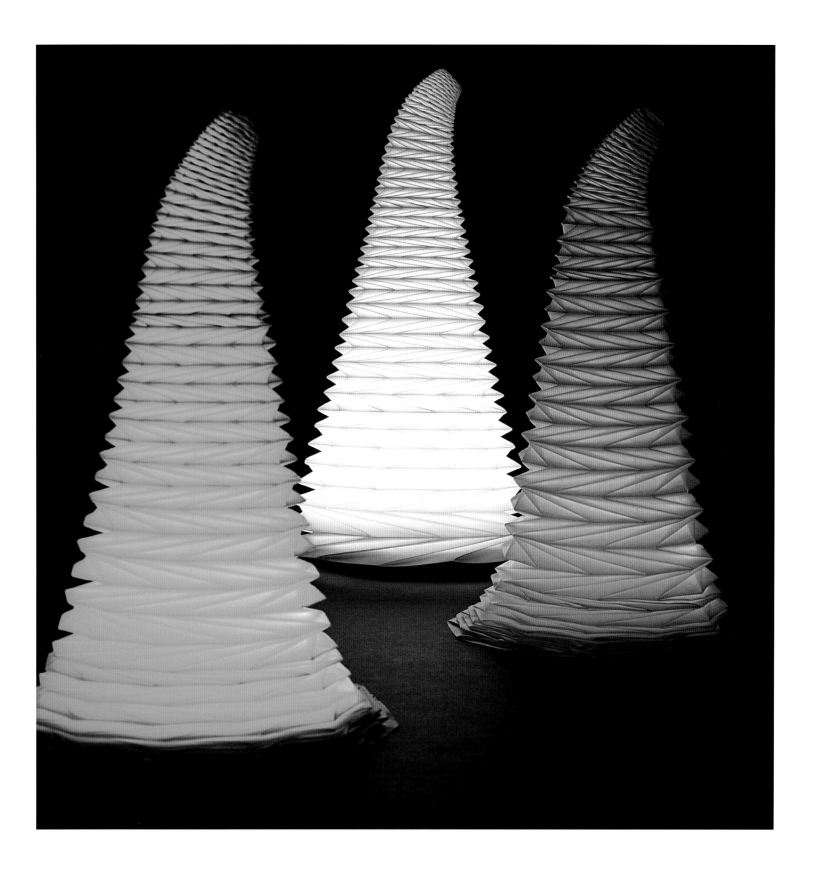

FOLDABLE LANTERN

◖ Height x Diameter
 A: 11.8 x 5.1 inches (300 x 130 mm)
 B: 14.4 x 5.1 inches (365 x 130 mm)
 C: 11.8 x 4.5 inches (300 x 115 mm)
 D: Width x Length x Height
 5.3 x 5.3 x 11.8 inches (135 x 135 x 300 mm)

MUKU MUKU

◗ Height x Diameter
 20 x 11 inches
 (510 x 280 mm)

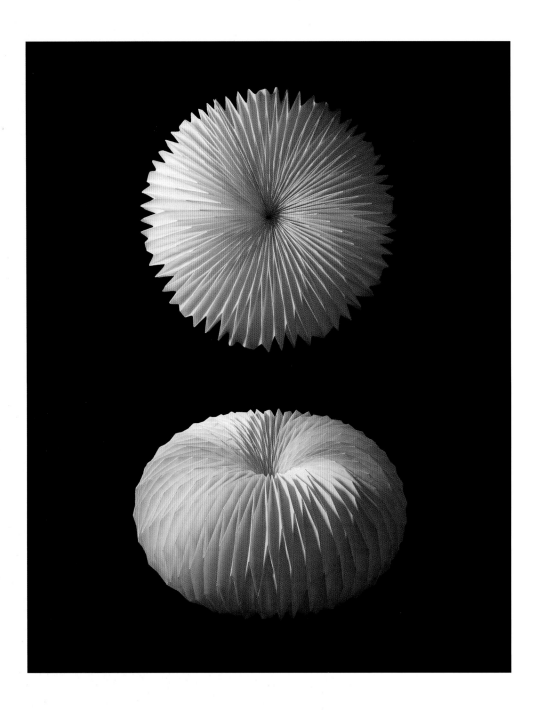
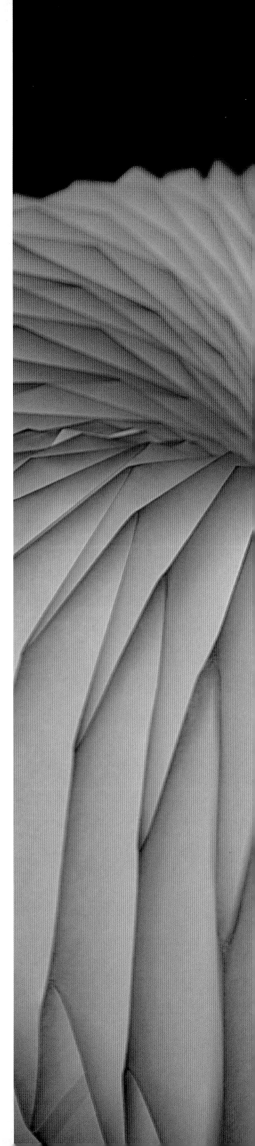

TORNADO

- Height x Diameter
 9.4 x 18.9 inches
 (240 x 480 mm)

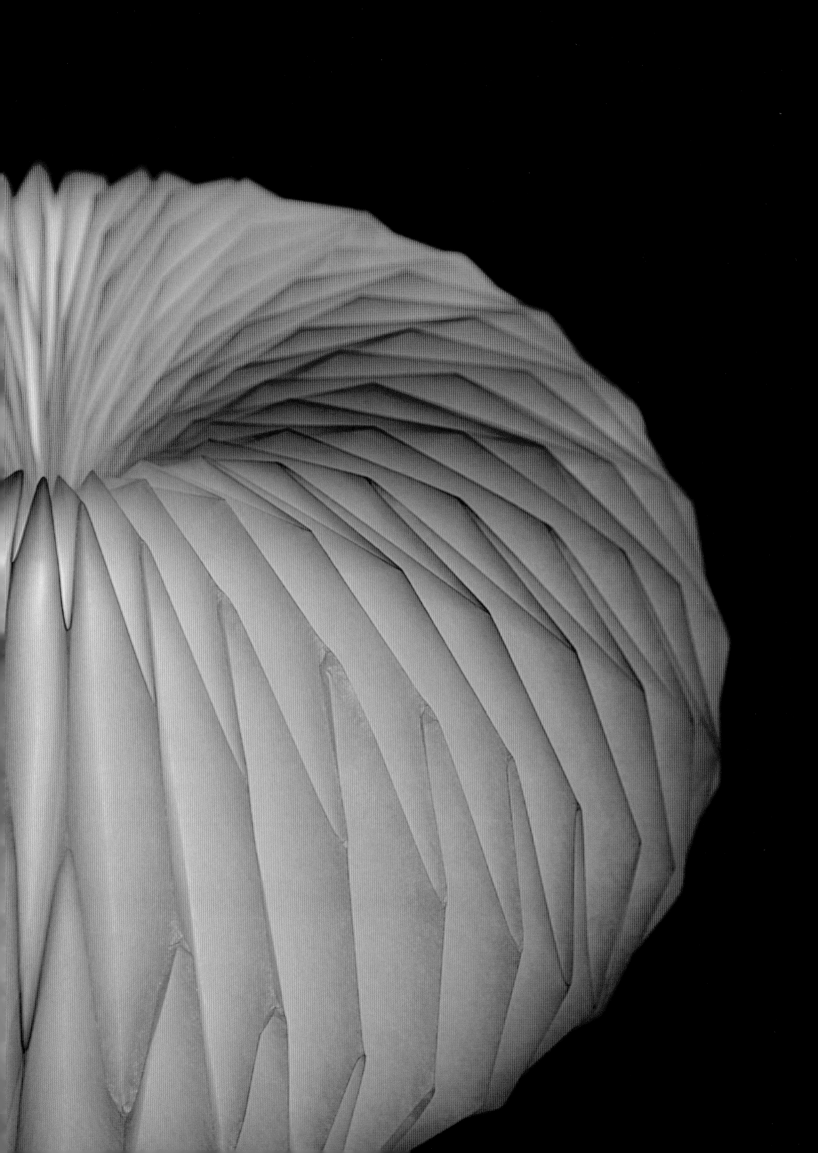

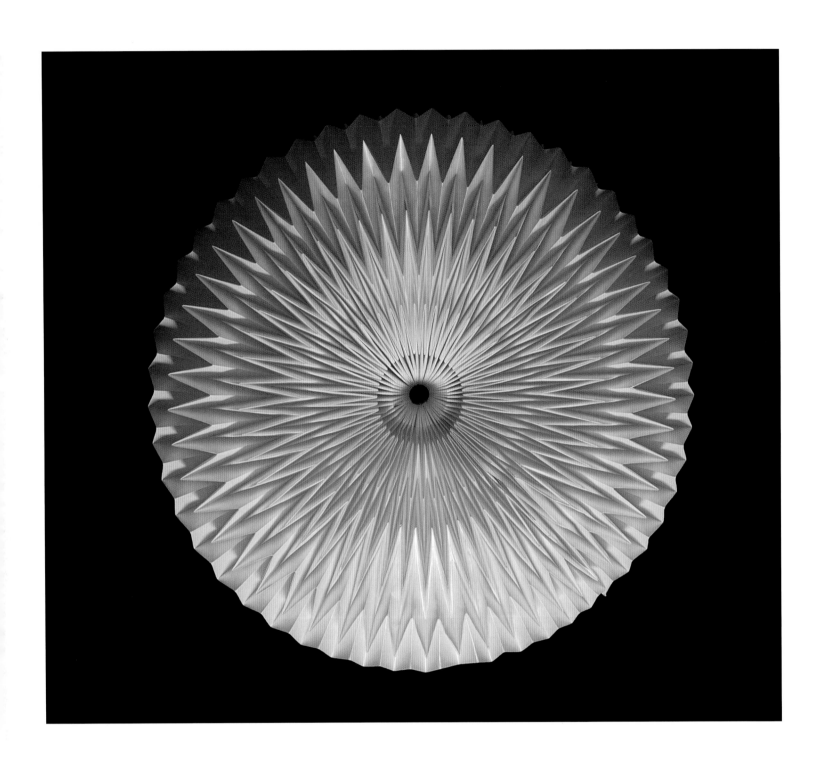

KABURA

● Height x Diameter
9.4 x 18.9 inches
(240 x 480 mm)

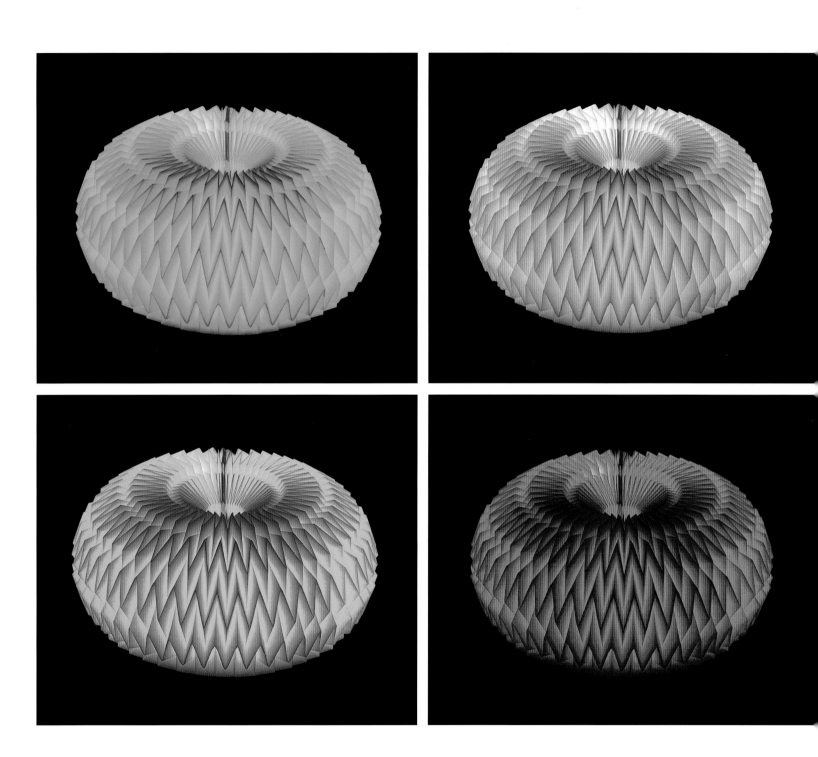

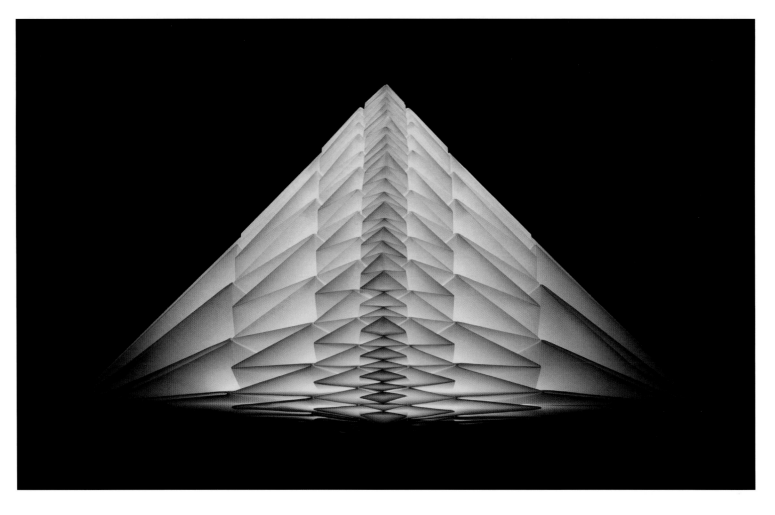

FAN 45

- Width x Length x Height
 19.3 x 19.3 x 9.6 inches
 (490 x 490 x 245 mm)

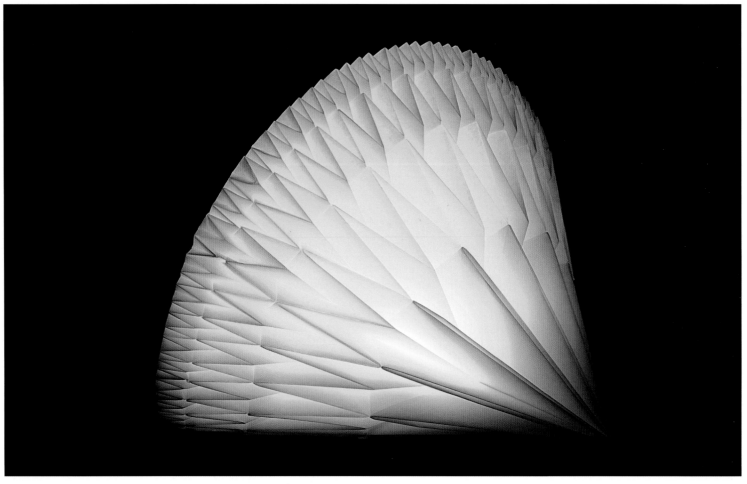

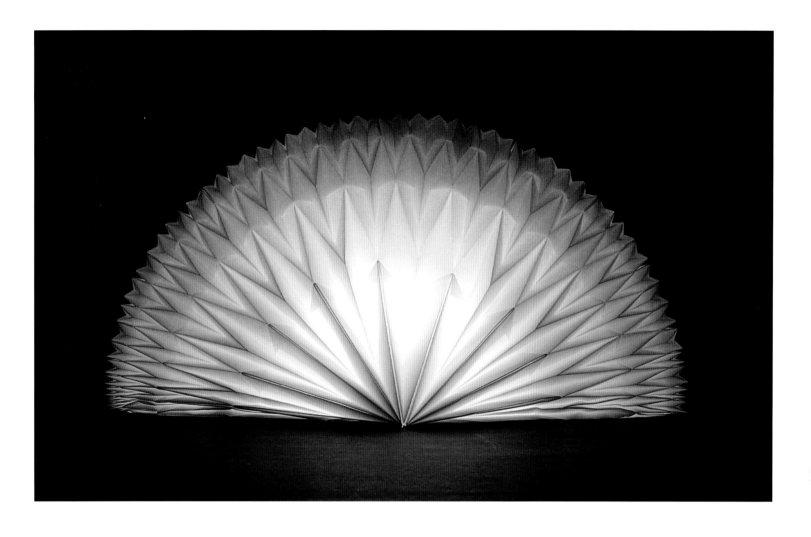

FAN 60

- Width x Length x Height
 28.7 x 16.3 x 14.4 inches
 (730 x 415 x 365 mm)

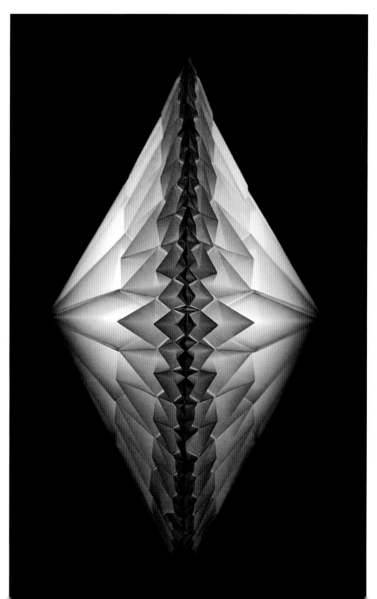

METHODS AND INSTRUCTIONS

Here are diagrams that show, chapter by chapter, how to fold and further develop, if not all the models, then at least the basic ones. We sincerely hope that these explanations will help readers understand these works and fire their imagination.

LEGENDS

VALLEY FOLD
(FOLD TOWARDS
YOU)

MOUNTAIN
FOLD (FOLD TOWARDS THE BACK)

FOLD AND UNFOLD

TURN THE SHEET
OF PAPER OVER

ENLARGED VIEW

TURN THE SHEET IN THE
DIRECTION OF THE ARROWS

INSERT

FOLD SO THE "O" SYMBOLS MEET

A CREASE PATTERN*
(IF SHOWN)

MOUNTAIN FOLD

VALLEY FOLD

*CREASE PATTERN SEEN
FROM THE MAIN SIDE

CHAPTER ONE
CONSTRUCTING WITH THE KNOT

1 **THE PENTAGONAL KNOT** (illustrations on pp. 24–25)

How to Make a Star

Make a pentagonal knot with a strip of paper, then refold one of the outer strips and insert it inside the knot. Now look at the pentagon you have made against the light. The layers of paper will be superimposed in regular sections, and you will be able to see a perfect star. After you fold the strip inwards, you can wrap it around the other strip and repeat the operation a number of times. You will end up with the bookmark shown in the illustration.

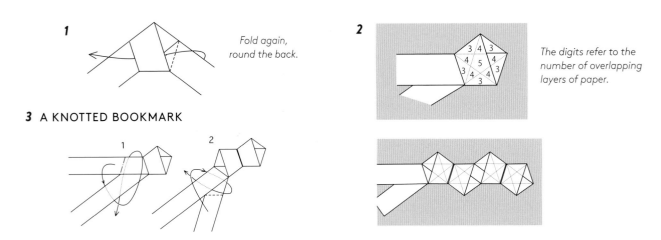

1

*Fold again,
round the back.*

2

*The digits refer to the
number of overlapping
layers of paper.*

3 A KNOTTED BOOKMARK

THREADING A STRIP THROUGH THE KNOT

Another way to obtain a regular star by layering paper is by threading a second strip through the knot. If you apply the same "knotted bookmark" method to two strips, you can create a ring. A decagonal ring similar to the one in diagram 7 was included in Kōji and Mitsue Fushimi's volume, *Origami no kikagaku* [Geometric Origami], published by Nippon Hyōronsha in 1979. There, however, the ring was created from a single strip of paper in which the strips were alternately superimposed and knotted, while here two strips are used.

4

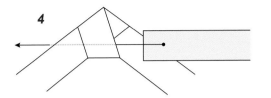

More knots can be created using the same method.

5

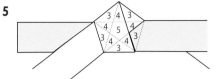

Looking at the knot while you hold it against the light, you should be able to see a star.

The digits indicate the number of superimposed layers of paper.

6 A RING OF PENTAGONAL STARS (illustrations on p. 24)

Make a knot with one of the two strips and wrap the other around it.

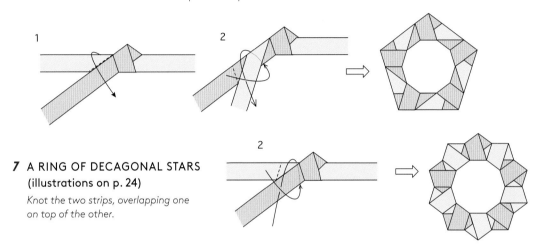

7 A RING OF DECAGONAL STARS
(illustrations on p. 24)

Knot the two strips, overlapping one on top of the other.

<table>
<tr><td>**2**</td><td></td></tr>
</table>

CONSTRUCTING WITH MOLECULES

The Basic Structure of the Molecule

A molecule is made out of a long narrow sheet of paper. It is folded gradually at an angle so that it wraps around itself until the two ends are finally closed by being inserted into each other. Flat or solid shapes can be created by introducing thin strips of paper into the slots of the molecule. It is fun to use the molecule as a guide or as a central element for the creation of new forms.

1 THE SQUARE MOLECULE (illustrations on pp. 26, 28–31)

Fold a long, narrow sheet of paper repeatedly at 45 degrees, then close the ends by inserting them into each other.

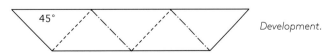

45°

Development.

FOLDING SCHEME

1 **2**

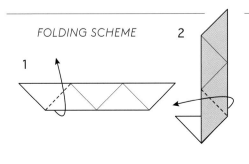

3

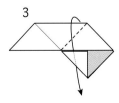

Slip through the opening.

4

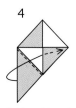

Fold and insert.

5

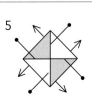

The "gaps" follow the arrows.

Planar Figures

Insert narrow strips of paper through the openings of the molecule. It is possible to come up with a variety of compositions by folding and interweaving these strips. Carefully calculate where the ends of the strips should begin and end.

HOW TO JOIN STRIPS

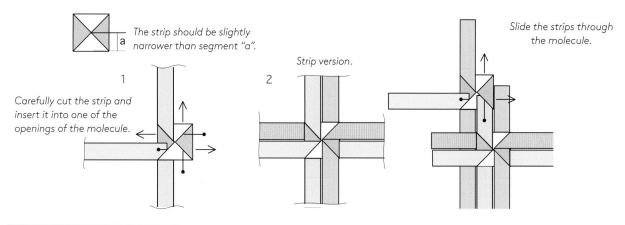

The strip should be slightly narrower than segment "a".

Strip version.

Slide the strips through the molecule.

1

Carefully cut the strip and insert it into one of the openings of the molecule.

2

Solid Figures

Before inserting the strip, mark the fold lines. Illustrated here is the process for making a cuboctahedron.

COMPOSITION OF A BASIC CUBOCTAHEDRON

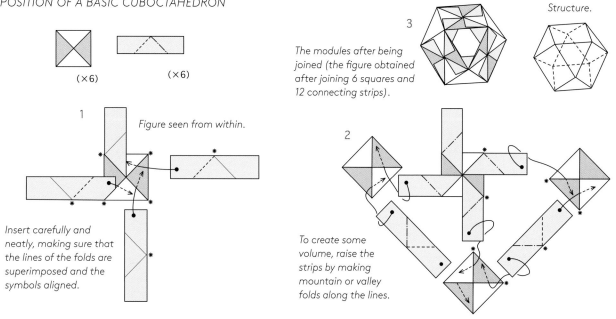

(×6)

(×6)

3

The modules after being joined (the figure obtained after joining 6 squares and 12 connecting strips).

Structure.

1

Figure seen from within.

Insert carefully and neatly, making sure that the lines of the folds are superimposed and the symbols aligned.

2

To create some volume, raise the strips by making mountain or valley folds along the lines.

2 THE PENTAGONAL MOLECULE (illustrations on pp. 38–43)

There are two versions of the pentagonal molecule—with or without an opening at the center. The first is better suited for further development. An unbroken version can be achieved through the gradual insertion of strips.

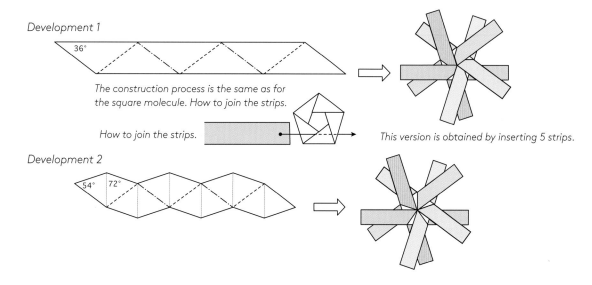

Development 1

36°

The construction process is the same as for the square molecule. How to join the strips.

How to join the strips.

This version is obtained by inserting 5 strips.

Development 2

54° 72°

3 THE HEXAGONAL MOLECULE (illustrations on pp. 27, 32–37)

The hexagonal molecule can be constructed with the same procedure used for the pentagonal molecule. Here, however, we prefer to adopt a procedure that requires 2 strips of paper, as in the figure on the right. In this system, the impact of the paper's thickness is reduced.

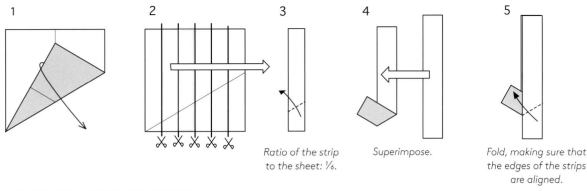

Ratio of the strip to the sheet: ⅙.

Superimpose.

Fold, making sure that the edges of the strips are aligned.

HOW TO CREATE THE MOLECULE

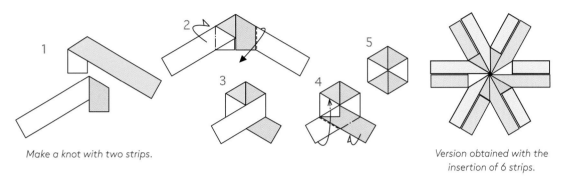

Make a knot with two strips.

Version obtained with the insertion of 6 strips.

CHAPTER TWO
TESSELLATIONS

1 FLAT FOLDING A SQUARE (illustrations on pp. 17, 44–83, back endpapers)

The Twist

To make this type of fold, use two fingers to lift the sheet and make a crimp in each of the four directions, then flatten out by twisting the point of intersection. (It is actually more a question of lowering, or opening the intersection between the folds than one of flattening.) You can continue joining as you twist to the right and left.

Exercises with a Square Twist

EXAMPLE 1
Make the folds as indicated in the diagram.

TWIST TOWARDS THE RIGHT

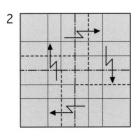
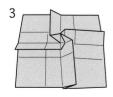

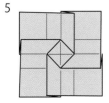

Make the crimp all the way to the center of the sheet.

Flatten the crimp by twisting towards the right. Flatten the center.

Intermediate step.

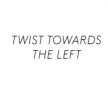

TWIST TOWARDS THE LEFT

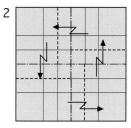

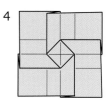

Twist the crossed crimps.

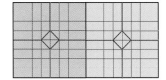

Fold grid.

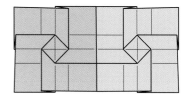

Join the two modules with a twist to the right and a twist to the left.

Exercises in Square Tessellation

Composing modules with a twist. Mark the folds needed to achieve the result you desire, then alternate modules that are twisted to the right and to the left. In this way you can come up with numerous different motifs.

Flattened squares should be arranged with maximum precision.

A module.

Four models juxtaposed. Fold grid.

Final result.

Unlimited Square Tessellation

This model is obtained by dividing it in half, and then in half again along the diagonal of each square.

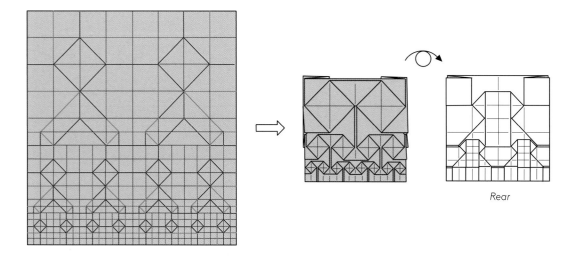

Rear

FLAT FOLDING A TRIANGLE (illustrations on pp. 60–61, 64–67, 81)

The Twist

For the triangle, use 60 degree folds. The basic folds will be mountain folds alternating with valley folds. Lift the sheet with two fingers and make a crimp in three directions, then, twisting, flatten the triangle at the point of intersection. Each time, twist towards the right and towards the left. By doing so, you will end up with a motif composed of equilateral triangles.

Exercise with a Triangle Twist

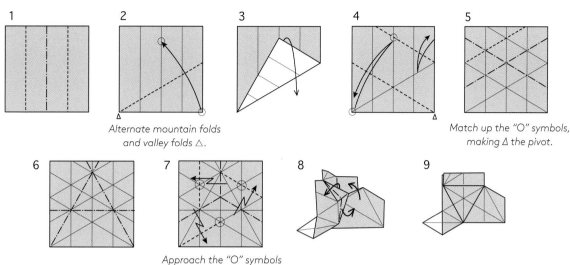

1 | 2 | 3 | 4 | 5

Alternate mountain folds and valley folds △.

Match up the "O" symbols, making △ the pivot.

6 | 7 | 8 | 9

Approach the "O" symbols from the rear.

Exercises in Triangular Tessellation

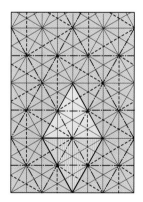

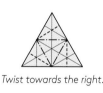

Twist towards the right.

Twist towards the left.

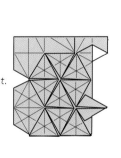

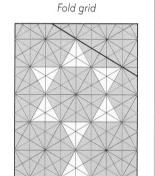

Fold grid

Alternate between twisting towards the right and twisting towards the left.

The yellow areas indicate the triangles formed by folding.

THE SPIRAL (illustrations on pp. 17, 44–48, 50–51, 80)

The Twist Superimposed

These are folds that are twisted more than once, that is, structures made from folds on which other, similar folds can be made. Thanks to these overlaps, the sheet wraps around itself, creating a spiral.

Double Twisted Exercises

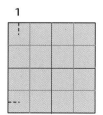

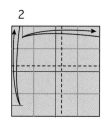

1 | 2 | 3 | 4 | 5

Form the first twist, creating a small square twisted in the center.

After creating the first twist, temporarily reopen the sheet.

6

7

8

9

10

Create the second twist by taking the points marked by the symbol "O" between two fingers and bring them closer to the back.

(Intermediate view) Start to gently flatten the center of the paper.

Fold the outer flaps inwards as you reform the central twist.

The double twist spiral completed.

Exercises with Double Twisted Spirals

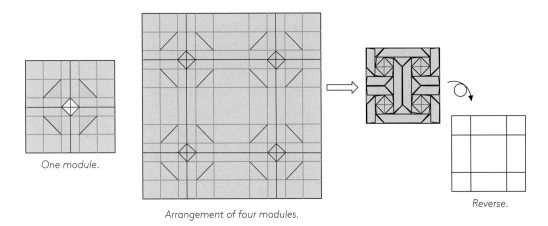

One module.

Arrangement of four modules.

Reverse.

CHAPTER THREE

INFINITE FOLDS

Four Types of Infinite Folds

Here we present four varieties of infinite folds known as the dovetail, the arrowhead, the double pleat, and the consecutive pleat. Within certain limits, the angles of the folds can be varied as desired. We therefore offer diagrams for four different angle choices for each variant. Each angle produces a different form. For the dovetail and arrowhead types, you will use grids with trisections and quadrisections as well.

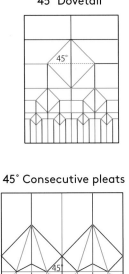

45° Dovetail

45° Arrowhead

45° Consecutive pleats

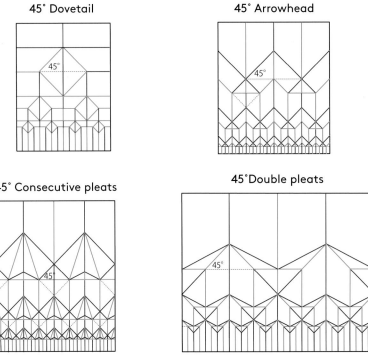

45° Double pleats

VARIATIONS OF THE DOVETAIL

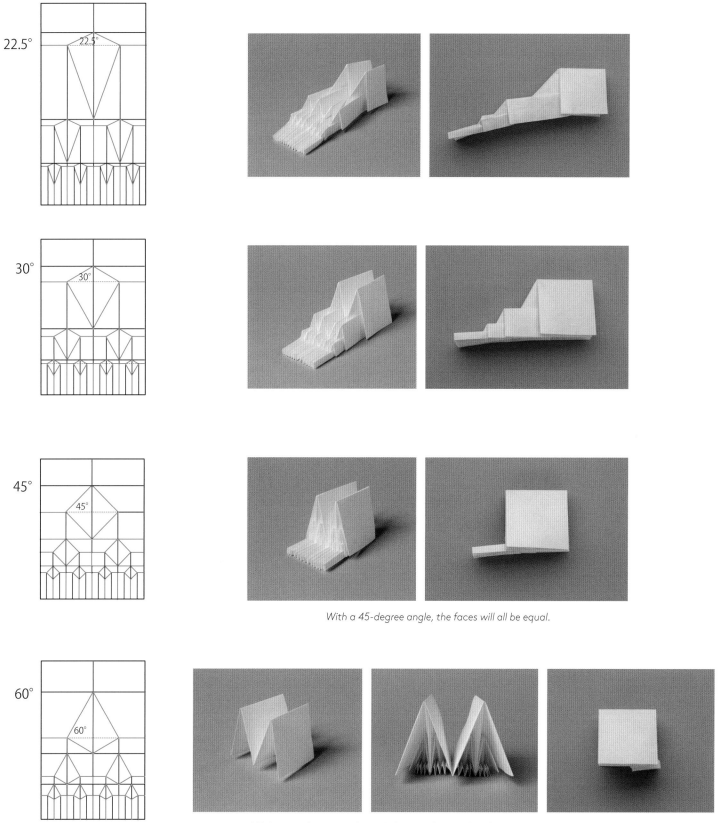

With a 45-degree angle, the faces will all be equal.

With an angle greater than 45 degrees, the smallest folds will end up inside the larger ones.

VARIATIONS OF THE ARROWHEAD

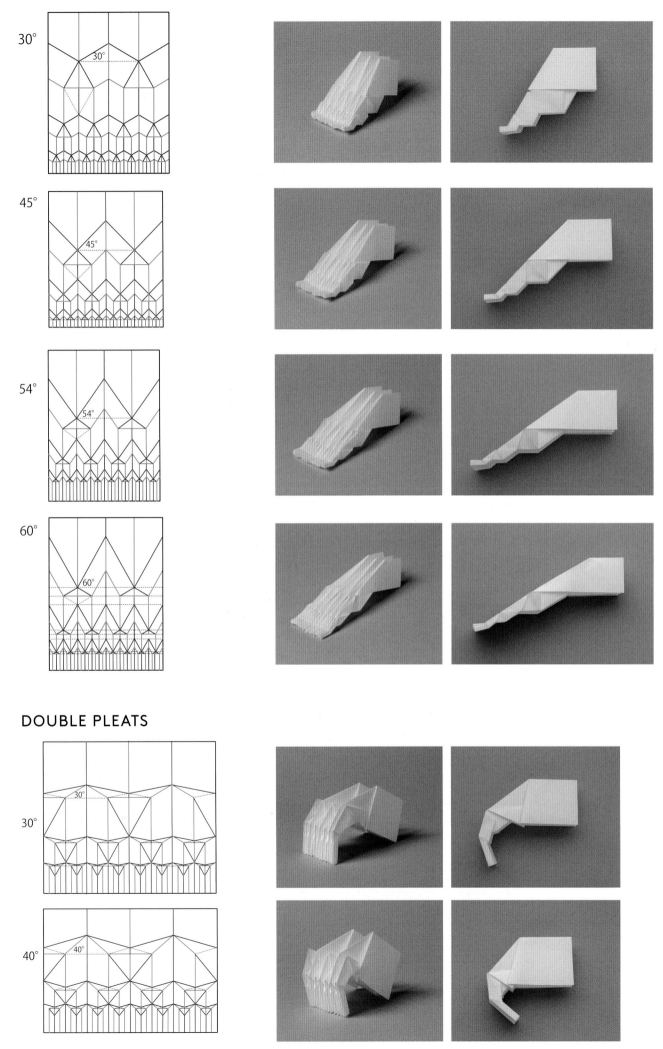

30°

45°

54°

60°

DOUBLE PLEATS

30°

40°

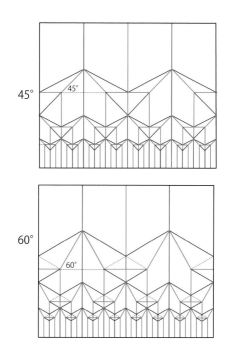

45°

60°

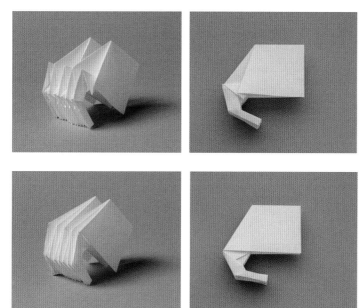

CONSECUTIVE PLEATS

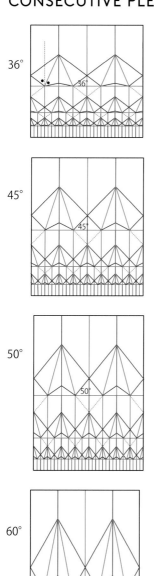

36°

45°

50°

60°

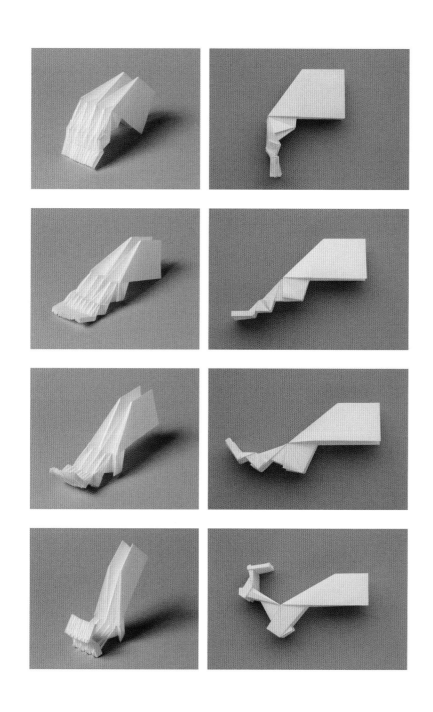

THREE OR MORE PARTITIONS

Variations of the Dovetail

TRIPARTITE DOVETAIL

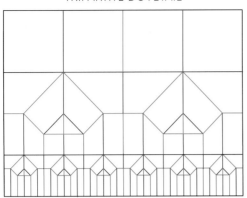

QUADRIPARTITE DOVETAIL

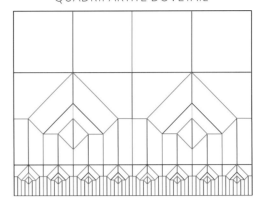

Variations of the Arrowhead

TRIPARTITE ARROWHEAD

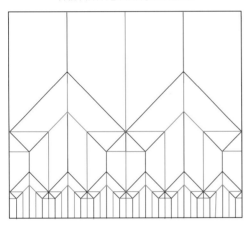

QUADRIPARTITE ARROWHEAD

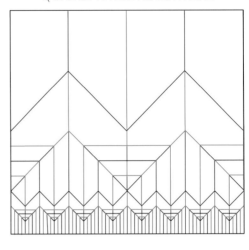

Applying the Dovetail and Arrowhead Variations

With the variations of the dovetail and arrowhead, it is possible, to some extent, to vary the angle of the folds and the manner of joining the modules in order to create different motifs.

DIAGRAM 1

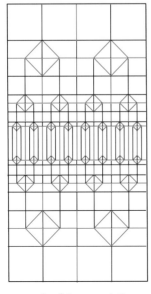

*Applying a variation
to the dovetail.*

DIAGRAM 2

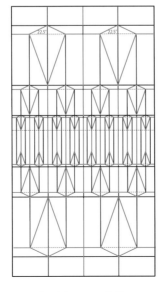

*Applying a variation
to the dovetail.*

DIAGRAM 3

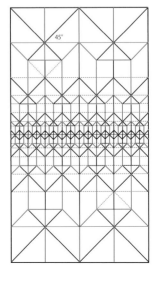

*Applying a variation
to the arrowhead.*

Arrowhead Lampshade (Fan) (illustrations on pp. 168–169)

With the variations of the dovetail and arrowhead, it is possible, to some extent, to vary the angle
of the folds and the manner of joining the modules in order to create different motifs.

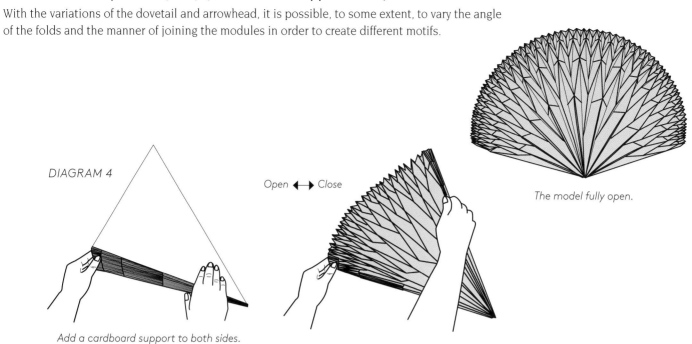

DIAGRAM 4

Open ◀▶ Close

The model fully open.

Add a cardboard support to both sides.

CHAPTER FOUR
REPETITIVE FOLDING

THE ZIGZAG (12 Angles) (illustrations on pp. 1, 114–123)

After making the valley and mountain folds indicated in the chart, begin from one end and gradually proceed to form a cylinder.

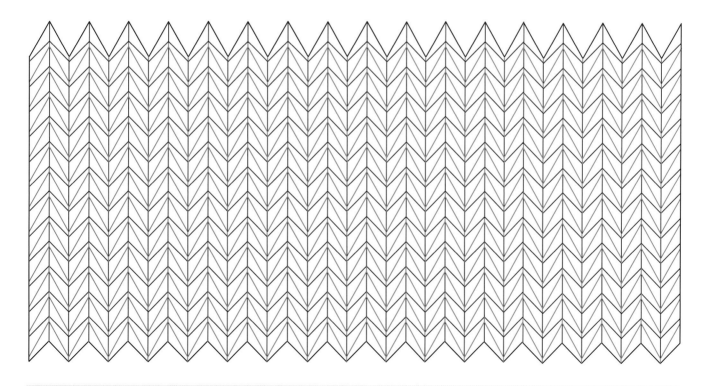

NOTE: The basic creases needed to create the patterns are indicated in the chart.

Applications of the Triangular Base

Diagram 1 shows the procedure for folding the triangular base. By repeating the folds in the illustrated grid, you can obtain the pattern known as "pineapple" or "sea cucumber," which has been used by several origami artists, most notably Shuzo Fujimoto. By developing this scheme further, you can come up with the different motifs presented in this section and even create "infinite" folds. Either side can work as the front, but as we prefer the main side to be the one with the mountain fold, we have illustrated its fold lines here.

1 TRIANGULAR BASE

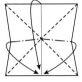

Fold grid seen from the front.

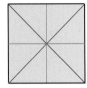

3 TRIANGULAR BASE FOR INFINITE FOLDS (MOUNTAIN AFTER MOUNTAIN) (illustrations on pp. 140–141)

2 PINEAPPLE OR SEA CUCUMBER PATTERN (REPETITION OF DIAGRAM 10)

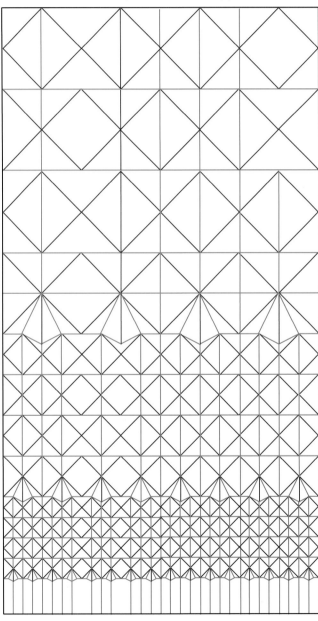

4 TRIANGULAR BIFACIAL BASE (RED WAVE)
(illustration on p. 153 bottom)

*A model developed from a triangular base
in which the front and back are identical.
The triangular base appears on both sides.
Other means of bisection are possible as well.*

5 DOUBLE TRIANGULAR BASE (BRAIN)
(illustrations on pp. 148–149)

Multiple Folds (illustrations on pp. 134–135)

Gradually draw together squares of uniform size, aligning their axes, then proceed by flattening the folds. Once the creases are flattened, twist to create the fan and fold the ends inside. The number of squares and creases depends on the time available.

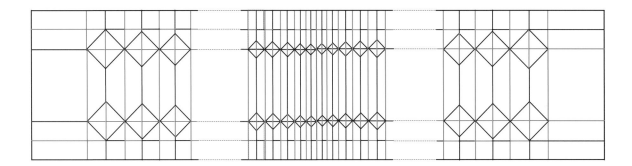

Wave Series (illustrations on pp. 150–151)

Illustrated here are the basic folds. Fold the paper by combining the indicated folds.

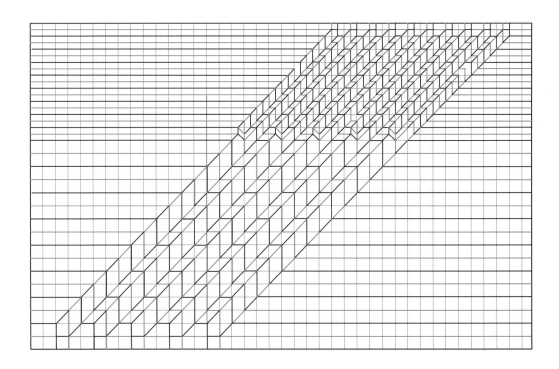

THE LIGHT BEHIND THE FOLDS

1 NON-FOLDABLE MODELS (illustrations on pp. 154–155)

Helical Columns with Square Base A, B and C

None of these three columns with square bases, obtained by varying the angle of the folds, can be resealed. Their height can vary according to your wishes. The top and bottom openings of the large models in the illustrations were obtained with the easiest of the systems, that is, by refolding the final level inwards. The number of levels in the fold grids and diagrams depicting the final result is not necessarily the same.

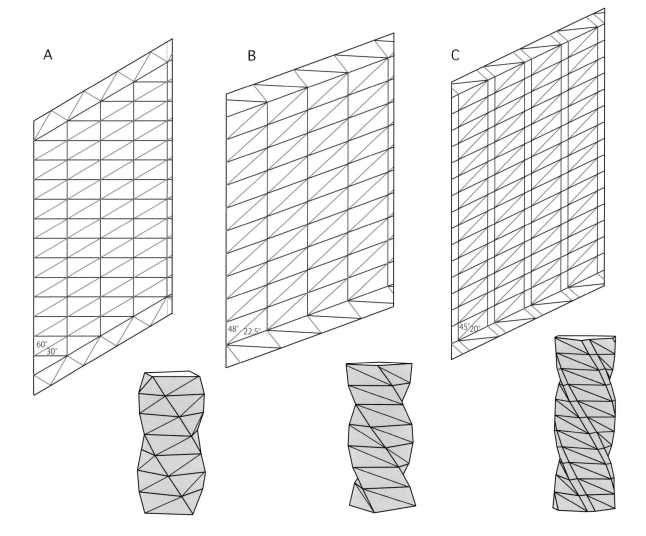

The Pyramid (illustrations on pp. 160 bottom, 161)

A simple form obtained by cutting. The base here is square but can also be triangular.

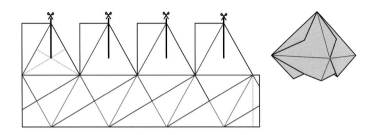

Square Section Columns with Fold-out A and B (illustrations on p. 162 top left)

The fold-out portion becomes an unusual decoration for the column and can be made in a variety of ways.

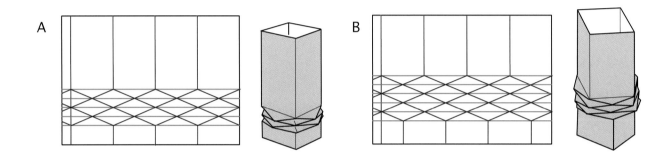

The Hexagonal, Heptagonal, Octagonal, and Dodecagonal Dome (illustrations on p. 157)

Each of these domes uses the model known as the "box cover." Different colors were used for the valley and mountain folds, but actually any of these lines can become a valley or mountain fold, with no distinction. In this model we chose to refold the base strip inwards in order to end up with a double layer of paper; but if you use thicker paper you may find that folding it a few centimeters inwards is sufficient. Folding at an angle of 45 degrees will make all these domes look very similar. Once you have made the folds, glue one edge to the opposite one to form a cylinder, then close it at the top.

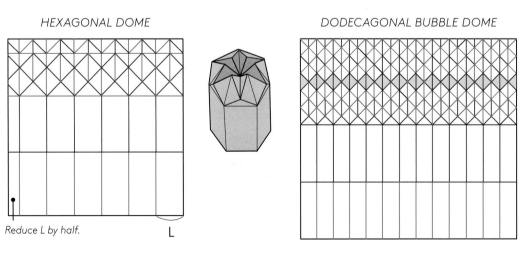

HEXAGONAL DOME

DODECAGONAL BUBBLE DOME

Reduce L by half.

L

Stop folding inwards at the height of the gray squares. As you twist inwards, at the center, the upper part will remain in place even without glue. You can create a decahedron by dividing the end of this grid into 11 equal parts.

Intertwining Zigzag Strips (illustrations on pp. 159 top right, bottom left, bottom right, 160 top)

Here is how to make a solid by folding zigzag strips of paper and then intertwining them as you would to make a basket. The basic module consists of a triangle, either concave or convex, created from three strips. The structure will be perfectly sturdy even without glue.

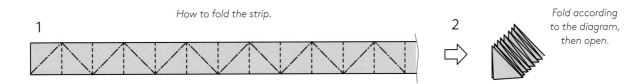

How to fold the strip.

1

2

Fold according to the diagram, then open.

How to Build a Solid Icosahedral Structure

Use 6 strips of 12 units apiece, as shown in the diagram. Instead of cutting the strip of paper, then folding it, it is more practical to make the folds first, then cut the segment with the portions that you need. Looking at the icosahedron from the perspective from which it is depicted in diagram 1, you may distinguish a kind of lateral band consisting of a decagonal ring. Slowly interlock 10 units of the strip around this ring. The remaining 2 units will overlap.

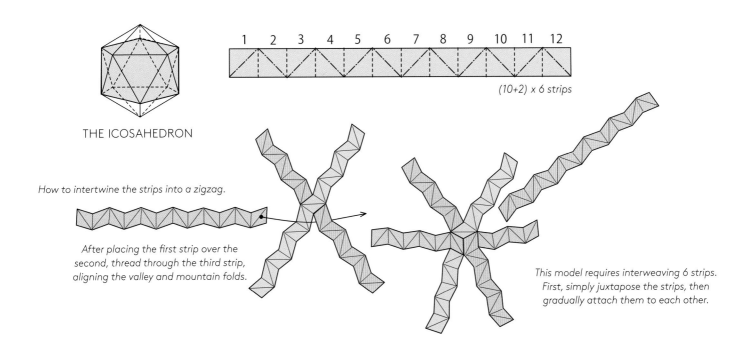

THE ICOSAHEDRON

1 2 3 4 5 6 7 8 9 10 11 12

(10+2) x 6 strips

How to intertwine the strips into a zigzag.

After placing the first strip over the second, thread through the third strip, aligning the valley and mountain folds.

This model requires interweaving 6 strips. First, simply juxtapose the strips, then gradually attach them to each other.

Composition based on 3 strips.
The triangle can be concave or convex.

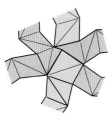

Convex triangle.

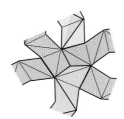

Concave triangle.

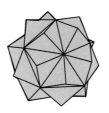

Final result with convex triangles.

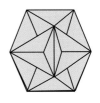

Final result with convex triangles.

187

FOLDABLE MODELS

Pagoda (illustrations on p. 162 top right)

In this model, the base of the lampshade is not resealable. Here is the crease pattern of the foldable part. After making the folds shown in the diagram, form the quadrangular pyramid and gradually fold the layers, starting from the base.

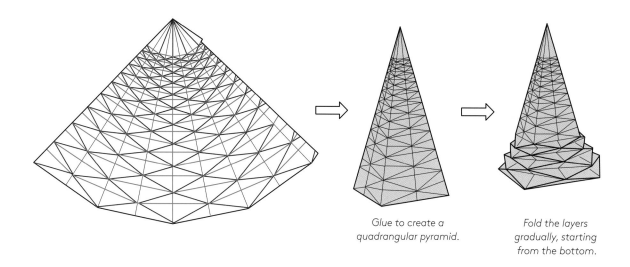

Glue to create a quadrangular pyramid.

Fold the layers gradually, starting from the bottom.

Taiko Bridge
(illustrations on p. 160 top)

After gluing together the two shorter sides to create a tube with a square section, draw one side closer, then glue it. Fold both ends inward.

Kabura - Decagono
(illustrations on pp. 166–167)

After making the folds indicated in the grid, glue the ends to form a cylinder. Starting at both ends, flatten the folds, level after level. The number of levels is dictated by preference.

Foldable Lantern (illustrations on p. 162 bottom)

After making the folds indicated in the grid, close the cylinder and glue. Then flatten the folds, proceeding gradually from both ends. Choose whatever size and number of levels you desire. Flatten inwards from time to time, in keeping with the opening.

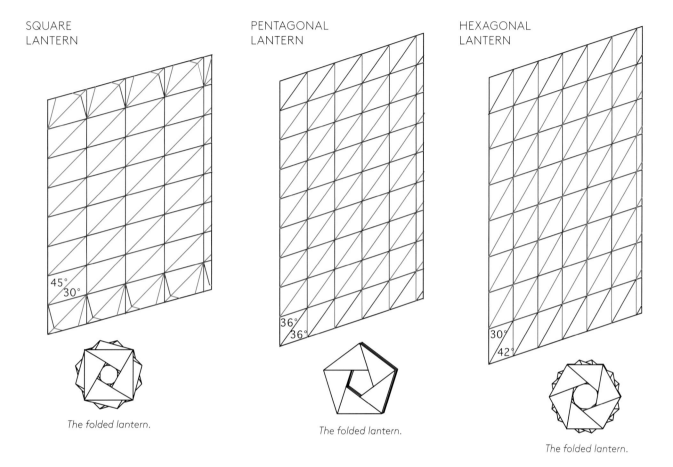

SQUARE
LANTERN

45°
30°

The folded lantern.

PENTAGONAL
LANTERN

36°
36°

The folded lantern.

HEXAGONAL
LANTERN

30°
42°

The folded lantern.

The pentagonal lantern as it is closed and opened.

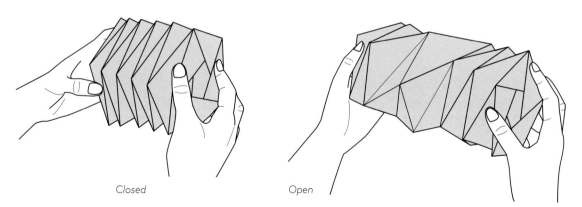

Closed

Open

Watering Can—Dodecagon (Muku Muku)
(illustrations on p. 163)

Slowly twist each level in the opposite direction to the previous
level. As it grows taller, the top will lean slightly to one side,
a peculiar feature of this model.

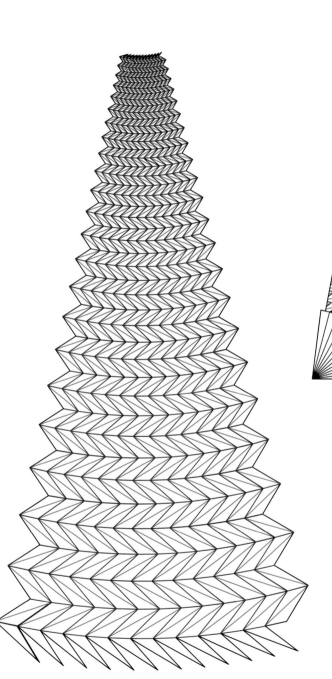

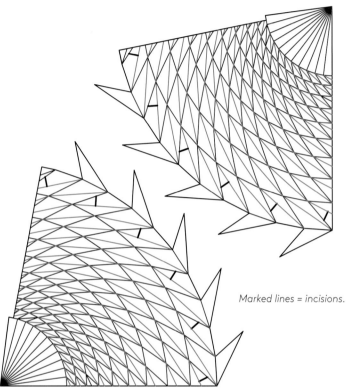

Marked lines = incisions.

Drop—Decagon
(illustration on p. 4)

The two modules can be inserted into
each other once the indicated folds have been made.
After gluing the model into a decagonal cone,
gradually flatten each level starting from the base.
To create the shape of a spindle, set the bases of two
mirror models side by side and insert the tabs into
the incisions indicated by the bold lines.
Choose however many levels you like.
The fold grid includes the edges meant to be glued.

BIBLIOGRAPHY

1. 10/8/1981 *Origami no tanoshimi* [The Pleasure of Origami], Chikuma Shobō, 1200 yen
2. 10/12/1983 *Yunitto origami* [Modular Origami], Chikuma Shobō, 1200 yen
3. 25/10/1986 *Hako wo tanoshimu* [Fun with Boxes], Chikuma Shobō, 1000 yen
4. 15/12/1896 *Yunitto arakaruto* [Modular Origami à la Carte], Chikuma Shobō, 1000 yen
5. 20/4/1987 *Rittai nana henke* [Seven Variations on the Polyhedron], Chikuma Shobō, 1000 yen
6. 25/2/1897 *Seichō suru rittai* [Expanding Solids], Chikuma Shobō, 1000 yen
7. 29/9/1987 *Rittai wo tsukurō* [Let's Build Solids], Seibundō, 880 yen
8. 29/9/1987 *Rittai wo tsukurō* [Let's Make Boxes], Seibundō, 880 yen
9. 29/9/1987 *Tsukatte asobō* [Playing with Origami], Seibundō, 880 yen
10. 17/2/1988 *Hako no hyakumensō* [The Hundred Sides of a Box], Chikuma Shobō, 1000 yen
11. 7/3/1988 *Chōhōkei de orō* [Making Origami from Rectangular Sheets], Seibundō, 880 yen
12. 12/7/1988 *Rittai karakuri* [Three-Dimensional Devices], Seibundō, 880 yen
13. 12/10/1988 *Tsunaide tsukurō* [Building through Assemblage], Seibundō, 880 yen
14. 12/10/1988 *Sekai no yunitto origami* [Modular Origami the World Over], Seibundō, 880 yen
15. 30/8/1989 *Hako jiyūjizai 1* [Boxes for Every Taste 1], Chikuma Shobō, 1230 yen
16. 30/9/1989 *Hako jiyūjizai 1* [Boxes for Every Taste 2], Chikuma Shobō, 1230 yen
17. 25/10/1989 *Hishigata rittai to omoshiro box* [Rhombic Polyhedrons and Fun Boxes], Chikuma Shobō, 1230 yen
18. 25/11/1989 *Rittai mangekyō* [3D Kaleidoscope], Chikuma Shobō, 1230 yen
19. 5/4/1990 *Origami hāto* [Origami Hearts], Chikuma Shobō, 1230 yen
20. 23/1/1990 *Rittai baraetī* [Various Geometric Solids], Seibundō, 970 yen
21. 23/1/1990 *Hako baraetī* [Various Boxes], Seibundō, 970 yen
22. 22/2/1991 *Shiki no hako* [Boxes for the Four Seasons], Seibundō, 1200 yen
23. 22/2/1991 *Kazari no aru hako* [Decorated Boxes], Seibundō, 1200 yen
24. 10/12/1991 *Dekorēshon box* [Decorated Boxes], Chikuma Shobō, 1200 yen
25. 17/1/1992 *Rasen wo orō* [Let's Create Spirals], Chikuma Shobō, 1200 yen
26. 12/2/1992 *Ugoku origami* [Self-Propelled Origami], Seibundō, 1200 yen
27. 20/2/1992 *Ichimai ori no hako* [Constructing Boxes Out of a Single Sheet], Chikuma Shobō, 1200 yen
28. 1/9/1992 *Tanoshii hako no sekai* [The Fun World of Boxes], Shinsei Shuppansha, 1300 yen
29. 1/9/1992 *Fushigina rittai no sekai* [The Amazing World of Solids], Shinsei Shuppansha, 1300 yen
30. 25/5/1993 *Tsuru to ōgi to* [Cranes and Fans], Chikuma Shobō, 1200 yen
31. 20/9/1993 *Osharena komonotachi* [Small Chic Objects], NHK Shuppan, 2330 yen
32. 7/7/1994 *Oriori no origami* [Origami for Every Occasion], Ishizue, 1300 yen
33. 25/5/1995 *Origami kiruto* [Origami Quilt], Chikuma Shobō, 1300 yen
34. 20/6/1995 *Origami supairaru* [Origami Spirals], Chikuma Shobō, 1300 yen
35. 20/7/1995 *Manpuku box* [Modular Boxes], Chikuma Shobō, 1300 yen
36. 25/8/1995 *Origami dezain* [Furnishing with Origami], Chikuma Shobō, 1300 yen
37. 20/9/1995 *Gifuto box* [Gift Box], NHK Shuppan, 2400yen
38. 29/9/1995 *Yūyū no origami* [Origami for Relaxing], Ishizue, 1300 yen
39. 17/7/1996 *Raku raku no origami* [Easy Origami], Ishizue, 1300 yen
40. 16/10/1997 *Origami no kazarimono* [Decorating with Origami], Ishizue, 1300 yen
41. 10/11/1997 *Men* [The Mask], Origami House, 3300 yen
42. 20/6/2000 *Rittai wo tsukurō* [Let's Build Solids], Seibundō, 1500 yen
43. 20/6/2000 *Hako wo tsukurō* [Let's Build Boxes], Seibundō, 1500 yen
44. 20/11/2000 *Tsukatte asobō* [Origami for Play], Seibundō, 1500 yen
45. 20/11/2000 *Hako baraetī* [Various Boxes], Seibundō, 1500 yen
46. 20/7/2001 *Origami Pcchiwāku* [Origami Patchwork], Seibundō, 1500 yen
47. 20/7/2001 *Yunitto hiroba* [Unit Polyhedron Origami], Seibundō, 1500 yen
48. 10/9/2001 *Rittai karakuri* [Three-Dimensional Devices], Seibundō, 1500 yen
49. 10/9/2001 *Kusudama origami* [Decorative Paper Globes], Seibundō, 1500 yen
50. 30/7/2002 *Ugoku origami* [Self-Propelled Origami], Seibundō, 1500 yen
51. 30/7/2002 *Tsuru no origami* [Origami Cranes], Seibundō, 1500 yen
52. 28/3/2003 *Kurashi no komono* [Small Everyday Objects], Seibundō, 1500 yen
53. 28/3/2003 *Iremono iroiro* [Containers of All Kinds], Seibundō, 1500 yen
54. 25/2/2005 *Ringu* [Rings], Seibundō Shinkōsha, 1800 yen
55. 25/2/2005 *Tsutsumu* [Origami Packaging], Seibundō Shinkōsha, 1800 yen
56. 20/7/2005 *Hako* [Boxes], Seibundō Shinkōsha, 1800 yen
57. 20/7/2005 *Denshō to sono ōyō* [Tradition and Its Practical Application], Seibundō Shinkōsha, 1800 yen
58. 15/8/2005 *Yukaina tamentai* [Fun Polyhedrons], Nihon Vogue, 1400 yen
59. 1/11/2005 *Kusudama* [Kusudama: Decorative Paper Globes], Seibundō Shinkōsha, 1800 yen
60. 14/2/2006 *Hanamari* [Floral Globes], Nihon Vogue, 1400 yen
61. 25/11/2006 *Hana kusudama* [Origami Petal Balls], Seibundō Shinkōsha, 1800 yen
62. 25/11/2006 *Tsutsumi to musubi* [Wrapping and Ties], Seibundō Shinkōsha, 1800 yen
63. 25/8/2007 *Ireko no hako* [Origami Nesting Boxes], Seibundō Shinkōsha, 1800 yen
64. 25/8/2007 *Shokutaku wo tanoshiku* [Fun at the Table], Seibundō Shinkōsha, 1800 yen
65. 27/7/2007 *Tsutsumu origami, hako no origami* [Origami Packages, Origami Boxes], PHP kenkyūjo, 1400 yen
66. 25/6/2008 *Origami shiki oriori* [Origami for All Seasons], NHK Shuppan, 1400 yen
67. 25/2/2009 *Hoshi to yuki no moyō* [Origami Stars and Snowflakes], Seibundō Shinkōsha, 1800 yen
68. 25/2/2009 *Hana no mōyō* [Origami Flowers], Seibundō Shinkōsha, 1800 yen
69. 5/6/2009 *Origami de tsukuru mochīfu tsunagi* [Complex Origami Motifs], PHP, 1400 yen
70. 1/2/2010 *Yunitto origami essence* [The Essence of Modular Origami], Nichibō Shuppansha (Japan Publications Inc.), 2200 yen
71. 25/3/2010 *Yunitto origami fantaji* [Modular Origami Fantasies], Nichibō Shuppansha (Japan Publications Inc.), 2200 yen
72. 25/11/2010 *Yunitto origami wandārando* [The Fantastic World of Modular Origami], Nichibō Shuppansha (Japan Publications Inc.), 2200 yen
73. 25/12/2010 *Ajisai ori* (AA. VV.) [Origami Hydrangea], Seibundō Shinkōsha, 1800 yen
74. 7/10/20011 *Hana no kusudama origami* [Floral Origami Globes], PHP, 1300 yen
75. 17/1/2012 *Tamentai origami* [Origami Polyhedrons], Nihon Vogue, 1400 yen
76. 31/1/2012 *Nejiri ori* [Twisted Folds], Seibundō Shinkōsha, 1800 yen
77. 26/2/2013 *Hako no origami 1* [Origami Boxes 1], Nihon Vogue, 1200 yen
78. 10/11/2013 *Hatto suru! Origami nyūmon* [Surprise! An Introduction to Origami], Chikuma Bunko, Chikuma Shobō, 820 yen
79. 30/1/2014 *Hako no origami 2* [Origami Boxes 2], Nihon Vogue, 1200 yen
80. 18/8/2014 *Hako no origami 3* [Origami Boxes 3], Nihon Vogue, 1300 yen
81. 30/4/2014 *Hajimete de mo kumeru kusudama origami* [Origami Globes for Beginners], Sekai bunkasha, 1300 yen
82. 13/11/2014 *Hoshi to yuki no sōshoku origami* [Origami Star and Snowflake Decorations]. Revised 2009 edition, Seibundō Shinkōsha, 1800 yen
83. 13/2/2015 *Hana no kazari origami* [Origami Floral Decorations]. Revised 2009 edition, Seibundō Shinkōsha, 1800 yen
84. 9/10/2015 *Origami de tsukuru ōnamento* [Decorations Created with Origami], Seibundō Shinkōsha, 1800 yen
85. 10/12/2015 *Dekita! Yunitto origami nyūmon* [Mission Accomplished! Introduction to Modular Origami], Chikuma Bunko, Chikuma Shobō, 820 yen
86. 20/2/2017 *Tsutsumi to fukuro no origami* [Origami Packages and Bags], Seibundō Shinkōsha, 1800 yen
87. 18/5/2017 *Ajisai ori* [Origami Hydrangea]. Revised 2010 edition, Seibundō Shinkōsha, 1800 yen

ACKNOWLEDGMENTS

I am very grateful for the support and assistance of the many people who helped me in the preparation of this book. For the introduction, I send heartfelt thanks to my fellow origami artist, Robert Lang, who was among the first to introduce science into this extraordinary paper universe, as well as to Hideto Fuse, who promptly agreed to help me view origami from the perspective of contemporary art.

David Brill, my long-time origami companion, has also supported me in this endeavor, demonstrating an intimate understanding of my work.

My thanks also go to the photographer Tsuyoshi Hongo, who has tirelessly devoted himself to executing the images, the photographer Kengo Endo, as well as Yoshiaki Teshima, for their suggestions regarding the photography, and finally to lighting designer Tadahiko Aso.

The publisher thanks the origami master Francesco Decio for his valuable advice.

ABOUT THE CONTRIBUTORS

David Brill, British origami artist, author of *Brilliant Origami*, and long recognized as one of the world's leading creative folders, is honorary member and president of the British Origami Society. He has produced a stunning series of ground-breaking designs, all demonstrating his innate ability to design beautifully engineered solutions and to fill the model with life through deft touches at the closing stages. He was awarded the Sidney French Medal by the British Origami Society for his outstanding contribution to origami.

Hideto Fuse was born in 1960 in Japan, in the prefecture of Gunma. He graduated from the Academy of Fine Arts in Tokyo. He obtained a Research Doctorate. As an art critic and anatomist, he has published some fifty titles, including *No no naka no bijutsukan* [The Museum in the Mind] and *Bi no hoteishiki* [The Equation of Beauty]. His research focuses on a theory of aesthetics as a conjunction between science and art.

Robert J. Lang, born in 1961, has been deeply involved in origami since the age of six, when he discovered several instructions for traditional designs in a library book. This early beginning ignited a lifelong passion for the art. He is now considered one of the leading origami artists in the world, with hundreds of original creations to his credit, as well as fourteen books authored, co-authored, or edited on the art, and numerous articles and instructions published in origami periodicals. He regularly lectures and teaches origami at conventions and workshops around the world. He has a Ph.D. in Applied Physics from Caltech, and has used his mathematical and engineering training to advance origami, both artistically and in its applications to science and technology. In his origami career, he has drawn upon many sources and influences, not least of which is the work of Yoshizawa-sensei. Yoshizawa's techniques, both technical and artistic, played a major role in Lang's own origami evolution. He is honored to be able to contribute an introduction to this work by Tomoko Fuse, modern master of origami art.

THE TUTTLE STORY "Books to Span the East and West"

Our core mission at Tuttle Publishing is to create books which bring people together one page at a time. Tuttle was founded in 1832 in the small New England town of Rutland, Vermont (USA). Our fundamental values remain as strong today as they were then—to publish best-in-class books informing the English-speaking world about the countries and peoples of Asia. The world has become a smaller place today and Asia's economic, cultural and political influence has expanded, yet the need for meaningful dialogue and information about this diverse region has never been greater. Since 1948, Tuttle has been a leader in publishing books on the cultures, arts, cuisines, languages and literatures of Asia. Our authors and photographers have won numerous awards and Tuttle has published thousands of books on subjects ranging from martial arts to paper crafts. We welcome you to explore the wealth of information available on Asia at **www.tuttlepublishing.com.**

Published by Tuttle Publishing, an imprint of Periplus Editions (HK) Ltd

www.tuttlepublishing.com

ISBN 978-4-8053-1555-2

Original edition:
Tomoko Fuse La Regina Dell'Origami © Snake SA 2018
Graphic Design and Production Clara Zanotti and Marinella Debernardi
Editorial Director Federica Romagnoli
Translated from Japanese to Italian Ornella Civardi
Translated from Italian to English Irina Oryshkevich

Texture background image on endpapers © Ortis/Shutterstock.com

Printed in Hong Kong 2001EP
23 22 21 20 10 9 8 7 6 5 4 3 2 1

Distributed by:
North America, Latin America & Europe
Tuttle Publishing
364 Innovation Drive, North Clarendon
VT 05759-9436 U.S.A.
Tel: 1 (802) 773-8930
Fax: 1 (802) 773-6993
info@tuttlepublishing.com
www.tuttlepublishing.com

Japan
Tuttle Publishing
Yaekari Building, 3rd Floor
5-4-12 Osaki, Shinagawa-ku, Tokyo 141 0032
Tel: (81) 3 5437-0171
Fax: (81) 3 5437-0755
sales@tuttle.co.jp
www.tuttle.co.jp

Asia Pacific
Berkeley Books Pte. Ltd.
3 Kallang Sector #04-01, Singapore 349278
Tel: (65) 67412178
Fax: (65) 67412179
inquiries@periplus.com.sg
www.tuttlepublishing.com

TUTTLE PUBLISHING® is a registered trademark of Tuttle Publishing, a division of Periplus Editions (HK) Ltd.

JAPANESE FLOWERING DOGWOOD
43.3 x 14.2 inches (1100 x 360 mm)
PAPER Washi/Paper Nao, Tokyo

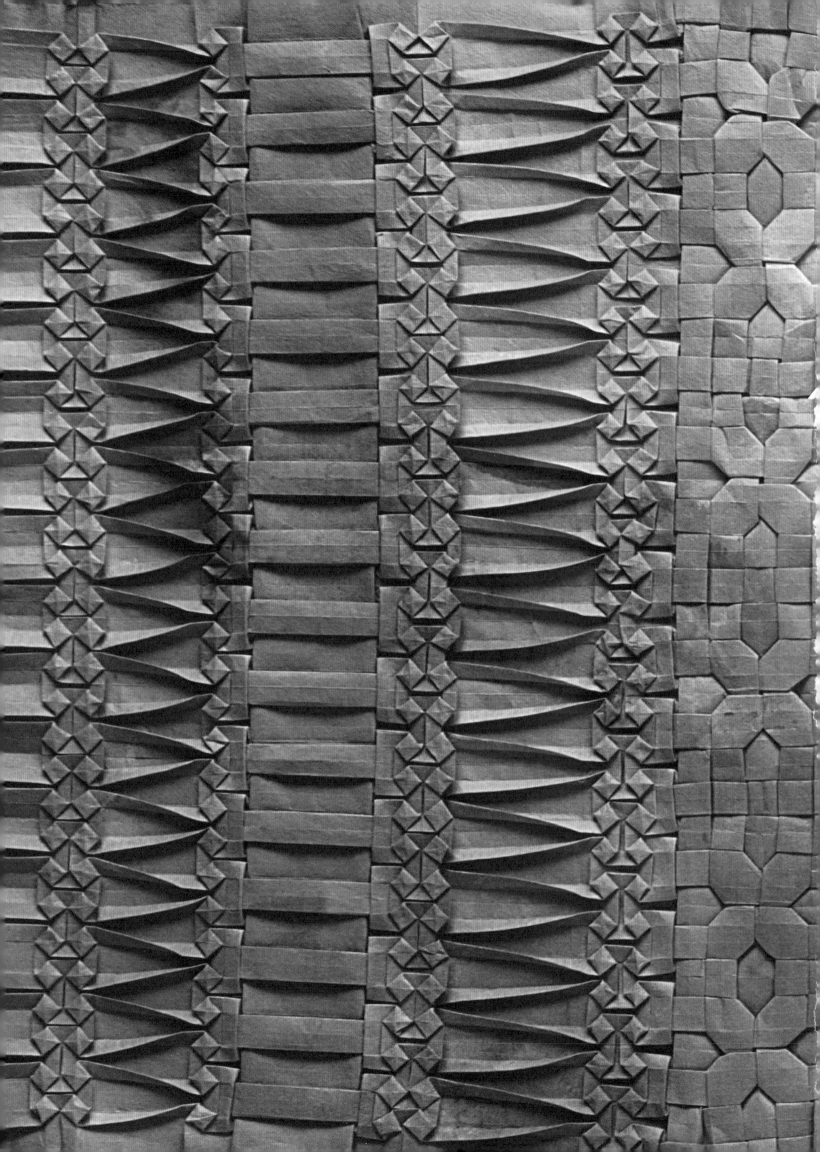